THE CARVER'S BOOK OF
AQUATIC ANIMALS
Surface Anatomy, Behavior, Patterns and Carving Techniques

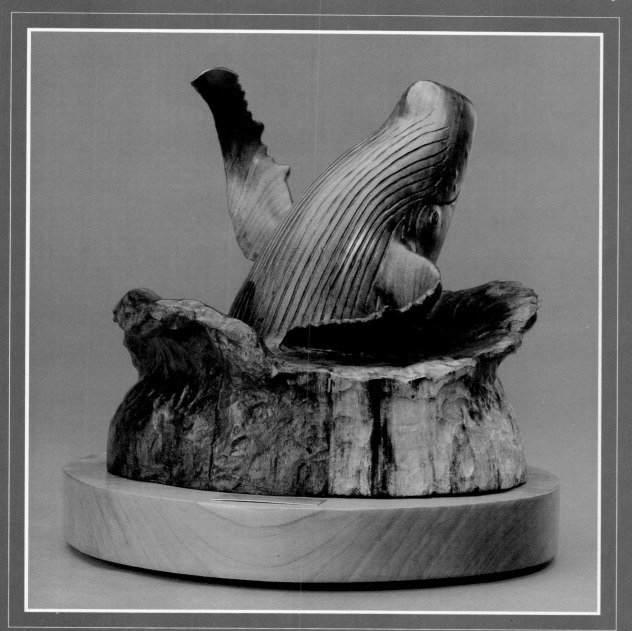

Howard Suzuki

With a Step-by-Step Guide to Carving Written with and Photographed by Douglas Congdon-Martin

Schiffer Publishing Ltd

77 Lower Valley Road, Atglen, PA 19310

DEDICATION

To Timothy and Deborah Effrem of Wood Carvers Supply, Inc. for their advice, strong support and encouragement in the development and completion of this book. To Douglas Congdon-Martin, a superb editor and new friend, for his support, help, and suggestions.

And finally, to my wife, Tets, for her patience, understanding and support in my efforts to bring to fruition the completion of this book.

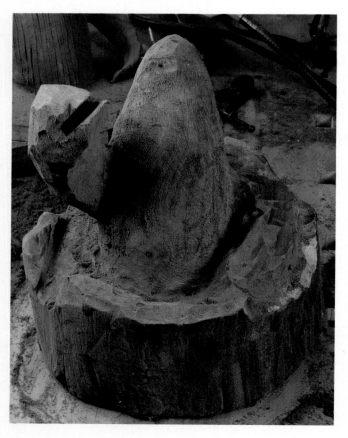

Printed in Hong Kong
ISBN: 0-88740-734-X

Book Design by *Balbach*

We are interested in hearing from authors
with book ideas on related topics.

Published by Schiffer Publishing Ltd.
77 Lower Valley Road
Atglen, PA 19310
Please write for a free catalog.
This book may be purchased from the publisher.
Please include $2.95 postage.
Try your bookstore first.

Library of Congress Cataloging-in-Publication-Data

Suzuki, Howard
 The carver's book of aquatic animals: surface anatomy, behavior, patterns, and carving techniques / Howard Suzuki: with a step-by-step guide to carving written with and photographed by Douglas Congdon-Martin.
 p. cm.
 Includes bibliographical references.
 ISBN: 0-88740-734-X
 1. Wood-carving--Technique. 2. Aquatic animals in art.
I. Title. II. Title: Aquatic animals.
TT199.7.S89 1995
731'.832--dc20
 94-44837
 CIP

CONTENTS

THE AUTHOR'S ACKNOWLEDGMENTS

I want to acknowledge the help I received from the many students who made helpful suggestions in the preparation of this book. I wish to particularly acknowledge the help of the members of the Gulf Coast Carvers Guild of Sarasota, Florida, the Charlotte County Carvers of Port Charlotte, Florida, the Bass Capital Carvers of Palatka, Florida, the Robert Buyer Wood Carving Studios of Norton, Massachusetts, and the Bonaire (N.A.) Foundation for the Arts.

I also wish to acknowledge the technical assistance on the biology of various species to Dr. Lynn LeFebvre, Project Leader, and Mr. Robert Bonde, Biologist, Sirenia Project, National Biological Survey; U.S. Department of the Interior; Mr. George Burgess, Director, Shark Research, Florida Natural History Museum; Dr. David Auth, Herpetology, Florida, Natural History Museum; Dr. Franklin Percival, Director, Florida Cooperative Alligator Research Project, U.S. Fish and Wildlife Services; Mr. Allan Woodward and Mr. Dennis David, Alligator Research and Management Sections, Florida Game and Fresh Water Fish Commission; and Dr. Dan Salden, President, Hawaii Whale Research Foundation; and Dr. James M. Barrett, Professor Emeritus of Biology, Marquette University, for reading and editing the manuscript.

I thank Chris Huss, Cindy Lott, Doug Perrine, and Carl Roessler for letting me use their outstanding photos in our book. To my good friends and fellow aficionados of the ocean, Dick Harrison, Underwater Photography, and Doug Perrine, Innerspace Visions, for their patience in being my "dive buddies" on our many trips around the world to exotic places to photograph the aquatic denizens.

THE PUBLISHER'S ACKNOWLEDGMENTS

The publisher thanks Timothy and Deborah Effrem for introducing us to Howard Suzuki. Their company, Wood Carvers Supply, Inc., is a leading mail order supplier of wood carving supplies in the U.S. and sponsors The Global Carving Challenge-Aquatic Life, the largest show featuring Aquatic Life wood carving in the world. Attracting carvers from around the world, it offers generous prizes in categories for painted and natural finishes. Information about the show and a catalog can be obtained from Wood Carvers Supply, Inc., Mail Order Division, P.O. Box 7500, Englewood, FL 34295-7500, Phone 800-284-6229.

FOREWORD

Howard Suzuki's sculpture is experiential. With rare exceptions, his subjects have been personally observed, photographed, and in some cases, measured and caressed prior to interpretation in wood. Howard has a Ph.D. in Anatomy from Tulane University with a focus on human and vertebrate anatomy. He has taught human anatomy for twenty-five years at Yale University, and the Universities of Arkansas and Florida. He is a lifetime outdoorsman and nature enthusiast. All of these characteristics melded to produce his interest in capturing detail in his subjects.

Howard's background and enthusiasm, combined with tantalizing impressions and someone else's photographs, were still not sufficient for him to express his feelings for aquatic animals. With dedication and boundless energy, he has sought opportunities to get close to his subjects. He spends an enormous amount of time diving and photographing aquatic animals, thus his personal reference collection of photographs and measurements of these animals is immense. In the absence of unlimited funding, he trades enthusiasm, time and talent for opportunities to volunteer, assisting biologists in their field studies. He has become a fixture on alligator research programs in Florida and has also spent considerable time on manatee, shark, sea turtle and humpback whale studies.

The first alligator hatchling that Howard carved was from a photograph by the renowned herpetologist, Archie Carr. By the following summer, Howard was invited to participate in alligator egg collections as a volunteer. He has never stopped that participation, and has become a valuable part of the research team for eight years, assisting in field data collection and lending his valuable photographic expertise to the effort. Several of his photographs have appeared in scholarly journals and have greatly improved the quality of numerous scientific and public presentations. Journalists covering the popular subject of alligators have contacted him for use of his photographs in nationally known publications.

Howard genuinely wants to make himself useful to the biologists he volunteers to help. Having made several expeditions with Sirenia Project biologists to photograph manatees at Crystal River, Howard asked what he could do to help the project with other manatee-related research. Biologists can always use the help of an excellent photographer such as Howard, as they often find themselves too busy working to document their activities well. This is especially true of field work in aquatic environments; handling sampling gear in the water makes accessories like cameras cumbersome. Howard more than repaid any favor done for him by bringing his impressive underwater camera gear along on a no-frills field trip to Merritt Island. His mission was to photograph seagrass plots using his wide angle 15mm lens and to document the various tasks of the field crew, which is no small feat in water with no more than two meter visibility. Howard himself derived little benefit from this trip, but then he may turn out a sculpture of manatee grass that will astonish the world.

Howard's thirst for accuracy and detail about his subjects does not translate into an absolute copy of nature. His pieces are definitely Suzuki. One can see in his carvings the progression of his interpretation as he becomes ever more familiar with his subject. He does not sensationalize behaviors or reputations of the animals he carves, but they have a genuine character based on his first-hand knowledge of them. After all, it would not be art if he could not inject himself into the scientific detail he works so hard to achieve.

Franklin Percival and Lynn Lefebvre
July, 1994

I first met Howard at the Southeastern Wildlife Show in Charleston, South Carolina. I was walking around looking at the work of my fellow carvers. When you go to as many of these shows as I do it takes something special to grab your attention. So I was sort of lost in my own thoughts until I came to Howard's table. What I saw there reached out and grabbed me and threw me on the floor.

Howard had sculpted a large mouth bass busting out of a stump of walnut. It was stunning. Very few people can get a real life likeness out of wood without filler or paint. But here it was! A beautiful sculpture, as real as if it were jumping out of a mountain lake.

We have since become good friends, growing to appreciate and respect each other's very different artistic styles, and coming to enjoy each other's company and friendship. This book should go a long way toward helping others learn from Howard as I have. I am sure you will enjoy it and use it for years to come.

Tom Wolfe
September, 1994

INTRODUCTION

Some fourteen years ago when I first started to carve aquatic life animals, no comprehensive information useful to three-dimensional artists was available. At first I depended upon photographs and paintings from wildlife books, but found them inadequate because anatomical details were either not shown or not clear. These books emphasized artistic appeal not anatomical detail.

Because of this, I decided to accumulate data on aquatic animals. With persistent and tedious library search, a great deal of information, scattered in different scientific publications, was gathered. Whenever possible, the library search was done in conjunction with the study of preserved specimens in scientific museum collections. Using my professional background in biological field and laboratory research, and proficiency in scuba diving and underwater photography, I added field observation to my studies. I took trips to exotic places where I could find adequate numbers of animals that I could observe and photograph. I have also helped research teams in the measurement, autopsy, and photography of various species. My studies resulted not only in obtaining more accurate structural and behavioral representations of the animals, but they also enhanced my artistic interpretations.

During the past few years, I have accepted invitations to teach courses in the carving of aquatic animals. As a woodcarving instructor, I learned much from my students, and quickly improved my methods and drawings. Through frequent travels into the field and student input I was able to enhance the details and format of my drawings. As I got more involved in teaching and as I saw the significant growth and interest in three-dimensional aquatic animal art in the past few years, I am more convinced of a need for a book on the elements of carving aquatic animals.

The main objective of this book is to illustrate and describe the surface anatomy of some popular aquatic animals in a way that is useful to three-dimensional artists. Representatives of various vertebrate groups are included, but the bony fishes were excluded because, in recent years, excellent books have been published on those animals. Most of the aquatic animals included in this volume are ones that I have personally observed and studied in the wild in their own habitat, the exceptions are the Sperm Whale and Great White Shark. I am still hopeful that one day I can observe them and other species in their natural environment.

The second objective of this book is to inspire you to create your own original designs, even though you may not have had the opportunity to observe wild and free aquatic animals. This book includes only a few examples of patterns showing animals in "action." Hopefully these will serve as catalysts for your own creations. The "action patterns" were developed by studying photographs of actual animals in motion, and incorporating the anatomical details shown in the topographic anatomy drawings included in this book. Myriads of other potential compositions can be garnered from studying photographs published in natural history publications or television videos.

I have used formats modified from those used in various field identification books. They include: (1) succinct descriptions; (2) primary drawings of animals shown in extended "lifeless" form on a single page to show proportions and locations of structures from different views, which can also be used secondarily as "patterns"; (3) examples of "action" patterns; (4) photographs and additional drawings to provide additional illustrative information; (5) descriptions of behavioral patterns and natural history to give the reader a broader understanding of the animal that is important in developing realistic designs.

Animals selected for inclusion in this book are distinctive in shape and can be readily identified by their form. Although information is presented on the coloration of the animals, painting techniques are not the purpose of this book. Likewise the stepwise carving procedures are not the primary purpose of this book. There is, however, a section written and photographed by Mr. Douglas Congdon-Martin, which describes in detail the steps I took to sculpt a breaching Humpback whale. I am indebted to Mr. Congdon-Martin for suggesting the inclusion of sculpting a breaching Humpback Whale. He took the necessary time to work with me in my studio photographing the work in progress and recording my comments as I sculpted the whale. The time spent working together was most enjoyable and productive. His contribution has significantly improved the worthiness of this book. Carving and painting techniques learned from carving other species can be readily adapted to these animals.

The description of each species is subdivided into several categories. **Identifying characteristics** list major unique characteristics of the animal. **Additional anatomical features** describe anatomical details essential to the three-dimensional artist. **Size and color** presents information that will be advantageous in the development of the design, and the incorporation of other species into the composition based on knowledge of comparative size. Information of **Eggs** is useful in creating sculptures of hatching and hatchling reptiles. **Some behavioral characteristics** are important in understanding form and function of the animals. **Special carving/sculpting suggestions** are helpful carving techniques specific to the species.

Some significant technical and popular references are listed in the back of the book, for individuals wishing to obtain further information on the animals.

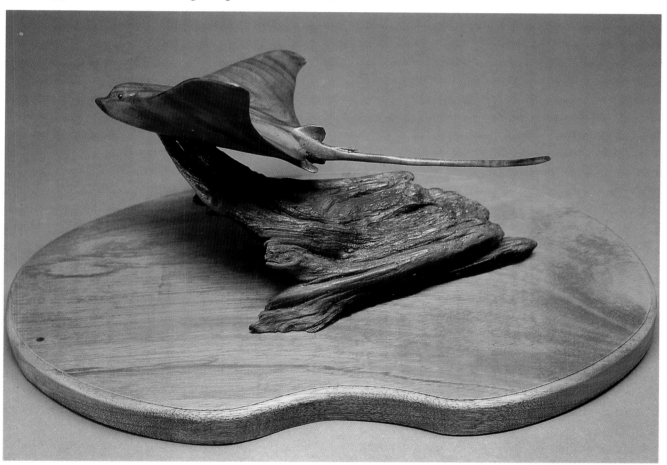

CLASSIFICATIONS OF ANIMALS DESCRIBED IN THIS BOOK

Class Chondrichthyes
Cartilaginous Fish with Jaws

Subclass Elasmobranchii
This subclass includes both the sharks and batoids.

Order Selachii

This order includes the **Sharks**, which are separated into a number of different families and numerous species. They have 5 to 7 pairs of gill slits along the sides of the head. Paired spiracles are small or absent with little functional use. Their pectoral fins are separate and distinct from the sides of the head and not associated with the gill slits. Included are the **Great White** and **Tiger Sharks.**

Order Rajiformes

This order is the **Batoid**, separated into seven families composed of rays, skates, and sawfish. They have pectoral fins fused to the sides of the head forming wing-like or disc-like extensions of the head, and all have 5 pairs of gill openings which are found on the under surfaces of the pectoral fins. Spiracles are large and functional. Included are the **Manta Ray** and **Spotted Eagle Ray.**

Class Reptilia
This class includes the snakes, lizards, turtles and crocodilia

Order Chelonia

This order includes the tortoises, land turtles and sea turtles. They have bony shells that are covered by horny plates, and have two pairs of extremities. The **Loggerhead Turtle** is included in this book.

Order Crocodilia

This order includes the alligators, crocodiles, caimans and gavials. They are lizard-like animals with prominent armor-like epidermal ridges. The **American Alligator** is represented in this book.

Class Mammalia
This class includes all warm-blooded animals that suckle their young, and have hair.

Order Cetacea

This order includes the whales, dolphins and porpoises, which are subdivided into two suborders: the toothed whales (Odontoceti) and the baleen whales (Mysticeti).

Suborder Odontoceti

These cetaceans have varied shapes, sizes and locations of their teeth. The **Sperm Whale, Orca, and Bottlenose Dolphin** are representatives of this group described in this book.

Suborder Mysticeti

As adults, these whales do not have teeth, but have keratinized plates called baleens, which vary in size, shape, and number according to the species. The **Humpback Whale** was chosen as a representative of this group. Tooth buds are present in the embryonic stage, but are absorbed as development proceeds.

Order Sirenia

This order includes the Manatees and Dugong. The **West Indian Manatee** is presented in this book.

GENERAL CARVING CONSIDERATIONS

1. Designs from single pieces.

In general, for those choosing to make naturally finished works described in this book, it is highly recommended that the carvings be made out of a single piece. Small structures of contrasting colors, such as teeth or claws, can be made separately and inserted without altering the integrity of the beauty of the wood grain.

2. Designs with glued pieces.

While I personally prefer to make my carvings out of single pieces of wood, it may not be possible or practical to do some without laminations. If the finished product is to be painted, glue joints will be covered and will not show. Below there is a drawing that illustrates several pieces of wood glued together to make an Eagle Ray. Try to keep the number of pieces to be glued to a minimum. In any case select wood with the proper cross-sectional grain to match the curvature of the animal to be carved. This is especially important if you wish to use a natural finish on your laminated piece. With rays, it is preferable to make the body and tail out of a single piece to assure structural integrity and a smooth transitional line from body to tail.

3. General shaping.

After the outline of an animal, such as a Tiger Shark is drawn on the material to be carved, initial band saw cuts are made from the top or bottom view. This is particularly important if the animals are drawn in a lifelike, curved shape. When viewed from the side, one pair of fins will appear to be in front of the other. If a straight side-view drawing is transposed on the block of wood, it would not be possible to have the animal shaped in a curved manner.

The side view cuts are made next, with the interval between the two pectoral fins left intact. With flat wide animals such as the Manta and Eagle Ray, additional vertical cuts may be made by placing the front end of the animal on the band saw table. In this position, the veritcal cuts will help shape the desired curved "flying" form of the outstretched modified pectoral fins. Standard procedures described in bird carving books may be used, holding the cut pieces together with masking tape. I cut outside of the marked lines, as I want to have sufficient wood available to vary the design as needed, and, more importantly, to leave enough wood to offset differences in the locations of structures on the right and left sides when the animal is in a curved position.

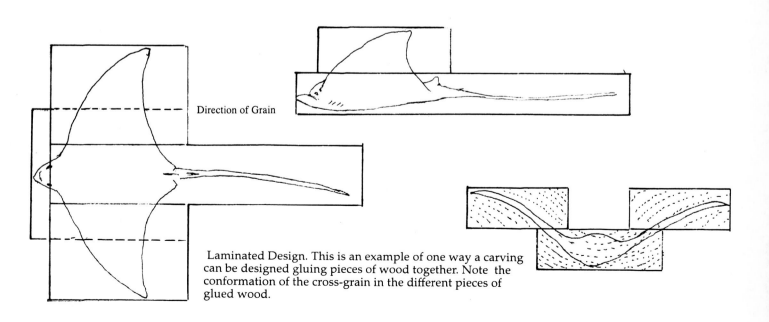

Direction of Grain

Laminated Design. This is an example of one way a carving can be designed gluing pieces of wood together. Note the conformation of the cross-grain in the different pieces of glued wood.

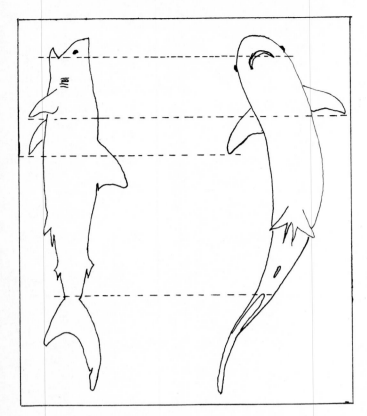

Curved Tiger Shark design showing changes in the relationships of structures between the dorsal and lateral views. Notice also the deceptive inaccuracy of the shortened tail in the lateral view. This demonstrates why one should lay out the pattern on the dorsal view and make the initial sawcuts from the top side.

4. Attaining smooth even surfaces.

After establishing the desired general shape of the animal, the next objective is to eliminate scratches and other defects such as depressions caused by the use of various carving tools. Major defects can be removed with wood rasps followed by wood or riffler files. This is followed by the use of scrapers made out of old window pane glass, traditional furniture makers's metal scrapers or knives, gouges or carving tools. Using these tools hastens the smoothing process. Scrap window glass can easily be cut into various shapes and used to scrape the wood. When it gets dull, re-cut the glass. **Caution: Always wear goggles and gloves as bits of glass can break off.**

When the surfaces appear to be smooth, use sandpaper. Using sandpaper initially to remove defects is not recommended, as sandpaper has a tendency to follow the contours of slight depressions and other defects that you want to eliminate. Applying a mineral spirits while smoothing the carving will quickly reveal defects.

Apply a lacquer-based sanding sealer and allow the carving to dry. This will not only reveal defects, but will aid in bonding the wood grain together to allow for a better finish. This process is repeated until the desired surface is obtained. This approach is particularly effective in obtaining a smooth surface over extensive areas, such as the broad surfaces of the pectoral fins and bodies of the Manta and Eagle Rays.

5. Knives modified as scrapers.

Knives and other metal tools when placed at right angles to the wood surfaces are very useful as scrapers. Old knives and other metal tools can be ground to different shapes to meet specific scraping needs. I find round-tipped scrapers with different radii, skew-shaped scrapers, slightly curved knife-shaped scrapers to be indispensable in scraping small surface areas. They have proven to be extremely useful in decreasing the time it takes to obtain defect-free smooth small areas in my carvings. Based on general shapes I desired, I had my friend Joe Olson of Randolph, Massachusetts make a set of incrementally sized round-tipped scrapers. These have proven to be invaluable.

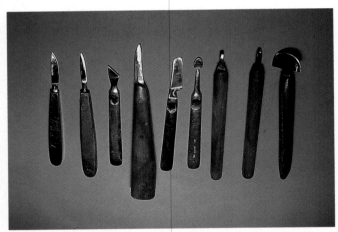

Examples of knives used as scrapers. They can be used as is or can be modified in shape to meet the specific needs. The three special round edged sharp tools shown on the right were designed and specifically made for me as scrapers by Joe Olson

6. Motorized leather wheels.

I sharpen all of my scrapers in a way that is similar to my carving tools. I use a set of motorized leather wheels, each with a different grade of abrasive. I do not concern myself with turning the edges to form burrs as one does in the procedure for traditional cabinet making scrapers. The wheels are ro-

tated counter-clockwise as you face it from the left. The tool to be sharpened is placed with the edge facing upward. With that rotation, the tool edge will not gouge into the leather wheel and be a potential hazard. In addition, if the tool slips, it will fly away from the user.

7. Detailing with a woodburner.

I use the Colwood Electronics Detailer™ with only two tips: the 3/16" spear point tip and the writing tip. The **spear point** tip is used to outline head, carapace, and plastron scales, the mouth, fin rays, gills, throat grooves, and skin creases. Eyes and eyelids may be also be sculpted using the same wood burning tip, as is described in the sections on the Loggerhead Sea Turtle and Sperm Whale. A pictorial description of carving the eyes on a humpback whale is shown in the section on the sculpting of breaching Humpback. The **writing tip** is modified by bending the tip at a right angle and is used to burn in alveolar teeth sockets in the partially open jaws of toothed whales. A description of this technique is included in the section on the Sperm Whale.

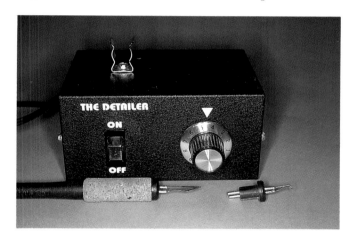

The Colwood Electronics Detailer is shown with a handle and replaceable a 3/16" spearpoint tip, the writing tip, and my modified writing tip. These are the only tips I use.

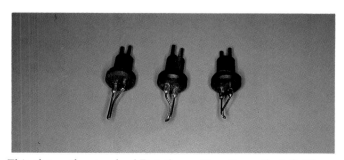

This shows the standard Detailer writing tip on the left. The middle tip was bent at a right angle, while the tip on the right was bent and ground down to a smaller dimension.

8. Carving Cradle

Below there is an illustration of a carving cradle I made and use. One inch thick plastic sponge pieces are cut to size and glued on the curve surfaces. The cradle can be used to hold Rorqual whales, such as the Humpback on their backs, and serves as stabilizing supports to aid in marking and carving the throat and abdominal grooves, and bumps and calluses. A pictorial description of the cradle's use is shown in the section on making calluses on a breaching Humpback Whale.

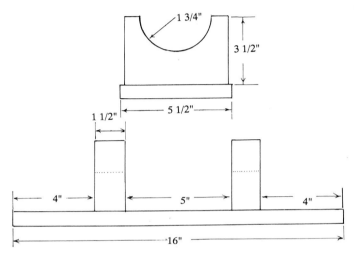

Carving Cradle made of two 5" long 2 x 4s and one 16" long 1 x 6.

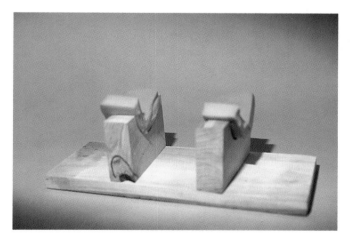

Side view of the carving cradle made out of scrap plywood and pieces of 2 x 4. A plastic sponge serves as a protector when the carving is placed on the cradle.

A humpback whale is supported on its dorsal surface by the cradle while the carver is cleaning the abdominal grooves using a diamond riffler file.

9. Modeling.

During the development of new designs, I first sketch ideas on paper. Crude models of sculptures can then be carved out of foam plastic insulation sheets. The materials are readily available at building supply companies in different thicknesses, easily cut and shaped with sharp carving tools and glued together with Liquid Nails™ adhesive.

With modeling clay, I use Classic Clay™ (developed and distributed by Philip Marcacci, Box 1871, Cucamonga, California) because it is easy to use, with minimal need for armatures. It is soft when warmed and hardens at room temperature. I usually shape the model on a small piece of plywood. If an armature is needed, metal coat hangers may be used. For larger pieces aluminum "wires" with larger diameters are available at art supply stores. I do not attempt to make a detailed finished clay model (as a bronze sculptor would do). The function of the model is to help crystallize the composition and design, to help determine the size of wood stock needed when made to full scale, and to serve as a guide while sculpting. A pictorial description of the technique is shown in the section on sculpturing the Humpback whale.

10. Strengthening fragile parts.

In sculpting animals out of a single piece of wood, thin fragile areas may have a weaker cross grain, such as the tails of batoids, the fluke and pectoral fins of cetaceans. These structures can be strengthened by coating them with low viscosity cyanoacrylate glue. It will soak into the wood and fill the wood pores. The structures can be readily sanded and detailed with a wood burner tip, but care must be taken not to inhale the fumes, as they are toxic.

11. Repairing defects.

In working with wood, one cannot avoid finding parts of the wood that are rotten or are becoming cracked, *etc.* Many defects can be effectively and aesthetically repaired using epoxy glue. A defect can be filled by mixing sawdust with the epoxy. Sawdust adds color and body to the mixture. The repaired portions may not match the rest of the wood, but can be very appealing to the eye. Epoxy is readily sanded and can be sealed with a clear finish.

If a crack in the wood is deep, use the slower polymerizing epoxy, so that it penetrates deeper into the wood defect before it sets. If it is necessary to add some more epoxy to fill in an area in which epoxy has been used, use the same brand and type.

Different epoxies and woods polymerize into different shades of colors. Before actually using a material on a defect, always test it by combining the ingredients and letting them harden. I recommend collecting, labeling and storing different types of sawdust in sealable plastic freezer bags.

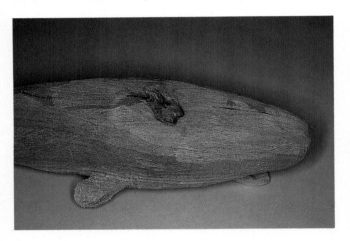

This illustrates a Sperm Whale carving with a knot-hole defect that was uncovered after the piece was initially cut out in the band saw. The grain pattern indicated the possibility of salvaging this potential carving.

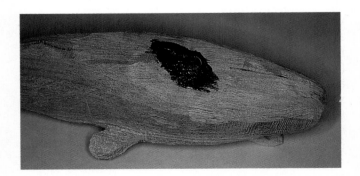

Regular epoxy was mixed with sawdust from the carving and placed on the knot-hole defect area.

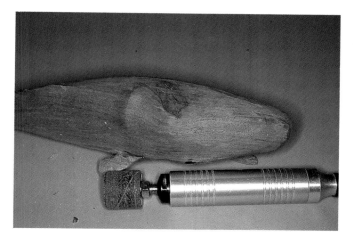

After curing for a day, the excess epoxy was smoothed off using a sanding drum.

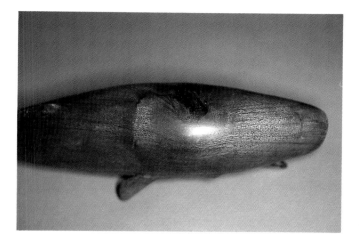

The appearance of the repaired area after further smoothing and the initial sanding sealer coat. The repaired area will blend in well in the finished carving. The knotty grain appearance will enhance the beauty of the completed carving.

12. Cleaning rotary burrs and cutters.

When my rotary cutters (diamond, ruby, carbide, steel, Kutzall, *etc*.) get clogged, I place them in a wide-mouth container filled with ammonia water and 409™ detergent. After the cutters soak for a few minutes, they are taken out and cleaned with a brush (toothbrush, steel, or brass), and rinsed in water. If an ultrasonic cleaner is available, it will do a marvelous job quickly. It is important that cutters be kept free of carbon resulting from overheating, as a clogged cutter will only exacerbate the burning problem in the wood without cutting cleanly.

Sometimes a rotary burr clogs when it cuts into an area that has been filled with epoxy that has not polymerized to the proper hardness. This may be due to impatience, not giving the glue proper

amount of time to harden, to the incorrect proportions of resin and hardener, or to the inadequate mixing of the parts. When the rotary cutters gum up with epoxy, I place the cutters in a bottle containing lacquer thinner, which dissolves and/or softens the epoxy. After soaking for a short period, the cutters are cleaned with a brass brush.

13. Mounting glass eyes in Cetaceans.

Mounting eyes in naturally finished carved animals which have movable eyelids requires a different method than in painted carvings, where eyelids can be made with epoxy putty. While the eyeball is generally spherical, the appearance of the eye is determined by the opening between the margins of the movable eyelids. The portion of the eyeball that is visible appears elliptical.

The following is a procedure that I use to insert plano-convex glass eyes into naturally finished carvings/sculptures. The following illustrates the use of a 5mm plano-convex glass eye inserted into a carving. If the proper illusion is to be attained, it is important that the inverted cone cutter you use be smaller in diameter than the glass eye which is to be inserted.

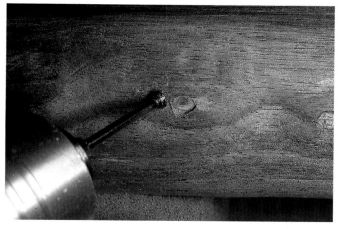

A 4mm inverted diamond cone rotary cutter is shown adjacent to an opening made on the orbital mound. The cutter was placed at an angle of approximately 70-75 degrees where the glass eye is to be mounted. The initial cut is shown.

The inverted rotary cone is in place at the angle previously indicated, as it forms the initial undercut for the placement of the glass eye. The shaft of the cutter is placed against the inferior margin of the lower eyelid and the cutting stopped.

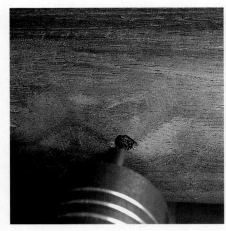

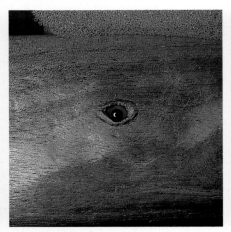

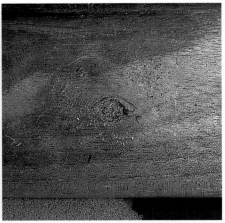

With the motor on, the shaft of the inverted cone is then gradually and carefully moved to a vertical position grinding away the wood to form the base of the orbit. After the proper orbital depth is reached (which is determined by the thickness of the glass eye), the cutter is moved upward (dorsally) to undercut the upper eyelid. The opening you make should be large enough to permit the glass eye to be slipped into the elliptical opening by angling the glass eye under the upper eyelid. The undercut should be deep enough to allow the eye to slip into the opening, with its lower edge just clearing the lower eyelid margin.

The glass eye in place (the red eye was used for demonstration purpose only). In this example the eye situated itself too deeply within the orbit and will need to be corrected. The outer eyelid margins are burned in and cleaned with a dogleg micro-chisel.

Since the orbital floor was too deep, some sawdust from the carving was deposited into the opening. When the glass eye is inserted, this raises it and the convex portion of the eyeball is more visible.

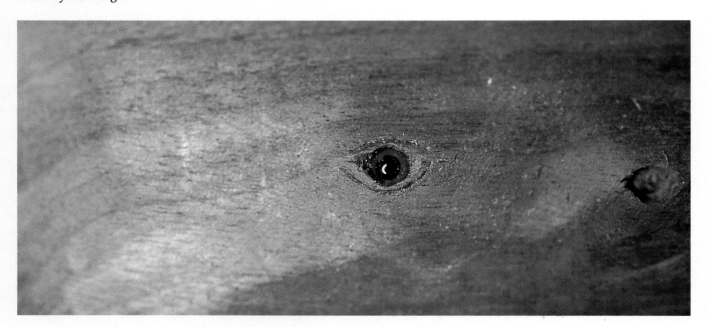

The glass eye is inserted on top of the sawdust, elevating it. The glass eye is mounted using epoxy mixed with sanding dust from the carving. The epoxy also fills in the space between the glass eye and eyelid margin and holds it in place. After hardening, the excess epoxy is removed and the eye cleaned.

CHAPTER II
GREAT WHITE SHARK
(SUBCLASS ELASMOBRANCHII, ORDER SELACHII, FAMILY ISURIDE)
CARCHARODON CARCHARIAS (LINNAEUS)

The Great White Shark belongs to the Mackerel Shark family which includes the Mako and Porbeagle Sharks. The Great White Shark is the fish-like creature that is probably most feared by humans. Justified or not, perceptions of the Great White's ferocity have been heightened by the attention given to this shark by writers and motion picture and television producers.

Identifying characteristics. The Great White Shark is readily identified by its robust fusiform body, pointed snout, almost half moon-shaped homocercal tail, firm pronounced lateral caudal keel on the caudal peduncle, small second dorsal and anal fins, and a black spot located at the base (axillary part) of the pectoral fin.

Additional anatomical features. The eyes appear wholly black, because both the iris and pupil are black, unlike other sharks which have contrasting light colored irises. This adds to the ferocious appearance of the shark. The mouth contains prominent serrated triangular teeth that are directed obliquely and posteriorly. Five pairs of prominent, long gill slits are located in front of the base of the pectoral fins. The tip of the dorsal fin is sharp, in contrast to the Mako Shark, which is similar in appearance, but has a dorsal fin that is round at the tip. A small anal fin is located behind the small second dorsal fin. The male is identified by the presence of a pair of "claspers" on the caudal edges of the pelvic fin. The caudal keel is flattened laterally and adds strength to the tail. The shark uses its tail muscles for the powerful speed it needs when going after its prey.

Size and color. These sharks are estimated to reach 25 feet in length and to weigh from 1 1/2 to 3 tons. The largest size was estimated by extrapolating bite measurements taken from prey. The upper surfaces of the head and body of the shark are grayish in color. The tail is almost entirely grayish, with variable splashes of white on the margin of the ventral leading edge. The abdominal surface is white and this color extends to the lateral margin in the caudal peduncle, ventral to the caudal keel, the sides of the head, and the area above the margin of the mouth.

Some behavioral characteristics. Great Whites are primarily solitary sharks that inhabit the colder waters of the world, sometimes straying into warmer waters, for example, the coast of Florida. They are aggressive predators that feed on large animals such as the pinnipeds, dolphins, large pelagic fish, turtles, and other sharks. They have been documented to have attacked, maimed, and/or killed human bathers, divers, and surfers.

Special carving/sculpting suggestions. When looking at the curved carving pattern of the Great White Shark note that the configuration of the head changes when the mouth is open. The upper jaw bulges down prominently and the rostrum points upward.

The technique of making white teeth is described in the Tiger Shark section. The pointed rostrum, homocercal tail with sharp caudal keels and small second dorsal and anal fins are very important identifying features that should be clearly carved. 3mm solid black eyes are used in the curved shark pattern on page 18.

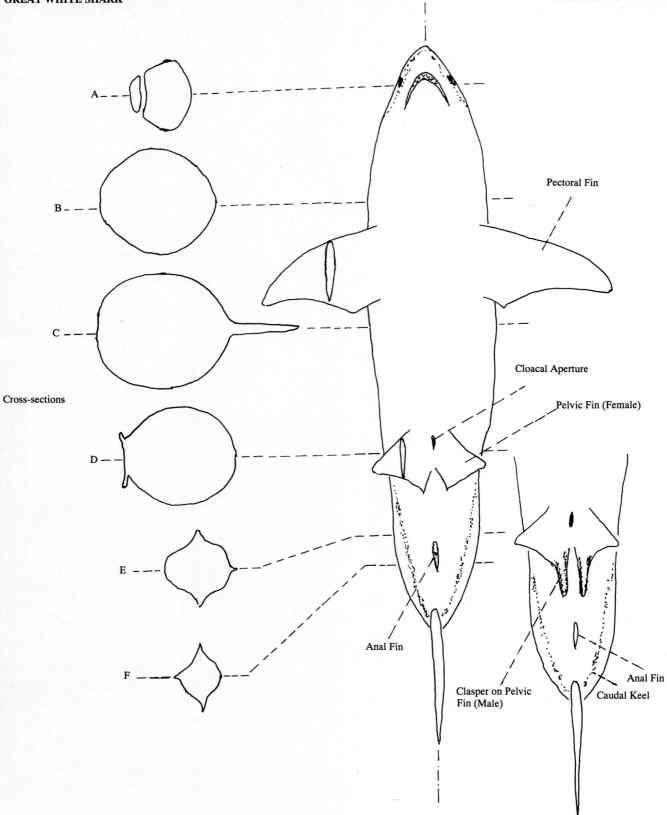

A

B

C

Cross-sections

D

E

F

Pectoral Fin

Cloacal Aperture

Pelvic Fin (Female)

Anal Fin

Clasper on Pelvic Fin (Male)

Anal Fin

Caudal Keel

LATERAL VIEW

DORSAL VIEW

Nostril

Eye

A

Gill Slits

Pectoral Fin

B

Axillary Spot

C

Pelvic Fin

D

E

F

Anal Fin

First Dorsal Fin

Second Dorsal Fin

Homocercal Tail

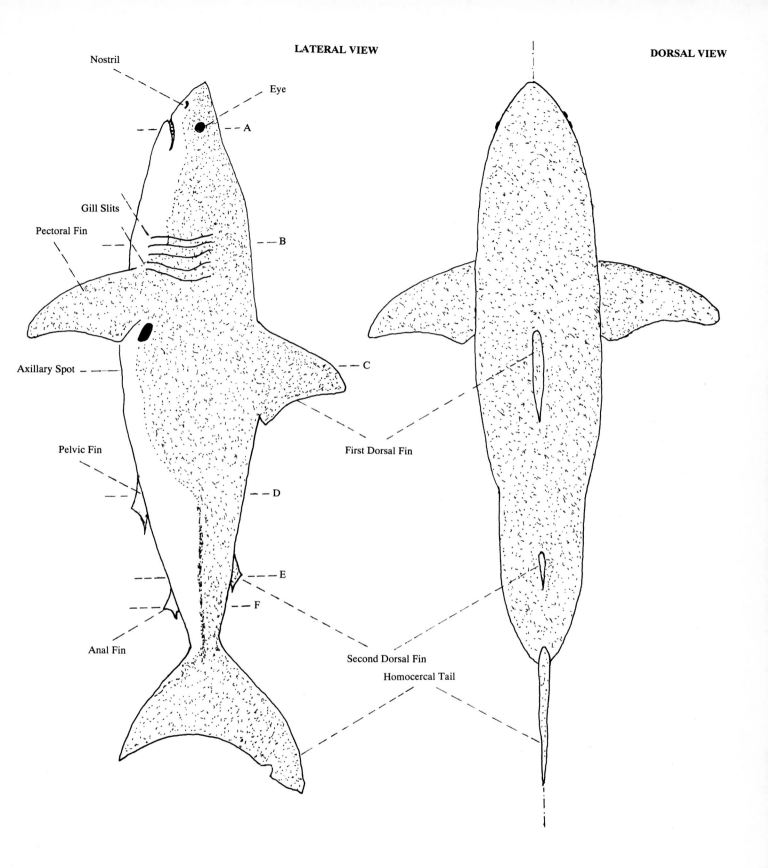

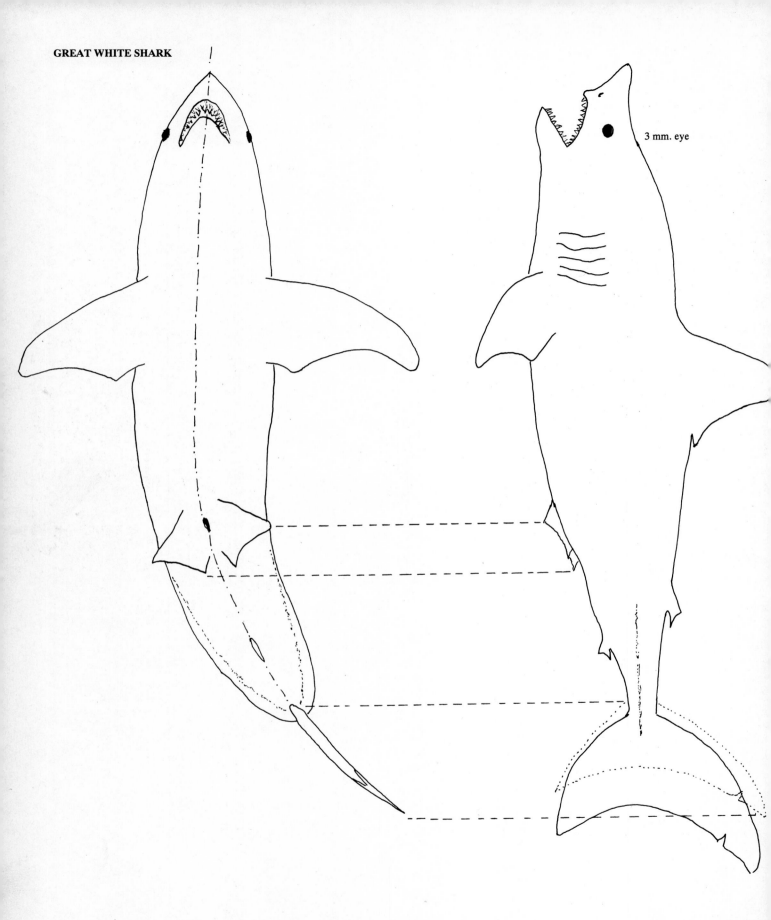

3 mm. eye

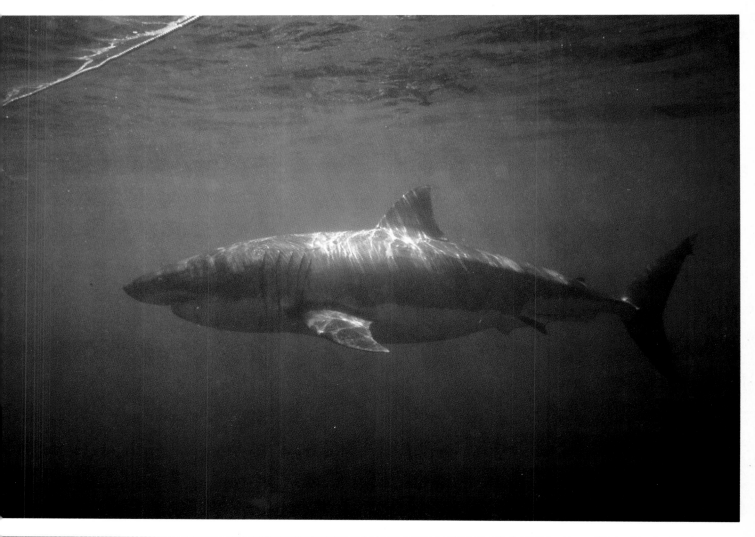

Great White Shark, South Australia. *Photographer: Carl Roessler, Innerspace Visions*

Great White Shark Carving made out of walnut on walnut base.

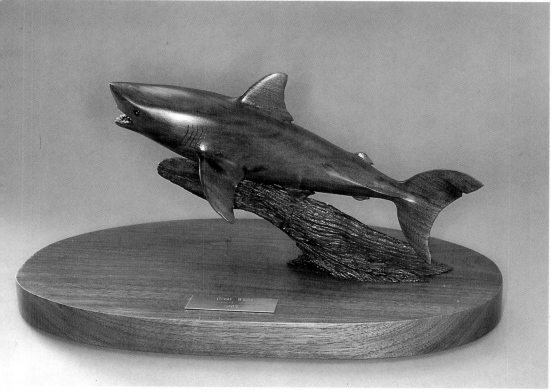

CHAPTER III
TIGER SHARK

(SUBCLASS ELASBRANCHII, ORDER SELACHI, FAMILY CARCHARHINIDAE)

GALEOCERDO CUVIERE (PERON AND LESEUR)

Tiger Sharks exemplify what is perceived by the general public as the "typical shark." They are dangerous sharks, verified to have attacked people. They are voracious omnivorous feeders that inhabit the semi-tropical and tropical waters. The generic name *Galeocerdo* is derived from the Greek meaning "weasel" or cunning. I have only seen one while scuba diving in the Exumas in the Bahamas, and that recognition made my heart beat faster.

Identifying characteristics. These sharks are readily identified by their long heterocercal tails, the upper lobe is long and narrow and much longer than the lower lobe. The head has a flat upper surface, and a rounded, short snout. The mouth is ventrally placed, with a pair of shallow furrows extending forward from each of its corners. The body has tiger-like vertical bars on the body.

Additional anatomical features. The Tiger Shark has a fusiform body which can become more broadly round with age. The nostrils are prominent and located near the tip of the short snout. The eyes are large with coppery colored irises. A small, slit-shaped spiracle is located behind the eye. Five pairs of short gills are located in front of the pectoral fins. The tip of the high sloping dorsal fin is round, as are the small second dorsal and anal fins. The tail may be up to 1/3 the body length. A slight round-edged lateral ridge is present on each side of the caudal peduncle and extends into the tail.

Size and color. These sharks have been reliably measured up to 18 feet in length, the average being 13 feet. A 14 footer has been weighed at almost 1800 pounds. Shades of dark gray to grayish brown on the dorsal and lateral surfaces blend into a lighter shade ventrally. Spots are present and may fuse to become vertical dark stripes. These have a tendency to disappear as the animal gets older, when they attain a more uniform color. Young sharks have spots rather than bars.

Some behavioral characteristics. Tiger Sharks are nocturnal in their habits, moving into the shallow reefs to stalk their prey. During the day they roam the open ocean. They are voracious feeders and eat a variety of organisms. Like the Great White Shark, they are known to have attacked people.

These sharks may show agonistic behavior when approaching prey. In this mode, the shark will swim around its prey and arch its back very prominently (Johnson and Nelson, 1973). Mammals with fur manifest such behavior; bared teeth and raised hair make them appear larger and more intimidating.

They move through the water by bending their bodies in sinuous curves, starting from the cephalic end and proceeding caudally (Daniel, 1934). See the drawing of the curved tiger shark on page 21.

Special carving/sculpting suggestions. When depicting the shark in a curved form, the cutout should first be made from the dorsal or ventral view. By placing a full sized lateral view pattern on this initial cutout of the Tiger Shark, you will get a better perspective on the actual locations of various parts. The apparent differences in positions of the paired fins and the shortened appearance of the tail will become apparent when viewed from a direct lateral view. This demonstrates the rationale for making the top or bottom view cut first.

5mm solid black eyes are used on the curved Tiger Shark pattern. An identifying feature of this shark is the shallow furrow extending from the corner of each side of the mouth. This feature can be made by burning lightly with a spear point burning tip.

Teeth can be made from a mixture of 5-minute epoxy and plaster of Paris. Let the mixture harden slightly, then dip the tip of a toothpick into it. Next touch the toothpick tip covered with epoxy on the mouth where the teeth are to be located. If you quickly lift the toothpick, the surface tension will lift the glue from the mouth surface into a point. Eventually it will fall away from the toothpick, and leave a small pointed tooth. In order to achieve this effect, the epoxy must attain a partially hardened state where it can be pulled, yet retain its pointed shape after the toothpick is pulled away.

4mm solid black eyes are used on the curved Tiger Shark pattern. An identifying feature of this shark is the shallow furrow extending from the corner of each side of the mouth. This feature can be made by burning lightly with a spear point burning tip.

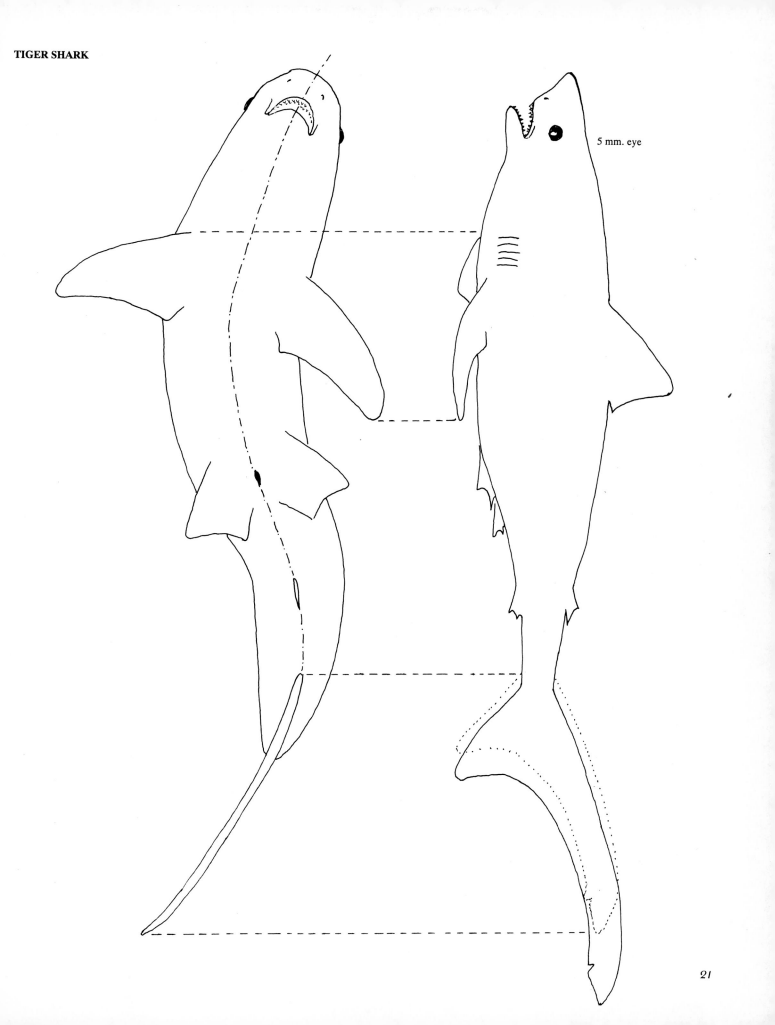

5 mm. eye

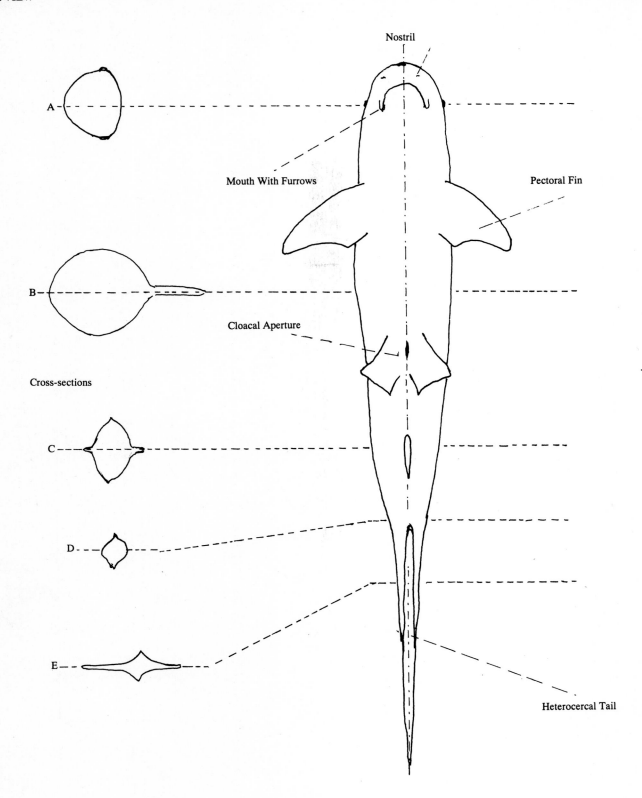

Nostril

Mouth With Furrows

Pectoral Fin

Cloacal Aperture

Cross-sections

A

B

C

D

E

Heterocercal Tail

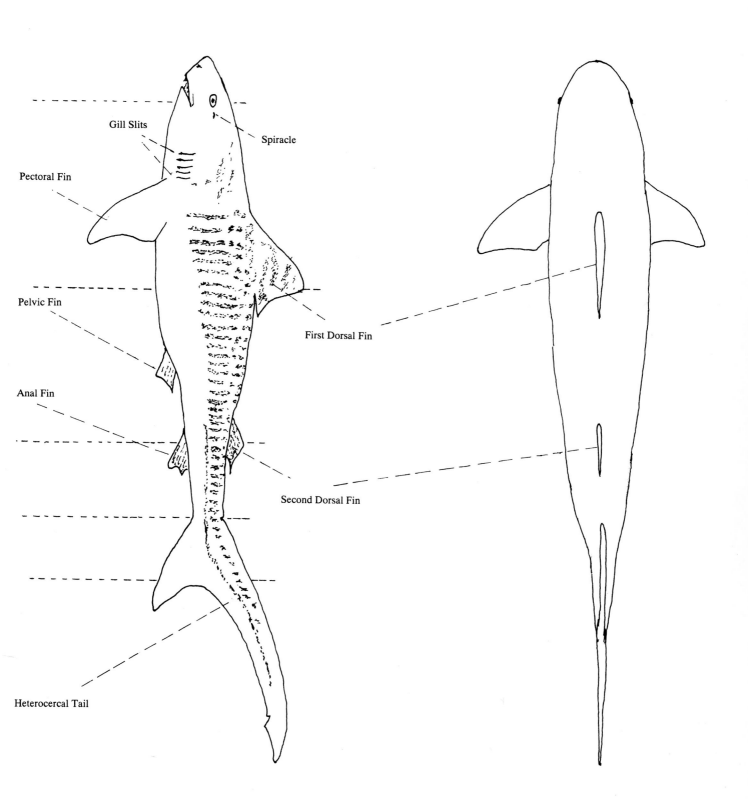

Gill Slits

Spiracle

Pectoral Fin

First Dorsal Fin

Pelvic Fin

Anal Fin

Second Dorsal Fin

Heterocercal Tail

TIGER SHARK

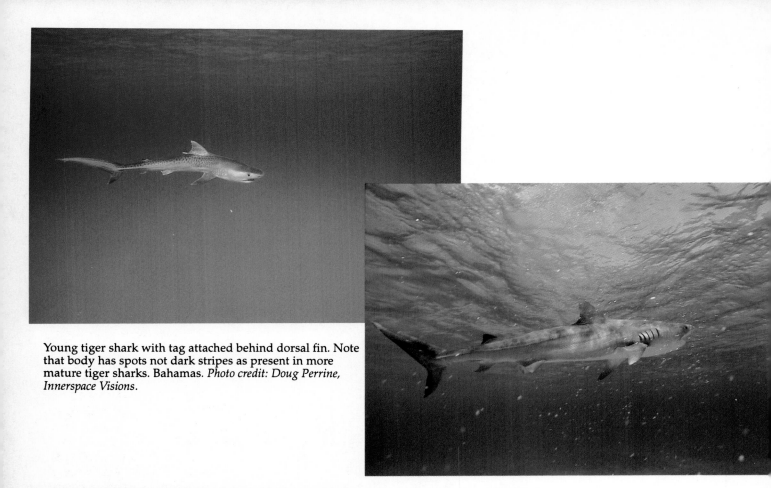

Young tiger shark with tag attached behind dorsal fin. Note that body has spots not dark stripes as present in more mature tiger sharks. Bahamas. *Photo credit: Doug Perrine, Innerspace Visions.*

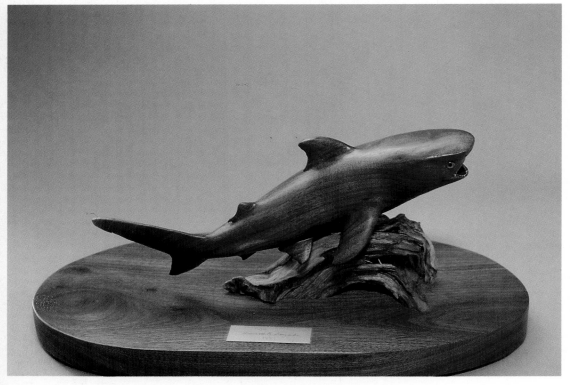

Adult tiger shark. Note the clearly demarcated diagonal connective tissue raphes along the side of the body. These serve as attachments for the segmentally arranged musculature. Bahamas. *Photo credit: Doug Perrine, Innerspace Visions*

Tiger Shark Carving made out of black walnut on a walnut base.

24

Mantas are large rays found in the temperate and tropical oceans and seas throughout the world. They are known for their tremendous leaps out of the water. Because they are plankton feeders, they cruise the waters near the surface. They appear to "fly" gracefully in the water slowly moving their large triangularly shaped pectoral fins up and down.

Identifying characteristics. Mantas have unique and distinctive cephalic fins, which are modified anterior divisions of the pectoral fins. The main portions of the pectoral fins are wing-like with falcate posterior margins. They have a short stocky tail. They are dark on the dorsal surface in contrast to a white ventral side.

Additional anatomical features. The head is wide, with two cephalic fins forming flexible ventral extensions that can be rolled spirally or inwardly. Like the pectoral fins, cephalic fins have a rounded cephalic edge with a tapered caudal edge. The mouth is wide and terminally located on the undersurface of the head. Nasal curtains which partially cover the nostrils extend cephalo-laterally from the corners of the mouth. Five pairs of long gill slits are located on the undersurfaces of the body adjacent to the pectoral fins.

Because of the wide head, the body is wide, with a slightly rounded elevation which quickly tapers as it reaches the base of the tail. The pectoral fins, which in cross-section look like the aerodynamically designed airplane wings, blend subtly with the body. The pelvic fins are small and located adjacent to the base of the tail. They do not extend beyond the pectoral fins and are hidden by them. The spiracles are small and appear as slits behind the eyes. The tail is short, oval shaped, laterally compressed, and does not have a spine at its base. There is, however, a rounded protuberance on the upper part of the base of the tail followed by a shallow groove. A small dorsal fin is located in front of the base of the tail.

Size and color. Mantas can grow to be over 22 feet from tip to tip across the pectoral fins and weigh up to 3000 pounds. The more frequently encountered sizes range between 11-14 feet. The upper surface of the Manta is usually black or gray, and is in contrast to its white undersurface. The outer surfaces of the cephalic fins are black, while the inner or medial surfaces are white.

Some behavioral characteristics. Mantas swim in the ocean by slowly "flapping their wings" like birds. When feeding, they swim with their mouths open wide, filtering plankton, crustaceans and small fish through the oral cavity and gill system. The flexible cephalic fin is used to help direct food into the mouth of the Manta. In addition, the cephalic fins may be used as a steering mechanism.

Mantas have been observed in open waters, at drop-offs adjacent to deep underwater cliffs around tropical islands, or along shallow waters near land masses and islands. They are known for their spectacular leaps out of the water, making resounding sounds and huge splashes as they hit the water. It has been speculated that this behavior is to remove surface parasites from their bodies. Others think that they do it for enjoyment.

While visiting the Galapagos Islands, I saw Mantas basking with their white ventral portions showing just under the surface of the water. When they swim upside down just beneath the surface with the tip of one or both pectoral fins showing, the fins could be mistaken for the dorsal fins or tails of sharks.

Because they are not bottom dwellers, mantas have evolved small spiracles. Spiracles serve as passageways for water to aerate the gills, as it egresses through the ventrally placed gill slits. Batoids, such as stingrays, that spend a significant part of their lives lying on the bottom have large spiracles to aid in the respiratory process. In those forms, the spiracles serve as the ingress for water to pass through the gill system. They are dependent on their spriacles for getting an adequate oxygen supply. Mantas are more constantly in motion and fulfill their respiratory needs by water passing into their mouths, through the gills and out the gill slits. Thus, they are able to meet their food and respiratory needs simultaneously.

Special carving/sculpting suggestions. The basic single block or glued block methods described in the Eagle Ray section apply to the Manta Ray. The Manta Ray, however, has a wide head with a pair of highly flexible cephalic fins. These fins can be depicted curving inward or outward. With the cephalic fins curving inward you may wish to indicate a broad open mouth. The mouth is almost as wide as the inner attached margins of the cephalic fins. To make a clean smooth curved surface on the

cephalic fins, I use appropriately sized half-round scrapers. (See No. 4 in the General Carving Considerations).

For the drawings in this book, 4-5mm glass eyes with brown irises and black pupils or black glass eyes may be used. Eye sockets are made using round diamond cutters. When using plano-convex eyes, small inverted cone diamond cutters are used to flatten the orbital surface upon which the eye is to be inserted. The inverted cone allows the orbit to be undercut for easier insertion of the glass eye.

MANTA RAY

DORSAL VIEW

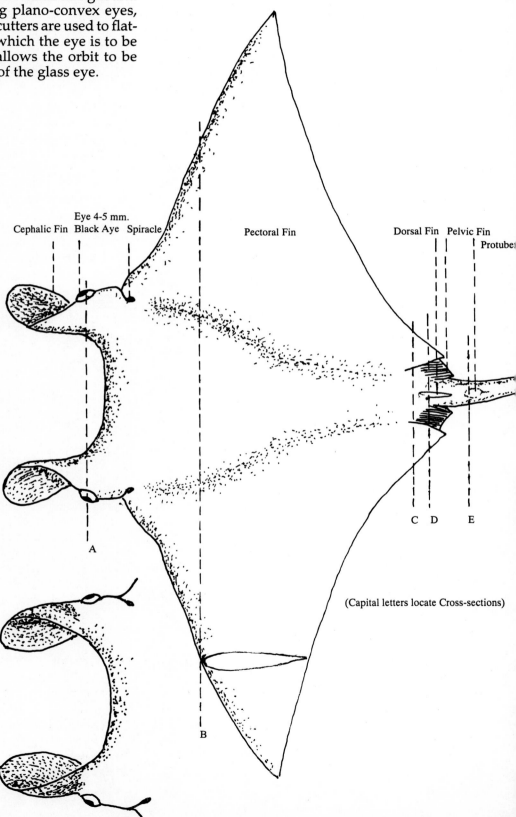

Cephalic Fin Eye 4-5 mm. Spiracle Pectoral Fin Dorsal Fin Pelvic Fin Protube
 Black Aye

(Capital letters locate Cross-sections)

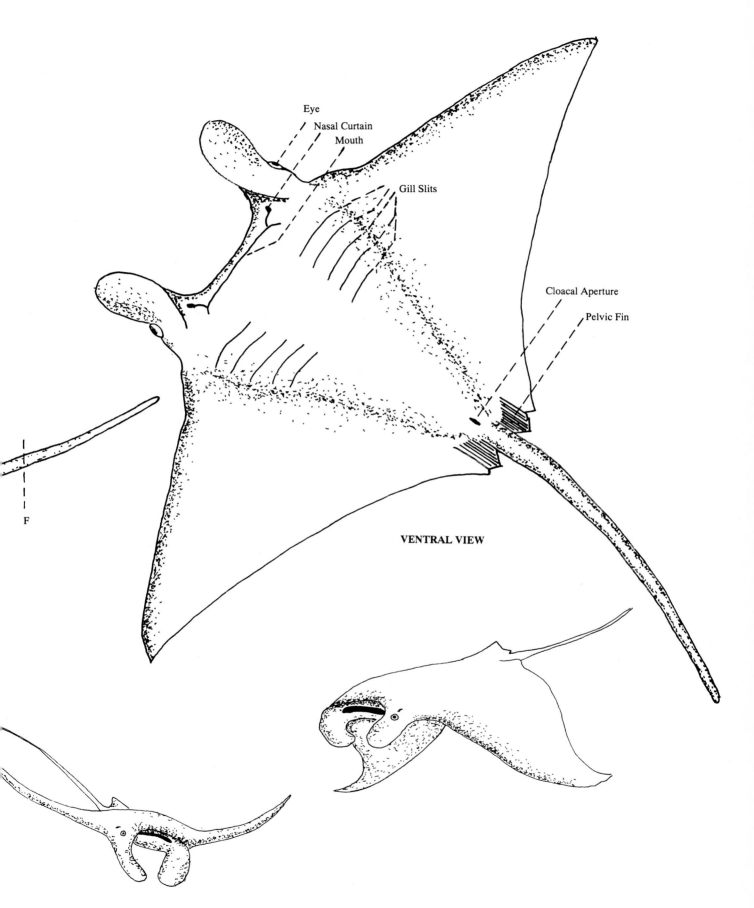

Eye
Nasal Curtain
Mouth

Gill Slits

Cloacal Aperture

Pelvic Fin

F

VENTRAL VIEW

MANTA RAY

Cephalic Fin

LATERAL VIEW

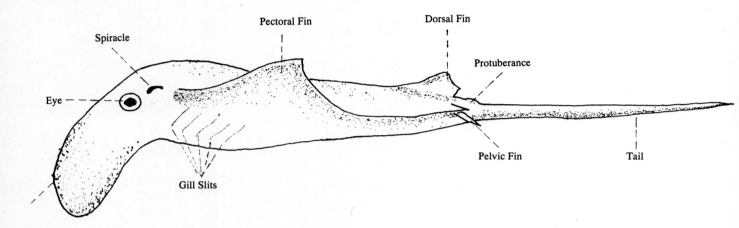

Spiracle

Pectoral Fin

Dorsal Fin

Protuberance

Eye

Gill Slits

Pelvic Fin

Tail

FRONTAL VIEW

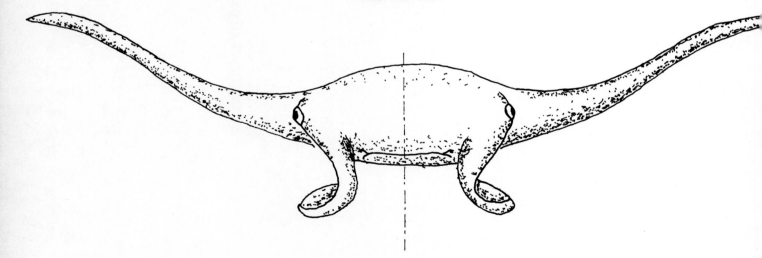

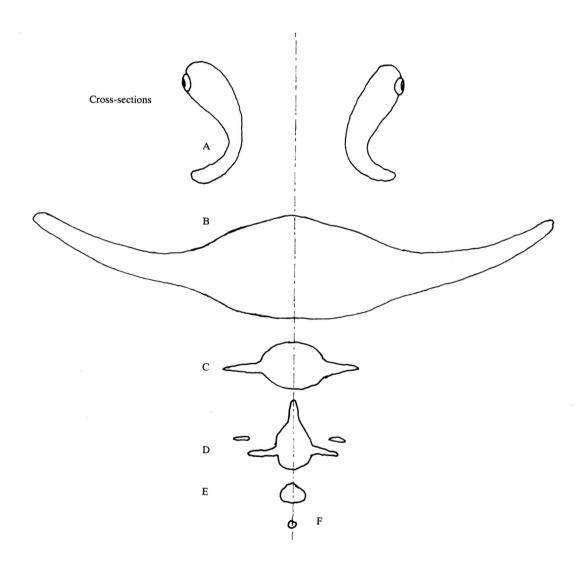

Cross-sections

A

B

C

D

E

F

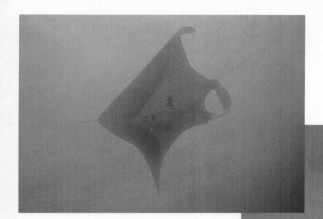

Manta Ray seen from below with small remora fish attached to ventral surface. Note the cut-off short tail and irregular black patches on ventral surface. Bonaire, Netherlands Antilles.

Manta Ray, lateral view, showing the prominent eye upon the eminence of the cephalic fin. The ventral surface on this individual is uniformly white. Turk and Caicos Islands, BWI. *Cindy Lott, photographer.*

Manta Ray seen from above with uniformly black dorsal surface. Note the small, yet prominent triangular dorsal fin, and the eye located on prominence of the incurved cephalic fins. The wide mouth is observed as a slit between the cephalic fins. Turk and Caicos Islands, BWI. *Cindy Lott, photographer.*

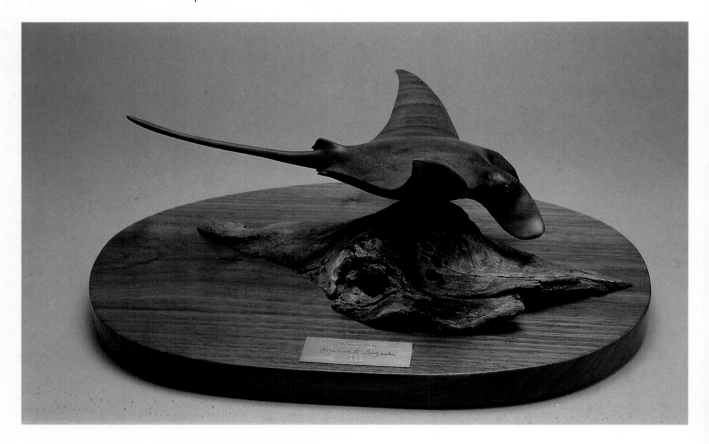

Manta Ray made out of walnut

CHAPTER V
SPOTTED EAGLE RAY

(SUBCLASS ELASMOBRANCHII, ORDER RAJIFORMES, FAMILY MYLIOBATIDAE)

AETOBATIS NARINARI (EUPHRASEN)

The Eagle Ray is a large and graceful fish often seen in the warm tropical waters of the Caribbean and Indo-Pacific regions. It is a sight to behold, particularly when one is fortunate enough to have one swim by while scuba diving or snorkeling.

Identifying characteristics. This ray is characterized by its broad head which is clearly delineated from its pair of almost delta-shaped "wings" (modified pectoral fins). The rostrum of the head is tapered and flattened giving rise to its being called the "duck-billed ray." The tail is long and slender, over twice as long as the width of the pectoral fins. The body is covered with small white rings over a dark background.

Additional anatomical features. The eyes are prominent and located on the side of the head. A pair of large elongated spiracles are located behind the eyes. Nasal curtains cover the nostrils on the ventral surface of the head. The mouth is located just caudal to the nasal curtains. A sharp subrostral ridge is present on the lateral margin of the rostrum. The head is delineated on the ventral side as a rounded eminence with short gill slits located on the edge of the eminence. The medial ventral surface of the body is also demarcated by a slight eminence. While there is a rounded eminence on the dorso-medial part of the body with a central sharp ridge, there is a smooth almost imperceptible transition from the body to the pectoral fins.

Unlike the manta, the rectangular pelvic fins are located ventral to (underneath) and extend beyond the caudal margins of the "wings." A small triangular dorsal fin with a rounded margin is located at the caudal portion of the body. Several poisonous spines are located on the dorsal part of the base of the tail. The base of the tail is compressed dorso-ventrally, being flat on top and forming a slight keel below.

Size and color. The adults may reach a wing span of up to 7.5 feet and weigh up to an estimated 500 pounds. Young Eagle Rays have whitish spots on an almost black background. These spots change to numerous whitish rings as the rays grow older. The undersurface is white.

Some behavioral characteristics. Unlike some other rays, such as the Southern Sting Ray, Eagle Rays are constantly in motion. They eat clams, conches, crustacea, *etc.* As bottom feeders, water is brought in through the spiracles and passes through the gills located within the body, where oxygen is absorbed. It is then directed out through the gill slits located on the ventral surface.

Eagle Rays are seen most frequently in deep open waters near shore. However, I have observed smaller ones in the shallow sandy bottoms on the inshore side of shallow coral reefs.

Special carving/sculpting suggestions. In carving rays using natural finish I highly recommend making them out of a single piece of wood. With this method, the flow of the wood grain is not disrupted by glue joints. For the size shown in this book, a block of wood about 3-4" thick, 8-9" wide and 9-10" long is needed. The thickness of the wood allows the carver to display the wings in an upward or downward motion. The body comprises about one half of the length of the wood, with the tail taking up the rest. To maintain maximum strength, the cross-sectional wood grain should generally parallel the curvature of the pectoral fins when viewed from the front. (*See the figure on page 9, General Carving Considerations*).

After sawing the dorso-ventral outline from a solid block of wood, remove the sawed pieces on either side of the tail. These pieces can be used to make smaller carvings, and lessen the amount of material the band saw needs to cut through. To stabilize the piece for the other cuts, reattach the remaining blocks with masking tape. The lateral view is sawed and pieces reattached with masking tape. If a band saw with sufficient height is available, stand the block on end to make the vertical cuts. This helps shape the dorsal and ventral parts of the pectoral fins ("wings")

In band sawing wood with complex curves, cutting outside of the lines is recommended in order to have sufficient wood available. A common problem with complex curves is that one side will have a sufficient amount of wood to carve the structure, while its bilateral side often ends up short. The extra thickness also allows for more flexibility in design.

The Eagle Ray's tail is too long and delicate to reproduce realistically in wood. I use artistic license and keep the tail relatively short and stockier than in real life. Reproducing the long tail found in nature does not necessarily add to the beauty of the design, but a graceful curvature to the tail will add subtle movement to the piece.

The spiracle is depicted as an oval depression. The detailing of the mouth, gills, fins, *etc.* are burned in, using a spear point wood burning tip.

3mm solid black glass eyes are recommended for the carving illustrated in this book. These eyes usually come attached to a wire. In mounting the eyes, drill a shallow depression using a small round diamond rotary bit 2-3mm in diameter to make the socket, enlarging as needed. Cut off the eye from the wire, and insert the short wire into the socket. Attach with 5 minute epoxy. About a quarter of the black eye should be seen sticking out beyond the surface of the head.

SPOTTED EAGLE RAY

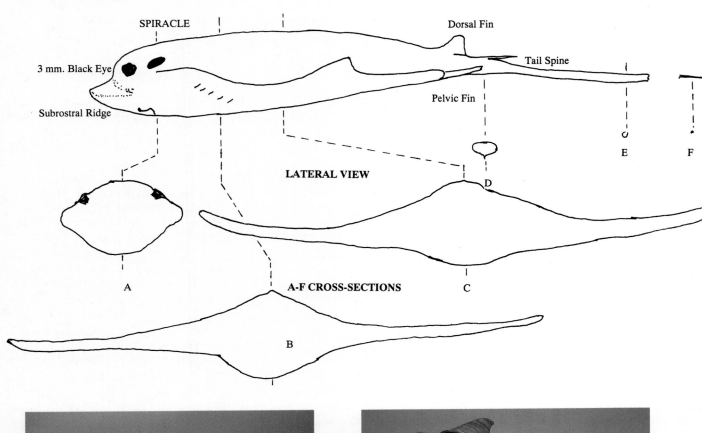

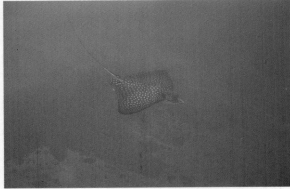

Spotted Eagle Ray. Note the spotted patterns on dorsal side extend on to the dorsal surfaces of the pelvic fins. Bahamas.

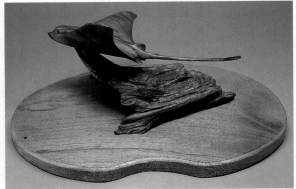

Spotted Eagle Ray carving made out of briarwood. It has a juniper support on a Honduran mahogany base.

32

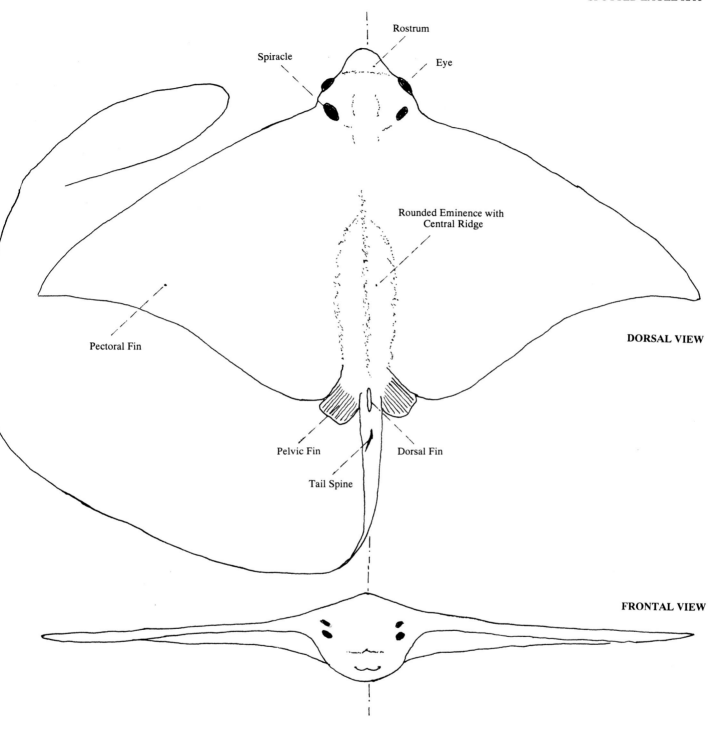

Rostrum

Spiracle

Eye

Rounded Eminence with
Central Ridge

DORSAL VIEW

Pectoral Fin

Pelvic Fin

Dorsal Fin

Tail Spine

FRONTAL VIEW

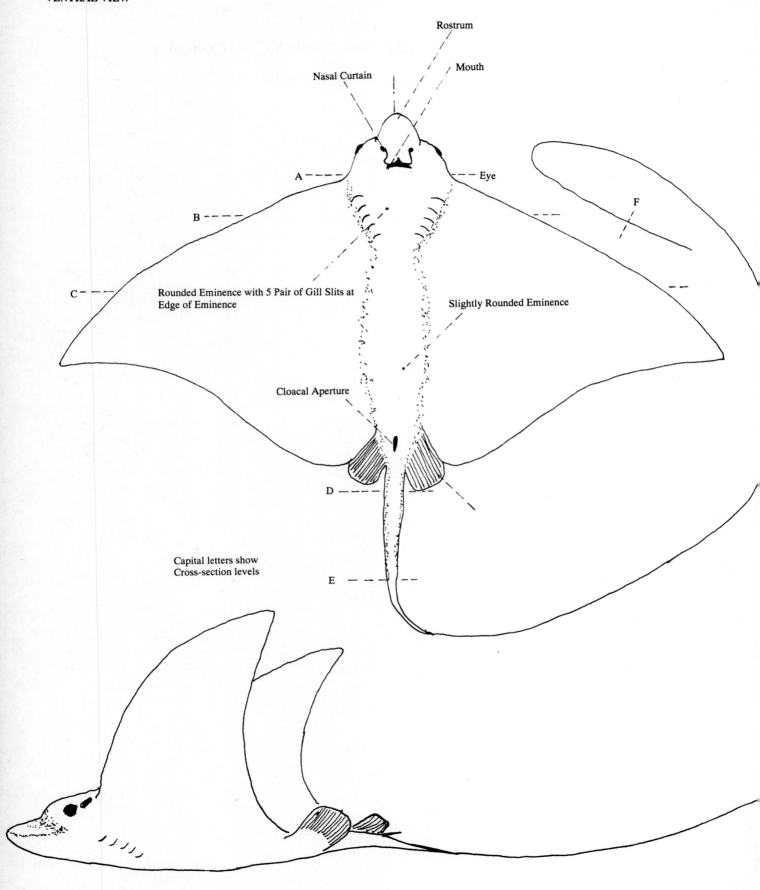

Rostrum

Mouth

Nasal Curtain

A

Eye

F

B

C

Rounded Eminence with 5 Pair of Gill Slits at
Edge of Eminence

Slightly Rounded Eminence

Cloacal Aperture

D

Capital letters show
Cross-section levels

E

CHAPTER VI
LOGGERHEAD SEA TURTLE
(CLASS REPTILIA, ORDER CHELONIA, FAMILY CHELONIDAE)
CARETTA CARETTA (LINNAEUS)

The Loggerhead is a large sea turtle often seen resting on the surface of warm tropical oceans throughout many parts of the world. The female apparently returns to land only to make nests and lay eggs.

Identifying characteristics. The adult Loggerhead is readily identified by its relatively massive head in proportion to its already large overall size. The top of the head has four prefrontal scales. Five lateral scutes are located on each side of the carapace. Three pairs of inframarginal scales are present on the bridge between the plastron and carapace. The turtle is reddish brown.

Additional anatomical features. Strong and heavy horny beaks (tomiums) cover the maxillary and mandibular bones (upper and lower jaw bones). The head usually has two prefrontal scales. The front and hind flippers have two claws on each flipper. The hatchling and young turtles have three rows of interrupted longitudinal dorsal keels located on some of carapace scutes. These disappear within a couple of years.

Size and Color. The adult female Loggerhead can attain carapace lengths up to 3.5 feet and weigh up to 300 pounds. While the color of the scales on the head and carapace are usually reddish brown, the color and scale patterns can be masked by algae growing on the shell, or the presence of barnacles. The carapace length of hatchlings ranges in length from an 1.375" to 2", with the average being 1.75".

Eggs. Between 40 and 190 eggs may be laid by the female Loggerhead each time it deposits eggs. The eggs are round and range in size from 1.375" to 2.125" in diameter. The egg shell is soft, leathery and off-white in color. Incubation takes up to 65 days.

Some behavioral characteristics. When Loggerheads swim, they use their front flippers, moving them in an up-and-down motion(on page 39).They usually raise and lower their flippers in unison. The hind flippers appear to be used to help change their swimming direction. While scuba diving, I have seen them come to the surface, take a breath and then dive to the bottom again. They have been seen resting or floating on the surface of oceans far from land.

There is evidence that the Atlantic Loggerheads are carried by the Gulf currents near the southeastern coast of the United States to the North Atlantic and then south again, where immature forms have been observed in the Azores. Apparently some of those turtles return to their natal grounds in the Caribbean and Southeastern coast of the United States being carried back by the vast southwesterly gyre of the Gulf Stream. In the Pacific, a young Loggerhead tagged in Japan was found near San Diego, California two and one third years later.

Special carving/sculpting suggestions. Following the general shaping of the carving, the scutes and scale markings can be created using the 3/16" spearpoint burning tip.

The eye and eyelid present a special problem, because of the orientation and textured appearance of the eyelids, I prefer to outline the eyelids and carve the eyes using the 3/16" spearpoint burning tip. The free margins of the lids are delineated into an elliptical shape, with the cephalic margin diagonally lower than the caudal margin. The eyeball is created by carefully shaping the area between the lids using the knife-edged burning tip. The eyeball is rounded smooth by using micro chisels or skews. The pupil is represented by burning a small depression in the middle of the eyeball with the spearpoint tip or by drilling a shallow round depression with a 3/64" diameter diamond rotary bit. The eyelids are detailed using the 3/16" spearpoint tip. Excess carbon is removed by gently brushing the surface with a fine metal brush.

The pair of claws on each flipper can be made by carving pointed claws out of round birch 3/32" diameter medical applicator sticks or round hardwood toothpicks. Tiny holes are made at the proper locations on the flippers using a common pin, brad or, appropriately sized numbered drill bit. Cyanoacrylate glue is placed on the proximal flat end of the claw and inserted into the hole.

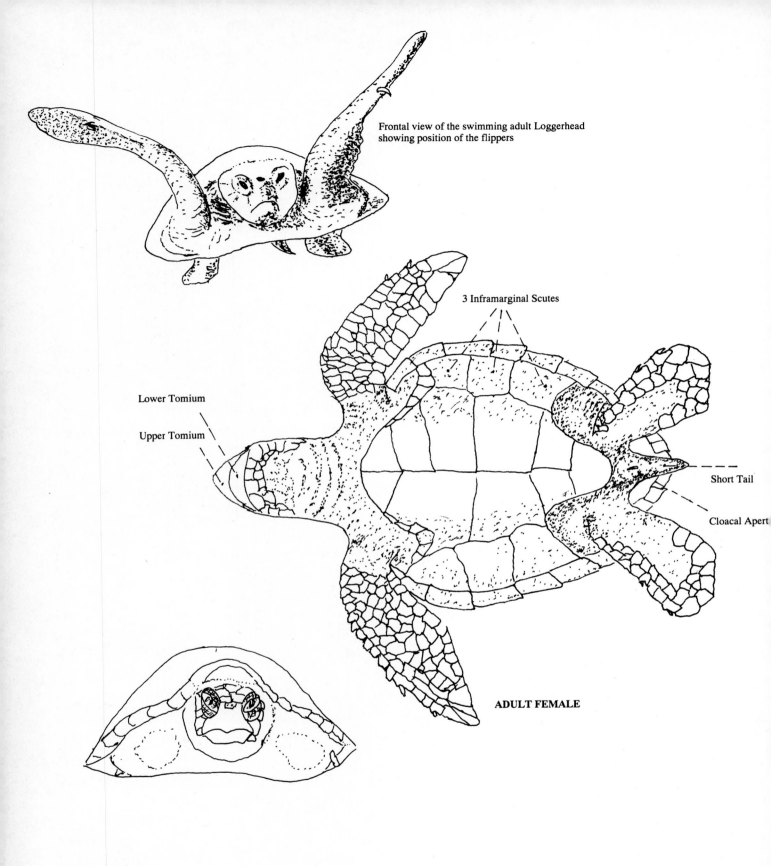

Frontal view of the swimming adult Loggerhead
showing position of the flippers

3 Inframarginal Scutes

Lower Tomium

Upper Tomium

Short Tail

Cloacal Apert

ADULT FEMALE

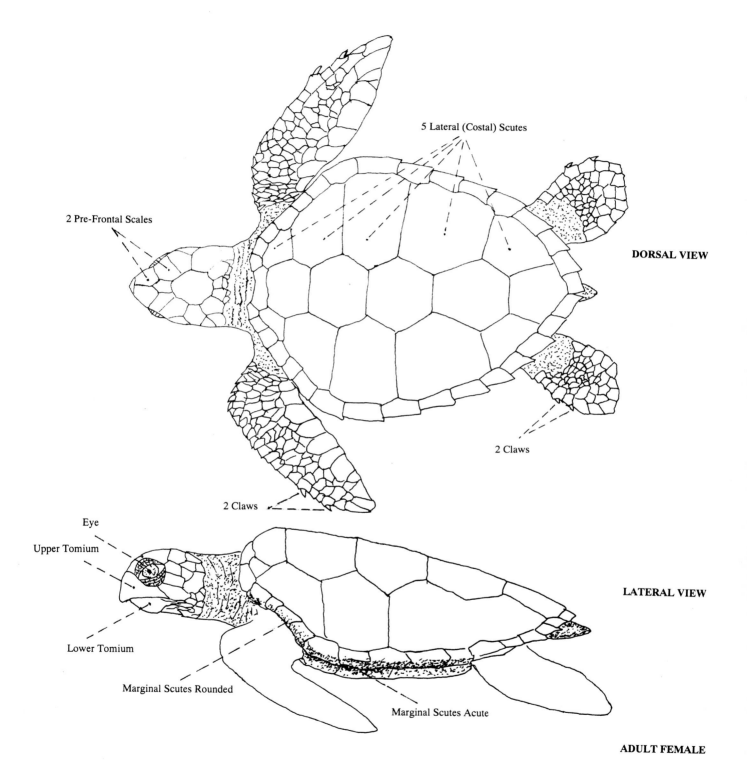

5 Lateral (Costal) Scutes

2 Pre-Frontal Scales

DORSAL VIEW

2 Claws

2 Claws

Eye

Upper Tomium

LATERAL VIEW

Lower Tomium

Marginal Scutes Rounded

Marginal Scutes Acute

ADULT FEMALE

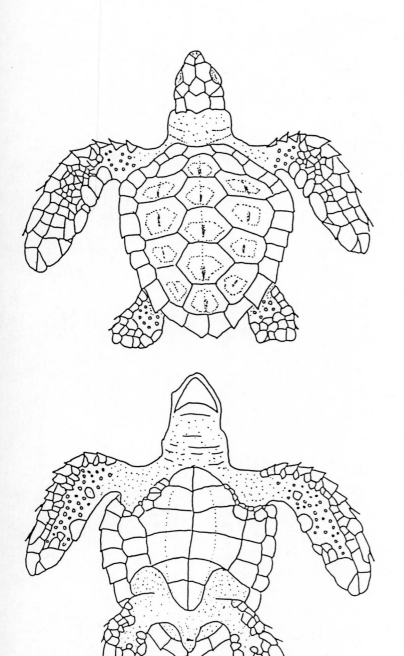

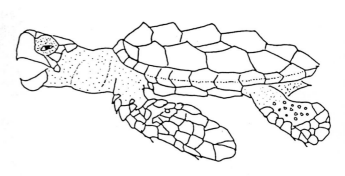

Cross-section Through Carapace/Plastron

Cross-section of Front Flipper

Cross-section of Hind Flipper

LOGGERHEAD HATCHLING

(FULL SCALE)

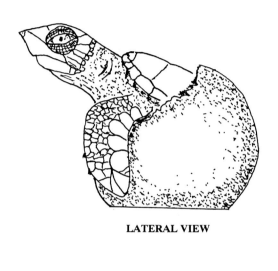

LATERAL VIEW

FRONTAL VIEW

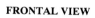

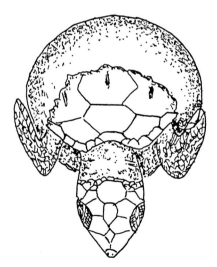

DORSAL VIEW

The turtle cut-out is made from a block of wood 2.75" long, 2.25" wide, by 2" high. This one is of American walnut. I always band saw the cut-outs well outside of the actual dimensions of the pattern to give me enough wood and flexibility in the design. **One can only remove wood in woodcarving, not add after it has been cut away.**

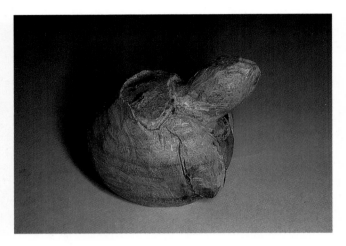

The hatchling is further shaped using different 3/32" diameter shaft ruby and diamond cutters. The carapace is carved further and the three dorsal ridges are carved using tapered round cutters. Pointed cutters are used to undercut the margins of the flippers and carapace/shell junctional areas. The ridges on the carapace are carved with flame diamond or ruby cutters.

I usually use a 1/4" diameter shaft, silver Kutzall ball-nose burr to round off the egg shape, and then use a 1/8" diameter shaft taper or flame Kutzall to roughly outline the head and flippers.

The taper or flame 1/8" shaft diameter Kutzall burr is still used to delineate the broken shell margin, carapace, head, neck and front flippers.

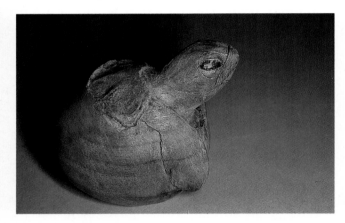

The shell is scraped with carving knives to remove the deeper cutter marks and sanded smooth with 150 grit wet and dry sandpaper. Next, burn a circle representing the outline of eyelid using a 3/16" spearpoint tip. Then burn in an elliptical outlines representing the lid margin at a down-ward forward oblique angle. The upper and lower jaws are detailed by burning in to help maintain proper relationship and proportion. Burn under lid margins. Deepen front and back of eyeball between the upper and lower lids by carefully burning them with the burning tip. Brush away the loose carbon resulting from the burning.

The eyeball is cleaned and smoothed using a micro-skew and a dog-leg micro-chisel.

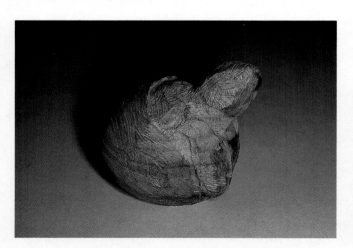

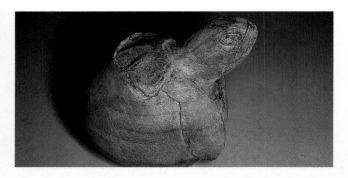

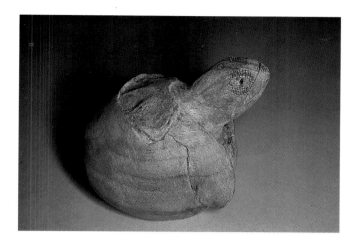

The pupil is made by burning in the vertical elliptical opening with a pointed knife-edged burning tip. Scale markings on eyelids are created by burning parallel lines following shape of lids, followed with markings at right angles to the previous lines. This will simulate the scales markings on the eyelids.

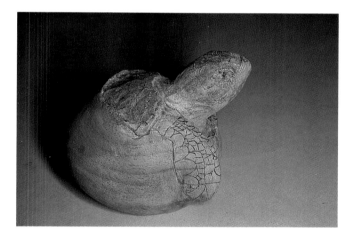

The rest of the scale markings on the head, carapace and flippers are made using the 3/16" spearpoint burning tip. The anterior margins of the 3 rows of ridges are sloped to the level of the adjacent cephalic scute. The burnings are then cleaned with a fine brass brush.

This shows the finished turtle, after it had been coated with lacquer sanding sealer, scraped and sanded to remove slight defects in the shell, and finally sprayed with several coats of Deft™ lacquer.

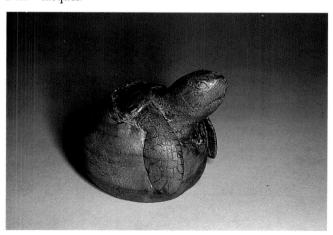

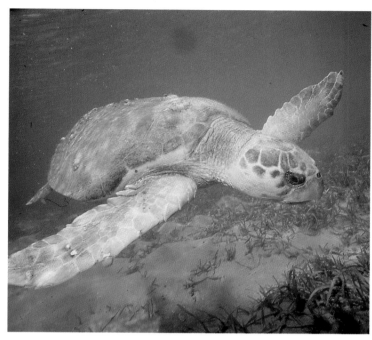

Photo of swimming adult Loggerhead

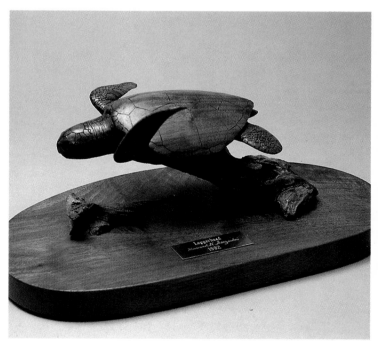

Swimming adult Loggerhead carving, walnut.

41

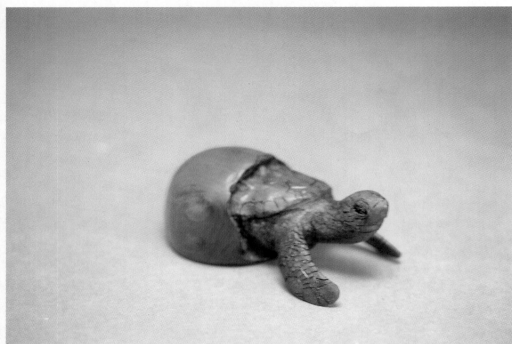

Hatchling loggerhead carving, walnut

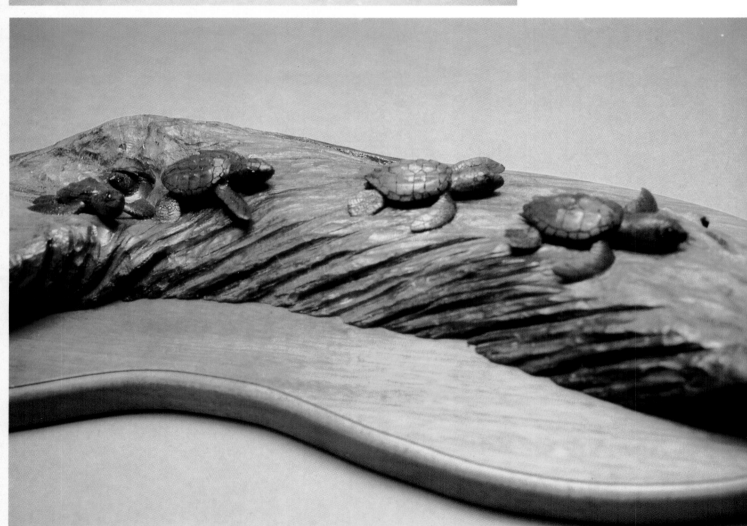

Hatchling loggerhead turtles, walnut, "Flight for Life."

AMERICAN ALLIGATOR
(CLASS REPTILIA, ORDER CROCODILLA, FAMILY CROCODILIDAE)
ALLIGATOR MISSISSIPPIENSIS (DAUDIN)

The American alligator is a well-known ferocious looking reptile inhabiting the swamps and freshwater lakes, ponds and streams in the southeastern part of the United States.

Identifying characteristics. The adult is a large lizard-like animal, whose body and tail are covered by rows of hard, sharp epidermal ridges. Those sharp ridges can cause skin cuts if an individual is not careful when handling a wild alligator. Most alligators living in parks and zoos have their dorsal body epidermal ridges worn down significantly because of crowded conditions in which they are forced to climb over each other. The head is broad and bluntly rounded at the snout. Its sides are covered by irregularly shaped and sized epidermal plates while the ventral surface has regularly shaped flat plates.

Additional anatomical features. The iris of the eye is a light olive color. The black pupils can change from a vertical slit, to a vertically oval shape, to a round pupil, depending upon the intensity of light. When alligators have lights flashed at their eyes at night, they appear red. This is the color of the reflected retina, and not the color of the iris...similar to the red eyes one sees in flash photographs taken of humans.

There are approximately 40 teeth on each upper and lower jaws. The teeth are variable in size and conical in shape; many are relatively small. However, the alligator has a large tooth located on each side of the lower jaw in the position equivalent to the "canine tooth" in a dog's mandible. The alligator's upper jaw has two to three large teeth located behind the large lower teeth.

The tail is highly muscular and dorsoventrally compressed. The lateral margins of the tail have raised ridged epidermal shields, with short and smaller ridges present on the medial dorsal surfaces. The lateral surfaces appear as flat plates.

Size and Color. Adult male alligators can reach 14 feet in length and weigh over a thousand pounds. Florida Game and Fish personnel captured and measured one animal 13 feet 8 inches long which weighed 1043 pounds. Adult alligators range from dark olive-brown to almost black. Hatching alligators are approximately 9" long. The head of the

hatchling alligator is proportionately shorter and has a more pointed snout than the adult. Young alligators are black with bright yellow cross-bands.

Eggs. During the spring, in Southeastern United States, the female alligator finds a nesting area adjacent to water, and builds a nest composed of cord grasses, reeds, cattails, sedges or other plants. Between 30 and 60 eggs with calcified shells are laid by the female alligator in late June. The female covers the eggs with plants, which decay and generate the needed warm temperature for proper development. Incubation takes about 65 days. The eggs are shaped like a chicken's egg but are approximately 3" long by 1.75" wide.

The calcified shell becomes weakened during incubation as the calcium mineral is absorbed by the embryo. At hatching, then, the baby alligator has a less difficult task in cracking the calcified shell, followed by a tearing apart of the inner membranous layer. After the alligator gets out of the egg, the remaining membranous portion of the egg collapses into irregular shapes. When they are ready to hatch, the baby alligator signals from within the egg by making high pitched "yerks." The calls are heard by the mother alligator, who responds by removing the nest covering of decayed vegetation. Females have been observed to physically transport their hatchlings to the water. In most cases the nests are so close to water, the hatchlings get to the water by themselves.

Some behavioral characteristics. Alligators are often seen sunning themselves on land adjacent to water. When on land they can move rapidly for a short distance. Alligators are primarily aquatic and thermo-regulate, feed, and breed in the water. They swim silently by moving their tails back and forth. When in the water you may see only a small portion of the animal's body and head. The females will protect their young during the first season after they hatch. Baby alligators are sometimes observed sunning themselves on the heads of their mothers.

Special carving/sculpting suggestions. After roughing out the adult alligator, locate the head structures, making sure that the eyes and orbits are kept close together. 4mm alligator glass eyes (available from Van Dykes, Woonsocket, South Dakota)

are used. Drill a shallow depression in the orbit using a 4mm inverted cone diamond rotary bit. The eye is inserted with the pupil oriented vertically. The head and orbital markings can be made using the spearpoint tip of the woodburner. The scale markings on the majority of the body can also be delineated using the same type of burning tip.

After the alligator body has been shaped, draw transverse lines representing the margins of the dorsal scutes. They are demarcated using inverted cone-shaped diamond rotary bits. Longitudinal lines are carved using thin diamond wheels marking the lateral scute boundaries. Appropriately sized flat ended tapers bring out the epidermal ridges.

Hatchling gator. A pattern for one style of hatchling gator is included. Rough out and shape the gator and egg, position and carve the feet, etc. Use 4mm alligator eyes. After making a flat depression in the orbit insert the eye with the pupil oriented vertically. The alligator scutes and scales can be detailed using the spear-point burning tip.

To reach the author's original size, enlarge so the alligator is 13" long. Use 4mm eyes.

ALLIGATOR HATCHLING

(FULL SCALE)

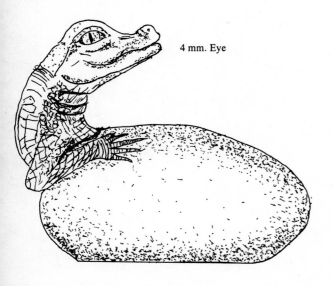

4 mm. Eye

LATERAL VIEW

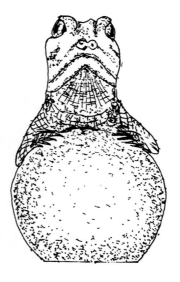

FRONTAL VIEW

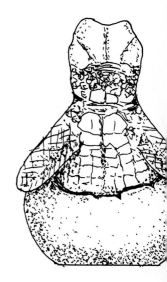

POSTERIOR VIEW

DORSAL VIEW

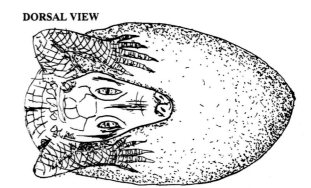

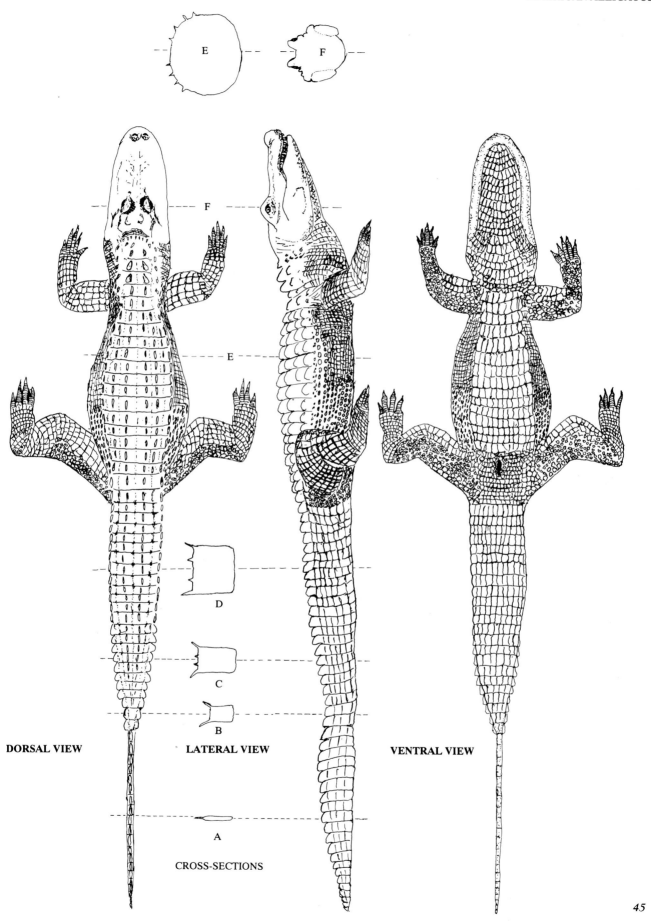

DORSAL VIEW

LATERAL VIEW

VENTRAL VIEW

CROSS-SECTIONS

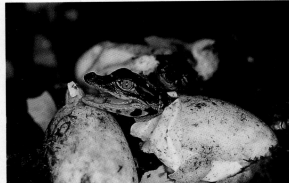

Gator coming out of its egg. Note that it is already feisty.

Gator hatchling carving made out of maple. The gator was stained with walnut color.

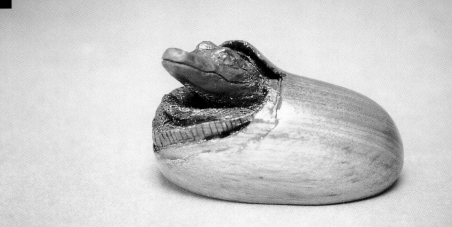

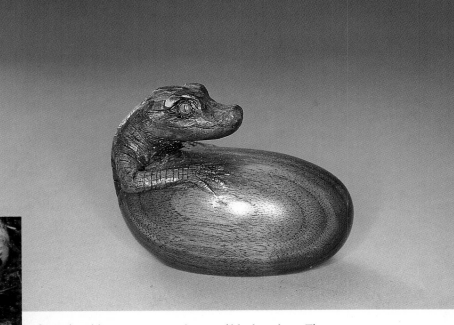

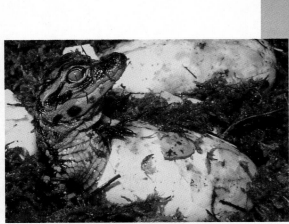

Gator hatchling carving made out of black walnut. The pattern for this style is included in this book.

The gator hatchling that served as model for carving pattern in this book.

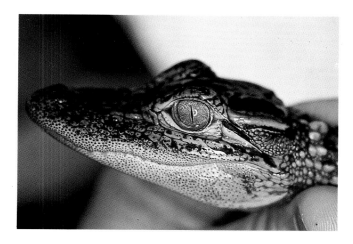

Photo of hatchling gator showing details of the head.

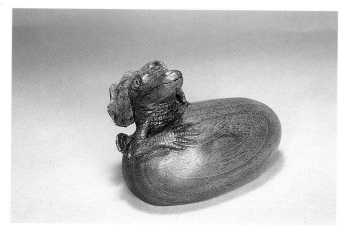

Gator hatchling made out of walnut

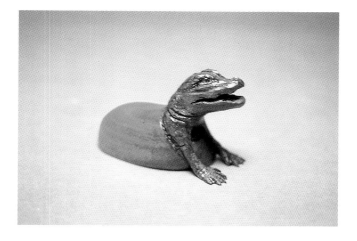

Gator hatchling made out of walnut based on previous photo.

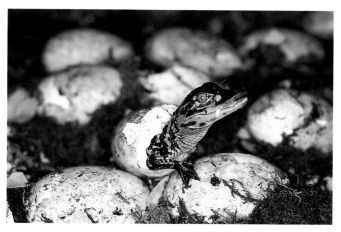

Gator hatchling coming out of egg

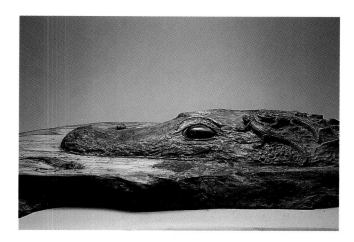

Full scale wood sculpture of 9.5 foot mother gator showing only her head with baby gators it. Carved from a spalted pecan log.

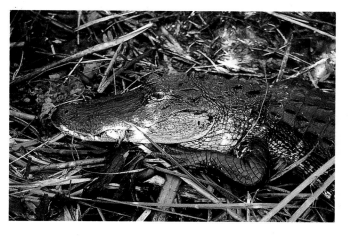

Side view of head and neck region of 7.5 foot female alligator. Note color of iris and elliptical shape of pupil. The pupil varies in shape depending on the amount of ambient light. At low light intensity the pupil will be roundish. At high light intensity the pupil will appear as a vertically oriented slit. Lake Woodruff, Florida.

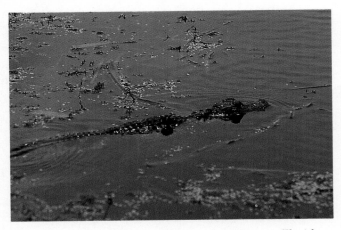

Photo of slowly swimming alligator. Lake George, Florida.

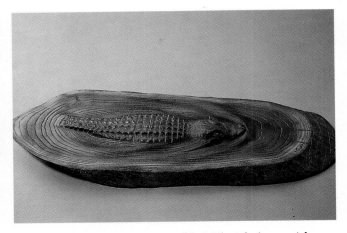

Carving of swimming gator entitled *Silent Swimmer*. After carving was completed, the area around the gator was lightly sandblasted to accentuate the wood grain as part of the waves.

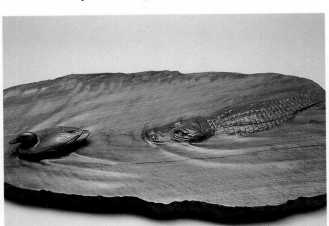

Carving of swimming gator going after a swimming duck and entitled *The Unsuspecting*. Made out of a walnut slab cut out of a tree trunk at approximately 30 degree angle. Observe that the grain of the wood manifests itself as part of the waves. The pattern of the wood grain determines the location and size of the animals.

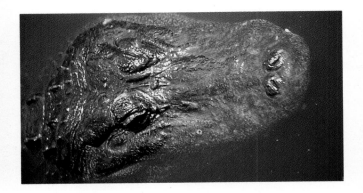

Photo of an almost submerged adult alligator resting in the water with only a small portion of its head above water.

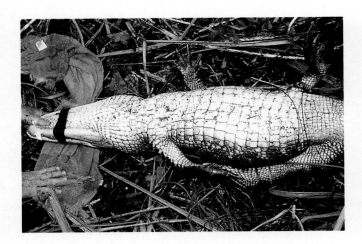

Ventral view of seven foot female alligator showing flat plate-like scute pattern. Lake Woodruff, Florida.

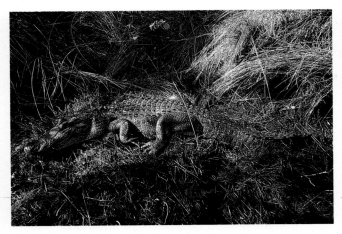

Side view of seven foot female alligator near her nest. Lake Woodruff, Florida.

CHAPTER VIII
GREAT SPERM WHALE
(ORDER CETACEA, SUBORDER ODONTOCETI, FAMILY PHYSETERIDAE)
PHYSETER MACROCEPHALUS (LINNAEUS)

The Sperm Whale is perhaps the best known whale because of the important role it played during the heyday of commercial whaling, the popularity of Herman Melville's classic book *Moby Dick*, and the art of scrimshaw developed by whalers using Sperm Whale teeth. While it may be the best known whale, I have not been able to see or photograph a single live Sperm Whale in the oceans. I have made an extensive trip to the Galapagos Islands and more recently to Dominica in the West Indies primarily to look for and obtain underwater photographs of this denizen of the deep. In the latter instance we spent every afternoon for 8 days looking for them and all I saw were rolling seas and white caps. The only consolation was that Dominica is a most beautiful, quiet, isolated, verdant island to visit. For me those whales have been very elusive. Such are the trials of a field investigator. My wife, on the other hand, does not have much sympathy for my hard work under these "trying conditions."

Identifying characteristics. The Sperm Whale is easily identified because of its massive bulbous head comprising from one-fourth to one-third of the body length. It has a single S-shaped blowhole located near the top left of the front-end of the head. The dorsal fin area has been modified to form a hump followed by a series of ridges on the dorsal surface. The fluke is triangular in shape with a prominent median notch on its free surface. The skin along the flanks and caudal portion exhibits a series of short irregular longitudinal creases.

Additional Anatomical Features. The head is somewhat dorso-ventrally compressed and blends into a more roundish body, which returns to a dorso-ventrally compressed appearance as it reaches the tail stalk. A post-anal ventral hump is present on the tail stalk followed by strong keel. The eyes are small, located on eminences on the sides of the head just posterior and superior to the corner of the mouth. Eyelids are visible and movable.

The lower jaw is slender and houses between 16 to 30 conical, pointed large teeth on each half of the lower jaw. Each tooth is separated by a wide space (diastema) and is oriented dorso-laterally from the mandible . Rudimentary teeth in the upper jaw are covered by mucosa and are not visible. The teeth of the lower jaw occlude into mucosal sockets in the "toothless" upper jaw. Several radiating short throat grooves are present just caudal to the lower jaw.

The pectoral fins are oval, short, and pointed at their apex. They are located behind the lower jaws and eyes. Females, but not males, have a callus in front of the dorsal hump.

Size and color. Males can reach a length of over 60 feet and weigh from 35 to 50 tons. Females are smaller and not as massive in appearance. Sperm whales range in color from black, bluish gray, gray to light brown. There are variable white areas and patches around the mouth and in the umbilical-urogenital areas.

Some behavioral characteristics. Sperm Whales are migratory animals following the seasons, seeking waters with optimal temperature and depth. They may swim together in pods or may be found alone or in groups of two or three. They are known for their ability to dive to great depths to obtain their favorite food, the squid.

Special carving/sculpting suggestions. When shaping the head, leave an elevation in the area where the eyes are to be located. Because of the small size of the eyes, it may be simpler to burn in the eyelid margins on the orbital eminence and carefully burn in the shape of the eyeball using a straight knife-edged burning tip. The pupil may be represented by drilling a shallow depression in the middle of the eyeball with a small round diamond cutter. Clean the areas burned with a fine brass wire brush.

With the lower jaw open, teeth will show. One method to represent this without cutting out the jaw and regluing is to make small diameter alveolar sockets and carve teeth to be inserted into the jaw. Modify a round writing burning tip by bending the tip to a right angle. Shape the tip by carefully grinding away a small amount of the metal to form a roundish diameter. Gently insert the heated tip into the lower jaw margin, slowly burning in alveoli (tooth sockets) which will house the teeth.

The teeth may be made using 3/32" diameter medical applicator sticks. The diameter of the stick can be decreased by placing the stick on a flat surface, holding one end, and then scraping the excess wood until the proper diameter is achieved. The stick is then sanded with 320 grit wet-and-dry sand-

paper. A conical tip is carved and the tooth is cut to the appropriate length. It is then picked up with a pair of tweezers. Gel-type cyanoacrylate glue is put on the blunt end and the tooth is inserted into the alveolus. Teeth may also be made using round tapered toothpicks available at your grocery store. A step-wise photographic essay is included elsewhere in this book. *(See "Making Teeth for a 12" Sperm Whale Carving" on page 53)*

The rough corrugated appearance of the sides can be simulated by using 2-3mm micro gouges (4-6 curvatures) to make shallow random horizontal cuts. If such gouges are not available, small, elongated, round tipped diamond rotary cutters can be used to randomly score the appropriate surfaces.

The throat grooves are burned in with a knife-edged tip. The caudal edge of the fluke can be serrated using fine carving blades or a #11 (spear point) scalpel blade.

GREAT SPERM WHALE

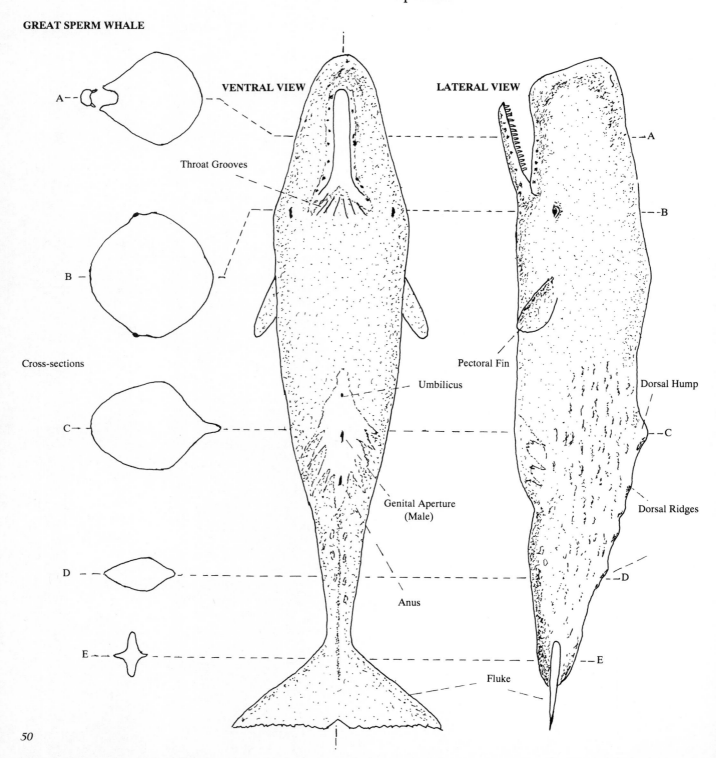

VENTRAL VIEW

LATERAL VIEW

Throat Grooves

Cross-sections

Pectoral Fin

Umbilicus

Dorsal Hump

Genital Aperture (Male)

Dorsal Ridges

Anus

Fluke

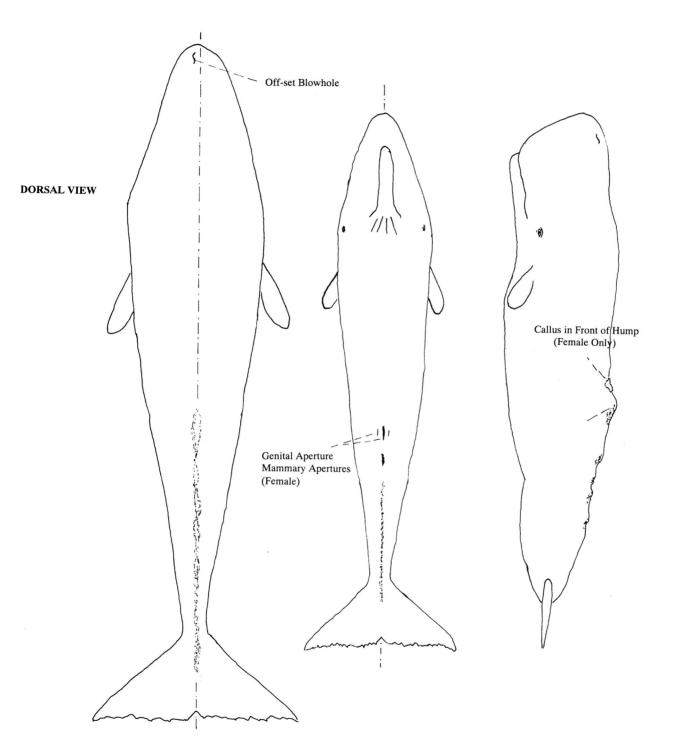

Off-set Blowhole

DORSAL VIEW

Genital Aperture
Mammary Apertures
(Female)

Callus in Front of Hump
(Female Only)

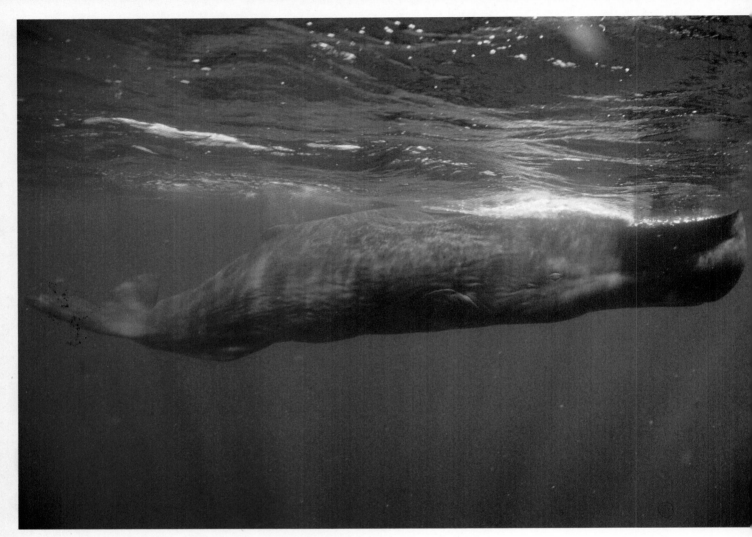

A side view of a young Sperm Whale swimming just under the surface of the ocean. The photo clearly shows the eye. The lower jaw is closed and seen in front of and below the eye. The pectoral fin is pressed against the body and is located behind the eye. Note the horizontal skin corrugations along the side of the body. Dominica, BWI. *Photo by Doug Perrine, Innerspace Visions.*

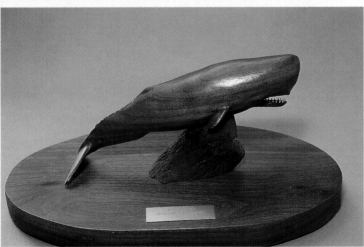

Sperm Whale sculpted in Black Walnut.

Making Teeth for a
12" walnut Sperm Whale Carving

In naturally finished wood carvings or sculptures of aquatic animals showing their open jaws and teeth, I do not cut the jaw off, detail it, and reattach the jaws. The glued joint will always be seen and detracts from the beauty of naturally finished works.

In order to keep the lower law intact and still insert ivory colored teeth made from light colored hardwood, I modified the Colwood Electronics writing tip by bending the tip at a right angle approximately 2.5mm (0.100" or 3/32") from the end. The outer surfaces of the probe are then filed to make a more rounded diameter so that it ends with dimensions of approximately .065" by .035".

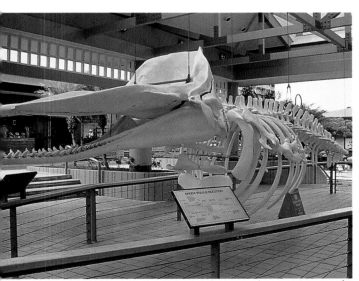

A dorsal view of the lower jaw of a Sperm Whale showing the dorsolaterally directed teeth and wide spacing between them (diastemata). This specimen is displayed at the Whaling Museum in New Bedford, Massachusetts.

Lateral view of the roughed-out Sperm Whale carving. It was shaped to this stage using Kutzall and carbide rotary cutters. The pectoral fins and jaws have been shaped in general. The location of the orbital eminence was marked and wood removed around the mark to form the eminence.

A view of s Sperm Whale skeleton showing the positions and orientations of the teeth. This skeleton is displayed at the Whaler's Village, Maui, Hawaii.

Ventro-lateral view showing the narrow lower jaw and the preliminary shaping of the adjacent upper jaw. The right orbital eminence is located on the upper surface of the carving.

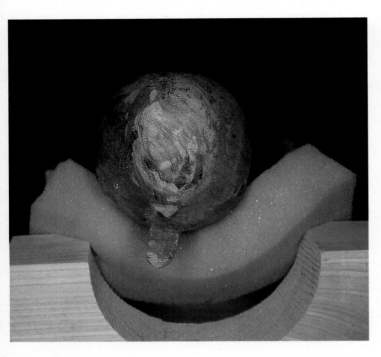

Frontal view showing the general shape of the lower jaw. The oral surface of the lower jaw has not yet been grooved.

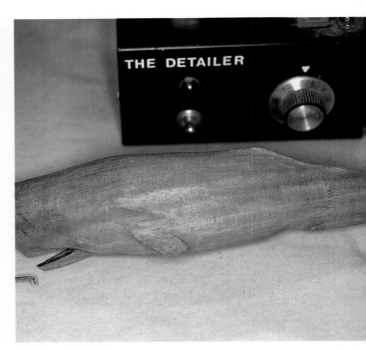

This shows a modified Colwood Electronics writing tip bent at a right angle. The bent tip is used to burn in alveolar sockets in the lower jaw.

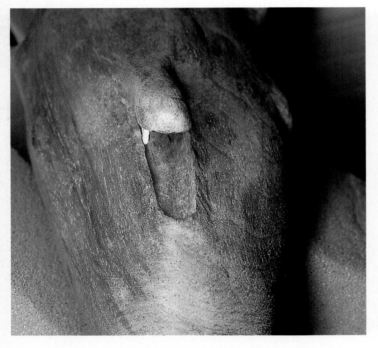

Ventro-frontal view showing oral surface (mouth lining) of the upper jaw. The upper jaw is carved so that the outer jaw margins form a sharp ridge, with the central oral surface being concave. The cavity is made by using small round diamond cutters or micro gouges. The upper jaw's outer margin should be wide enough to allow the lower jaw to fit within the outer edge of the upper jaw.

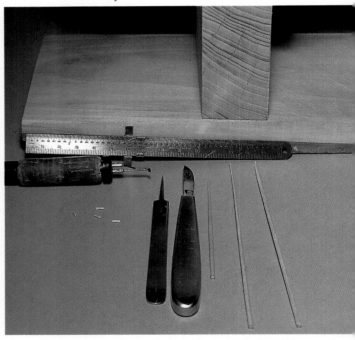

The materials and tools used in making teeth in the Sperm Whale. From right to left: 3/32" medical applicator stick; 3/32" applicator stick that has been scraped down to a smaller diameter (using a sharp scalpel or carving tool on a firm flat surface, after which the stick is smoothed by slowly moving a 220 grit wet-and-dry sandpaper over the stick while on the same firm flat surface); medical applicator stick (the apical portion is sharpened to a point after which the tooth is cut off from it); scalpel used as a scraper; a pair of tweezers; completed teeth 5/32" long, cut off from the smaller diameter applicator stick (a portion of the length serves as the root of the tooth within the socket); right angle bent writing tip; and steel rule.

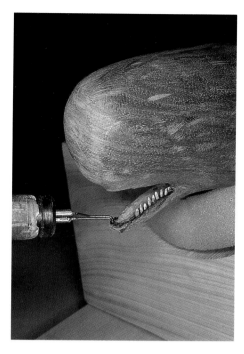

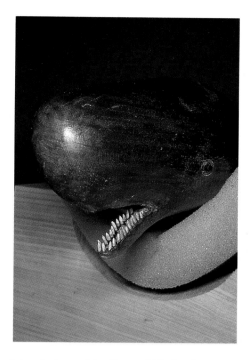

The heated modified writing tip is shown burning in an alveolar socket in the lower jaw. The alveolar socket sites are located, and the hot tip is placed on the jaw surface and pressed lightly. By burning carefully an alveolar socket will be formed in the jaw. The tip is rotated from side to side to make a more circular socket shape. The burning is repeated until the proper alveolar socket depth is attained. Loose carbon is removed using a brush. Note that placing the carving on the carving cradle stabilizes the whale for accurately locating and making the sockets and later inserting the teeth.

The diameter of the dowel is checked by inserting the applicator stick into the socket. After sharpening the end of the dowel, the tooth is cut to the proper length. A pair of tweezers is used to pick up the wooden tooth, dip its blunt end in the gel cyanoacrylate glue, and insert the tooth into the socket. After insertion the high viscosity of the gel glue will hold the tooth in its proper position.

A fronto-lateral view of the Sperm Whale after all of the teeth have been inserted. The carving is not finished. It has been coated with an initial lacquer sanding sealer.

Other Sperm Whale carving considerations

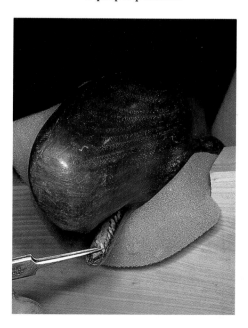

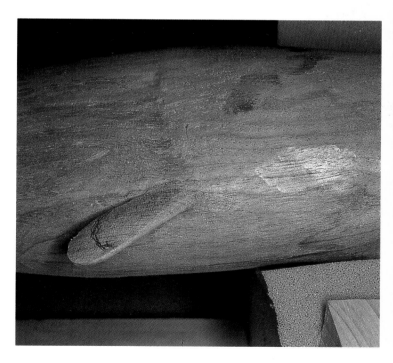

The carved pectoral fin is measured and marked to be shaped to its proper size.

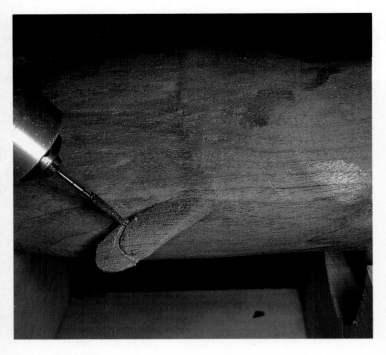

A tapered diamond cutter is used to first outline the shape to be cut, and then the excess wood is cut off.

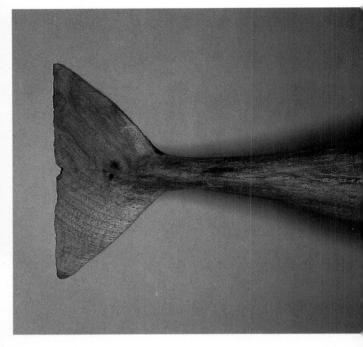

A dorsal view of the caudal section showing its general shape.

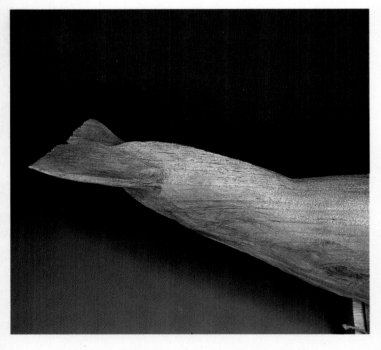

A lateral view of the caudal section showing its general shape.

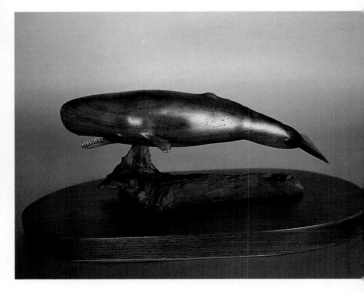

A lateral view of the completed Sperm Whale carving. The sperm whale is mounted on an irregularly shaped branch from a hardwood tree. The base is walnut.

Carving Cetacean eyes

Make an elevated roundish mound where the orbit is to be located. The eye will be detailed on top of the orbital mound. Draw with a pencil the opening of the eyelid margins.

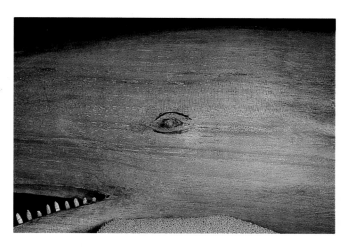

The upper and lower eyelid creases are delineated using the pointed knife-edged burning tip.

Use a pointed knife-edged burning tip to outline the open margins of the upper and lower eyelids. Insert the burning tip at an angle to go under the eyelid margins.

Continuing to use the pointed knife-edged burning tip, carefully round out the eyeball and "undercut" further the upper and lower eyelid margins . Deepen the areas in front and in back of the eyeball with the same burning tip. Use a brass brush to clean the area, then examine the results. Repeat until the desired effect of a roundish eyeball is attained. Finish rounding off the eyeball using micro-skew and dog-leg chisel. Then form the pupil in the center of the eyeball using a small round diamond cutter to make a round depression (in the carving shown, a 1/16" diameter cutter was used).

The attached margins of the upper and lower eyelids are deepened slightly.

The pupil may be accentuated by painting the pupil with modeler's gloss black enamel. A fine wire, 0.038" in diameter was used to pick up the paint. This is placed on the pupillary depression, allowing the paint to flow into the pupil. A fine point sable brush may also be used but since I do not know how to paint, I do not own any such sophisticated paraphernalia.

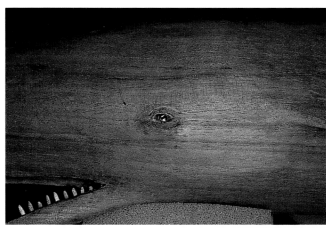

CHAPTER IX
ORCA
(ORDER CETACEA, SUBORDER ODONTOCETI, FAMILY DELPHINIDAE)
ORCINUS ORCA (LINNAEUS)

The Orca is not a whale, but is, in reality, the largest member of the dolphin family. They have become very popular and well known in recent years through their performances in aquatic theme parks and presentations by the visual media. During whaling days Orcas were often observed to herd baleen whales to within harpooning range; therefore, they were called "whale killers" by the whalers. Later the inadvertent reversal of the words brought about its well-known designation of **Killer Whale**.

Identifying characteristics. This large dolphin is easily identified by its sharply contrasting black and white colors, robust porpoise-like round head, and prominent dorsal fins.

Additional anatomical features. The Orca's body is rounded, robust, and spindle-shaped. The blowhole is located slightly to the left of center above the eye. The eyes are small and appear black. The forehead slopes down toward the upper jaw where, at the junction, it forms a slight indentation and gently tapers to the tip of the rounded jaws. In contrast to the Bottlenose Dolphin, the lower jaw terminates behind the upper jaw. The dorsal fin is probably the longest of all the cetaceans. The males have long straight erect triangular dorsal fins which may reach up to 6 feet in length, while the female's dorsal fin is shorter (up to 3 feet) and more rounded, almost a gentle falcate shape. However, dorsal fins of Orcas held in captivity become flaccid and the tips of the fins bend over radically. The pectoral fins are very distinctive as they are broad, rounded and prominent. The teeth are large and conical with a total of 24 in each of the upper and lower jaws. The upper and lower teeth have wide spacings (diastemata) that allow teeth to fit between each other when the jaws are closed. The fluke is large and broad and is deeply notched at its posterior median margin.

Size and color. Males can attain a length of over 30' and weigh up to 9 tons. Females are smaller and not as heavy in appearance. The white contrasting patterns, while variable, are constant enough to have specifically described named regions. A postocular spot is always present, while the flank has a patch which is contiguous with the variably white ventral region. The saddle, a grayish, variably shaped spot, is located just caudal to the dorsal fin. The ventral white region continues into the throat and shoulder area.

Some behavioral characteristics. Orcas are the only marine mammal known to prey on other marine mammals. Their diet also include sharks, salmon, and sea turtles. They are found world-wide. While they are particularly concentrated along coasts, they do roam the open oceans. They are migratory animals possibly due to the necessity of finding adequate sources of food. They may swim together in pods or be found alone or in groups of two or three. Like the Humpback Whales, they demonstrate spectacular breaching, spy-hopping, and tail slapping behavior.

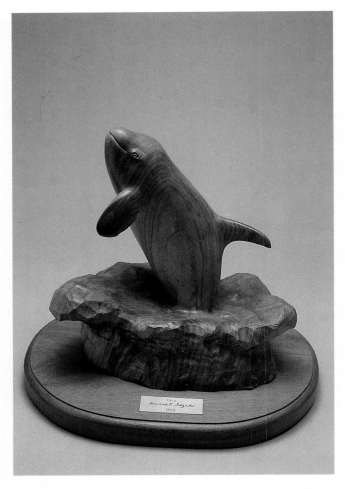

Breaching Orca carving made out of a Butternut log section.

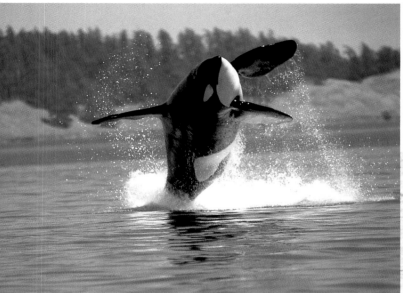

Breaching Orca, Vancouver Island, British
Columbia
Photo credit: Chris Huss.

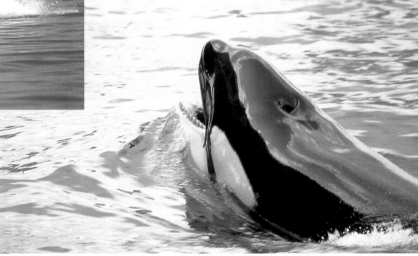

Head and Rostal region of Orca. Sea World,
Orlando, Florida.

ORCA

Jaws open showing diastemata of teeth.

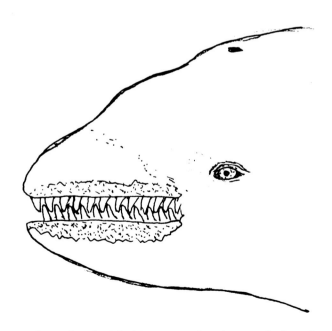

Jaws closed with skin removed to show occlusion of teeth.

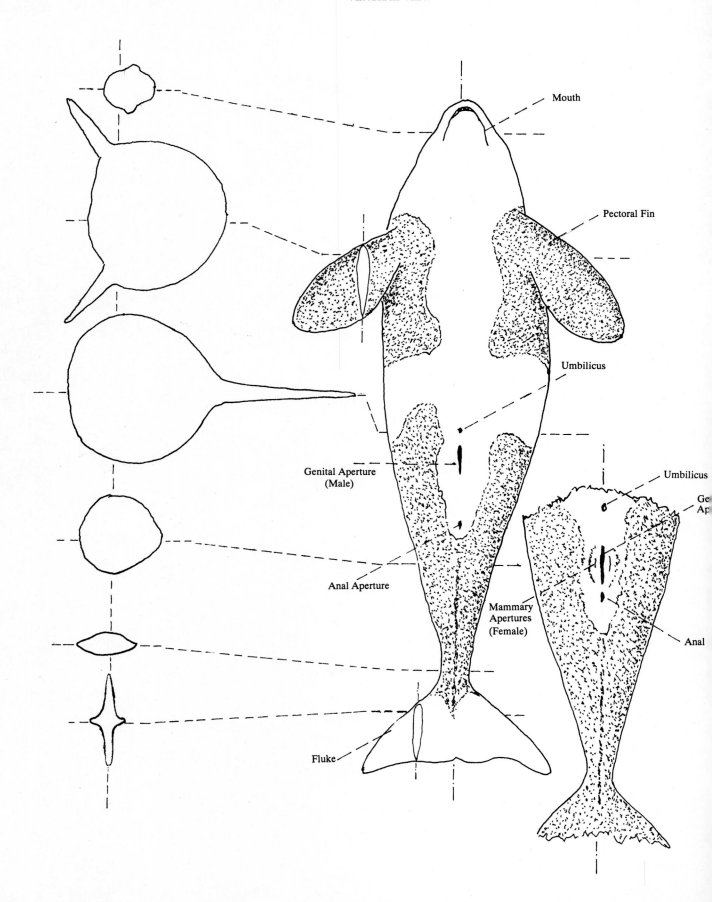

Mouth

Pectoral Fin

Umbilicus

Genital Aperture
(Male)

Umbilicus

Ge
Ap

Anal Aperture

Anal

Mammary
Apertures
(Female)

Fluke

LATERAL VIEW

DORSAL VIEW

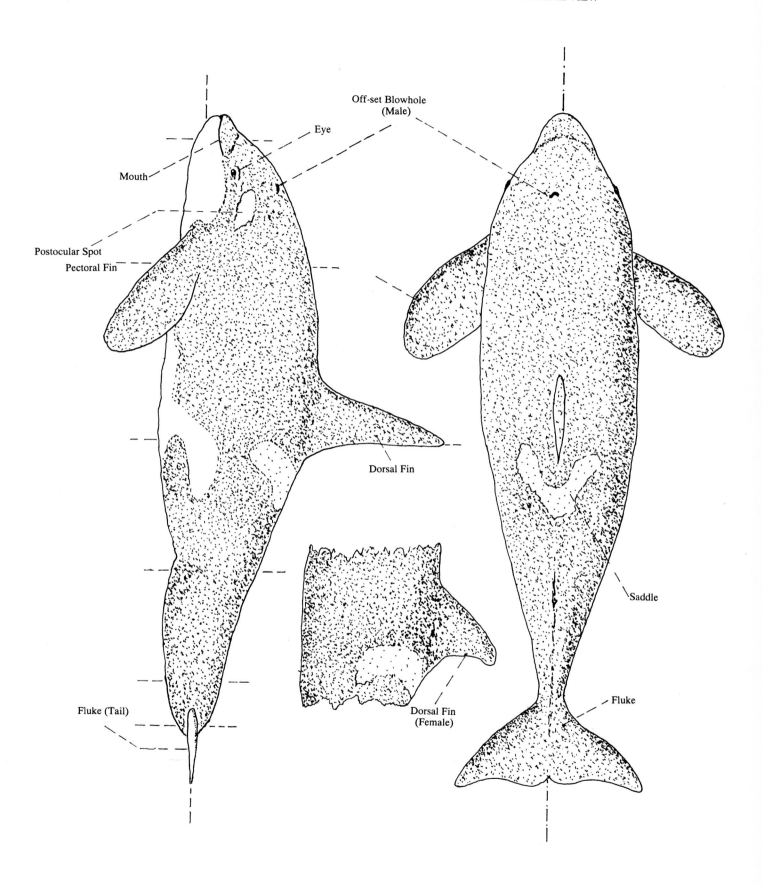

Off-set Blowhole
(Male)

Eye

Mouth

Postocular Spot

Pectoral Fin

Dorsal Fin

Dorsal Fin
(Female)

Saddle

Fluke

Fluke (Tail)

CHAPTER X
BOTTLENOSE DOLPHIN
(ORDER CETACEA, SUBORDER ODONTOCETE, FAMILY DELPHINIDAE)
TURCIOPS TRUNCATUS (MONTAGU)

This dolphin is one of the best-known Cetaceans in the world because of its depiction as a friendly and intelligent animal seen at marine aquaria and in movies, and also because of its world-wide distribution.

Identifying characteristics. This dolphin has a robust body with a rounded forehead which tapers to a prominent, short, stout proboscis or beak. The proboscis is formed by the upper and lower jaws with rounded tips. The lower jaw protrudes beyond the upper jaw. The upward curvature of the mouth gives it an appearance of a perpetual smile.

Additional anatomical features. The pectoral fins are short and curved posteriorly on the leading edges terminating in rounded tips. The dorsal fin is prominent with rounded tip and is falcate in shape. Both dorsal and pectoral fins are wing-shaped in cross-section. A transverse groove is present between the proboscis and forehead. The melon, the rounded eminence on top of the head, is delineated on the forehead by subtle curved grooves on its lateral margin. One centrally placed blowhole is situated on top of the head. It is a U-shaped slit when closed, the curved part facing forward. When open it looks like a round hole. There are approximately 18-26 teeth each in the upper and lower jaws. The posterior third of the body is strongly compressed ventro-dorsally where it terminates in the horizontally oriented fluke.

The melon is an oil filled cavity in the skull that appears to reflect and concentrate sound waves produced in the nasal cavities. The sound waves appear to play a role in echo-location, allowing the dolphin to locate prey and barriers.

Male and female urogenital openings are spaced differently. The female opening is more caudally located and close to the anal opening, while in the male the urogenital opening is located more forward and closer to the umbilicus. In addition, the female has a pair of mammary slits, located on each side of the urogenital slit, through which her milk is expelled from the underlying orifices to feed the baby. Occasionally rudimentary mammary slits are found in the male.

Size and color. The color of the dorsal and lateral surfaces of the body varies from a light gray to black. The ventral surface is whitish. Both the upper and lower surfaces of the pectoral fins are dark. The iris of the eye is dark brown with a black pupil.

Some behavioral characteristics. They are often seen in groups called pods. They enjoy "bow-riding" next to moving boats. They enjoy leaping out of the water. Wild bottlenose dolphins are generally wary. On the numerous occasions that I have gone into the water with them, they quickly disappear. Once, however, off of the Venezuelan coast, I got in the water with a small pod of curious dolphins who quickly surrounded me, swam rapidly up to me, stopped about 3 feet short of me, looked at me, and just as quickly turned and swam away. Many places now "train" wild dolphins to interact with snorkelers and scuba divers.

Special carving/sculpting suggestions. After roughing out the dolphin, shape the head to include the melon and a pair of round orbital eminences on the sides of the head. The eyes are located on top of the orbital eminences. Because the eyes are relatively small and partially hidden by elliptically shaped eyelid openings, I prefer to carve the eyes and eyelids using a spear point burning tip. This method was described in greater detail earlier in the section on the Loggerhead. 3 mm. glass eyes with light brown irises can also be inserted into a shallow flat bottomed hole made by using a cylindrical cutting diamond rotary bit. Eyelids may be created with wood filler. Another alternative is to undercut the eyelids with an inverted cone shaped end cutting diamond rotary bit. The elliptical shape of the eyelid opening is retained, and the glass eye is inserted into the opening without disturbing the carved eyelids.

The most frequent mistake made by the novice carver in sculpting dolphins is that the caudal peduncle is left too thick and heavy. The caudal portion is strongly compressed dorso-ventrally and thin with sharp upper and lower margins.

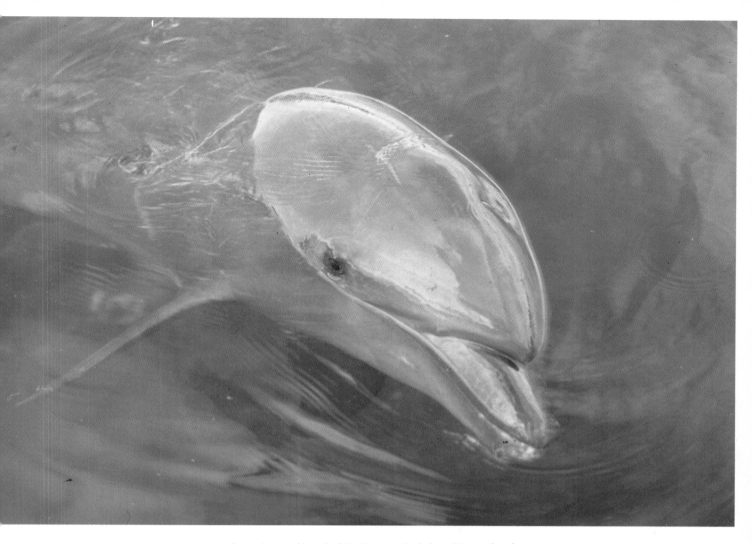

Surface photo of head of Bottlenose Dolphin. Marineland,
Florida

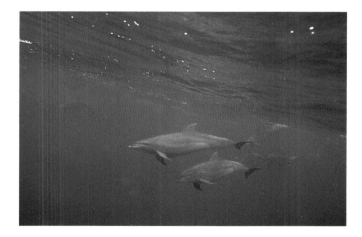

Underwater photos of several Bottlenose Dolphins. La Guiara
Banks, Venezuela

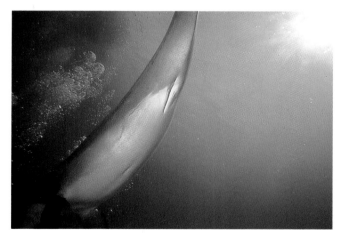

Ventral surface of female Bottlenose Dolphin showing
umbilicus in front of the long urogenital slit with small
paired mammary slits visible on each side. UNEXCO,
Freeport, Bahamas

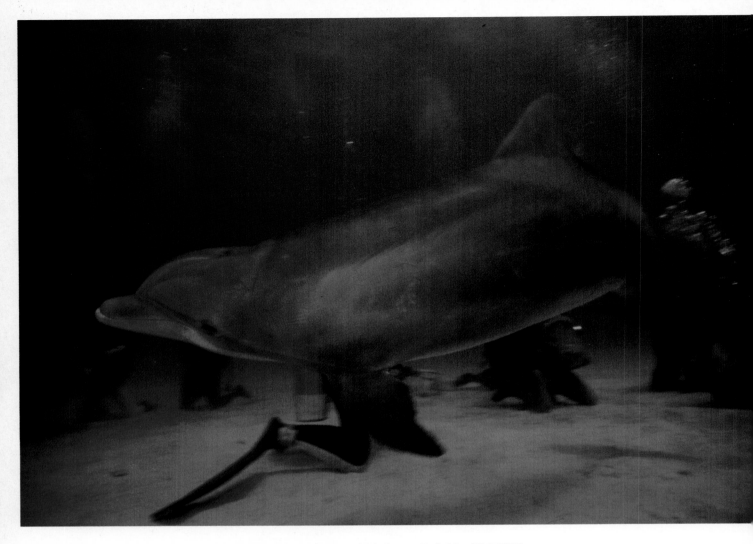
Dorso-lateral view of Bottlenose Dolphin. UNEXCO, Freeport, Bahamas

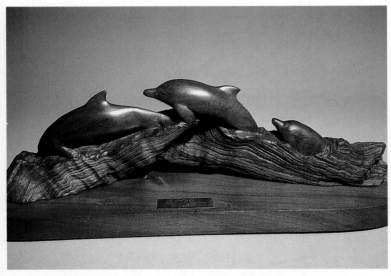
Bow Riders. Carving of Bottlenose Dolphins. Carved out of Buttonwood mangrove using only hand tools. This was made as a demonstration project for a teaching seminar held in Bonaire, Netherlands Antilles, 1992.

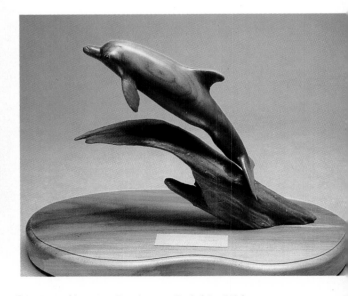
Carving of leaping Bottlenose Dolphin. Walnut

LEAPING BOTTLE NOSE
 DOLPHIN

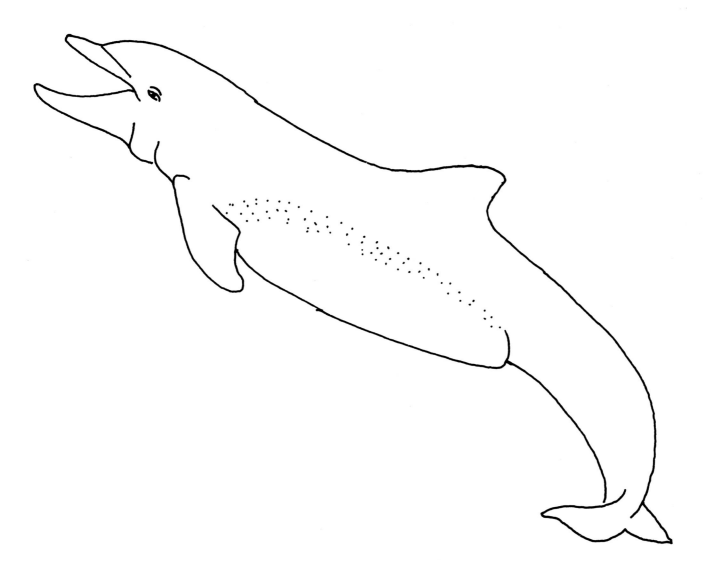

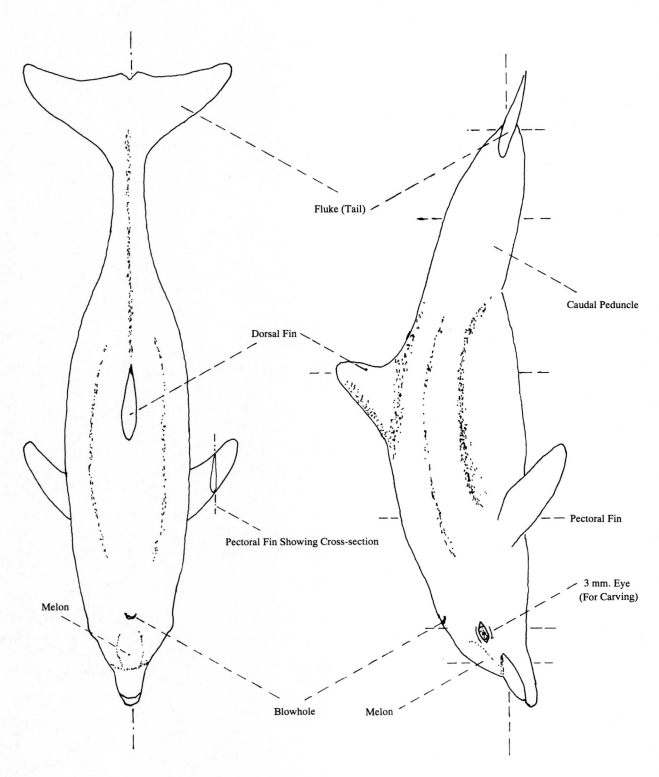

Fluke (Tail)

Caudal Peduncle

Dorsal Fin

Pectoral Fin Showing Cross-section

Pectoral Fin

3 mm. Eye
(For Carving)

Melon

Blowhole

Melon

DORSAL VIEW

LATERAL VIEW

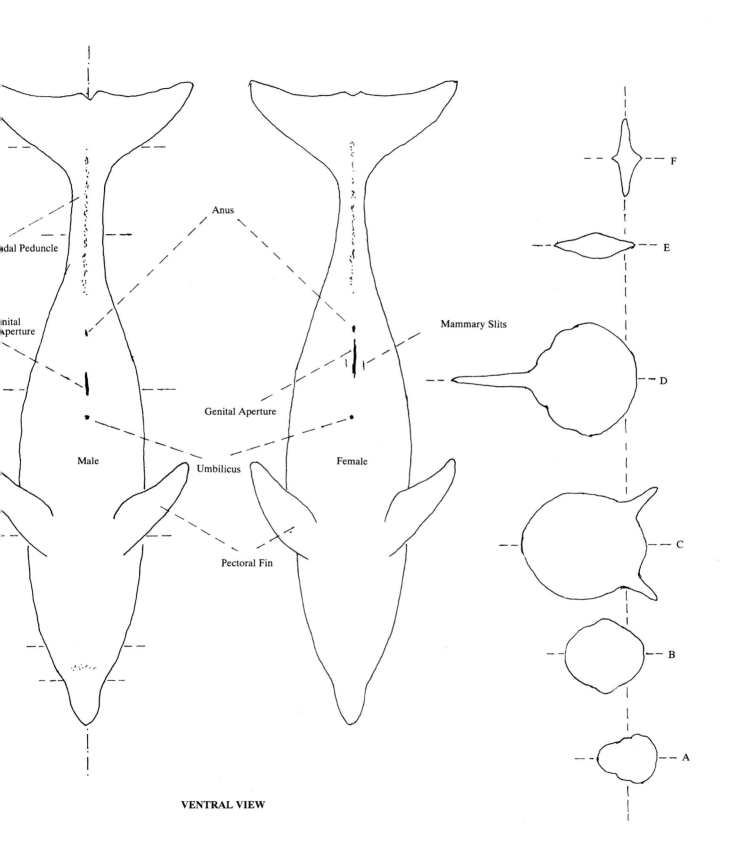

Anus

dal Peduncle

Mammary Slits

nital
Aperture

Genital Aperture

Male

Umbilicus

Female

Pectoral Fin

F

E

D

C

B

A

VENTRAL VIEW

CHAPTER XI
WEST INDIAN MANATEE
(CLASS MAMMALIA, ORDER SIRENIA, FAMILY, TRICHECHIDAE)
TRICHECHUS MANATUS (LINNAUES)

During the past twenty years, the odd looking manatee has become well known and popular. Visitors from all over the country and the world visit Florida during the winter months to see the animal in its native habitat. Go back a few years, however, and you can imagine an 18th century seaman who had been on the ocean for months when his ship finally anchored in a bight. How astonished he must have been to see a beautiful mermaid swimming in the water to greet him. Mermaid? No, it was the seaman's first view of the West Indian Manatee! After looking at a photograph of a manatee, how can a person mistake it for a mythical mermaid? But after months at sea, who knows what distortions can alter a man's mind?

There are several species belonging to the family Sirenidae, which include manatee species found in the West Indies, Amazon basin of South America, and Africa. A related species, the dugong, is distributed in the Indo-Pacific region. The Arctic Stellar Sea Cow was eradicated by humans some 250 years ago.

Identifying characteristics. The manatee has a uniquely formed large, tear-drop shape with a round, horizontally oriented tail. The upper extremities are in the form of short flippers. The body blends into a small head with highly mobile upper lips.

Additional anatomical features. The skin is thick, tough, and wrinkled, and is covered with sparse fine hair. Varying numbers of skin creases are present in the head region, at the base of the flippers and on the undersurfaces of the tail stalk. The head is small relative to the rest of the body. The body blends into the head without a visible neck. The manatee has a pair of prominent highly muscular, mobile upper lips, which have stout bristles. The upper lip join at an indentation called the philtrum. The manatee has 5 to 7 molar teeth in each jaw; incisor and canine teeth are rudimentary and not seen in the adult. The nostrils are located above the philtrum and appear as a pair of semicircular slits when closed, and round when opened. The lower jaw is round and overlapped by the prehensile upper lips. The eyes are small and deeply set surrounded by eyelids marked with radiating lines. The actual size of the visible part of the eye of a young manatee measures approximately 4.5 mm.

(less than 3/16") in diameter and about 10 mm in the adult. The ear openings are minute (1 mm in diameter) and lack external earlobes.

Only anterior (upper) extremities are present in the form of uniformly shaped flippers with rounded ends. Three or four nails are located on the distal upper surfaces of the flippers. The flippers are highly mobile and used for a number of different functions. Females have nipples located on the hind part of the flippers in their axillary region. The genital and anal openings appear as slits, the anal opening behind the genital openings. In the male, the genital opening is farther in front of the anal opening than in the female. There appears to be no sexual dimorphism in the manatee, although the female appears to get larger than the male.

The neonatal manatee's appearance is quite different from the adult. Its head is proportionately larger, with a number of dorso-ventrally placed shallow grooves in the head region. In Florida many of the neonatal manatees have a skin disorder that accentuates the roughened appearances of the skin. This skin disorder disappears as the animal matures.

Size and color. The manatee can attain lengths from 8 to 13 feet, with weights up to 3600 pounds. They are usually uniformly gray in color, although they are often covered by algae, which gives them a slight greenish cast. The newborn calf is about 3 feet long and weighs between 25 to 60 pounds.

Some behavioral characteristics. The manatee propels itself through the water by moving its horizontally oriented tail in up and down motions. When swimming slowly the flippers hang loosely; however, when moving rapidly, the flippers are placed against the sides of their body. Manatees may bank, roll over, or swim upside down. Manatees rest on the bottom, coming up every few minutes to get air. As part of a social interaction behavior, they often touch each other's head with their flippers. They will often swim up to a snorkeler, and when the snorkeler touches the manatee's body, it will roll over in apparent joy, implying that it would like its abdomen rubbed. However, humans should take care not to harass these animals. Let manatees choose whether or not they wish to interact with a human. Their slow speed and behavior makes them susceptible to injury by motorboats.

Reproduction. Mating occurs throughout the year. The gestation period is probably about a year. The female will usually produce one calf. Immediately after birth the calf will swim using only its flippers. After several days, it will begin to use its tail.

Status. It is estimated that there are over 1800 manatees living in the coastal waters of the southeastern United States. In some parts of Florida the population has increased, in other areas it is decreasing. Some manatee populations in the Caribbean and South America have been decimated by illegal hunting. Fortunately many of the Caribbean and South American countries are now instituting conservation procedures.

Special carving/sculpting suggestions. The mistake most frequently made in carving the adult manatee is making the head too large. The most difficult part to represent accurately is the mouth. The lower jaw can be represented as a roundish eminence, which is partially overlapped on its outer edges by the highly mobile skin covering the upper jaw. Hair follicles on the jaws can be represented by punching small shallow depressions with a brad type nail.

As stated earlier, manatee eyes are small. Therefore, black glass eyes no larger than 1mm in diameter should be inserted into the orbital depression of the manatee shown in this book. Eyes can also be represented by mixing black pigment with 5 minute epoxy, and dabbing a tiny drop of the mixture attached to the tip of a toothpick in the middle of the orbital depression. The epoxy will ball up and form a round eye. The eyelids are delineated by making fine radiating grooves using a #11 scalpel blade or similar style spear point knife.

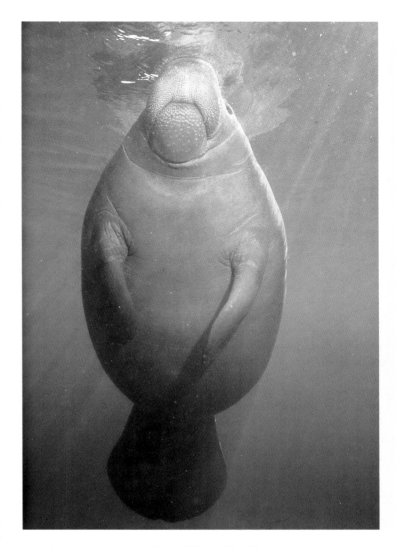

Ventral view of Manatee. Crystal River, Florida

Lateral view of manatee. Crystal River, Florida

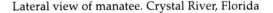

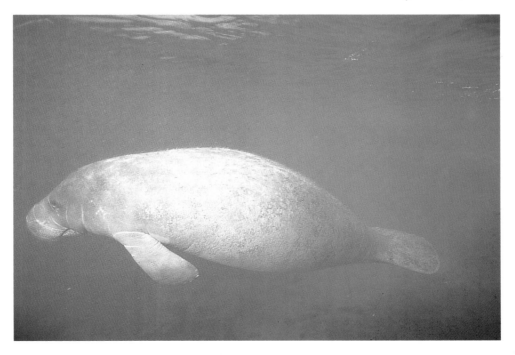

VENTRAL VIEW

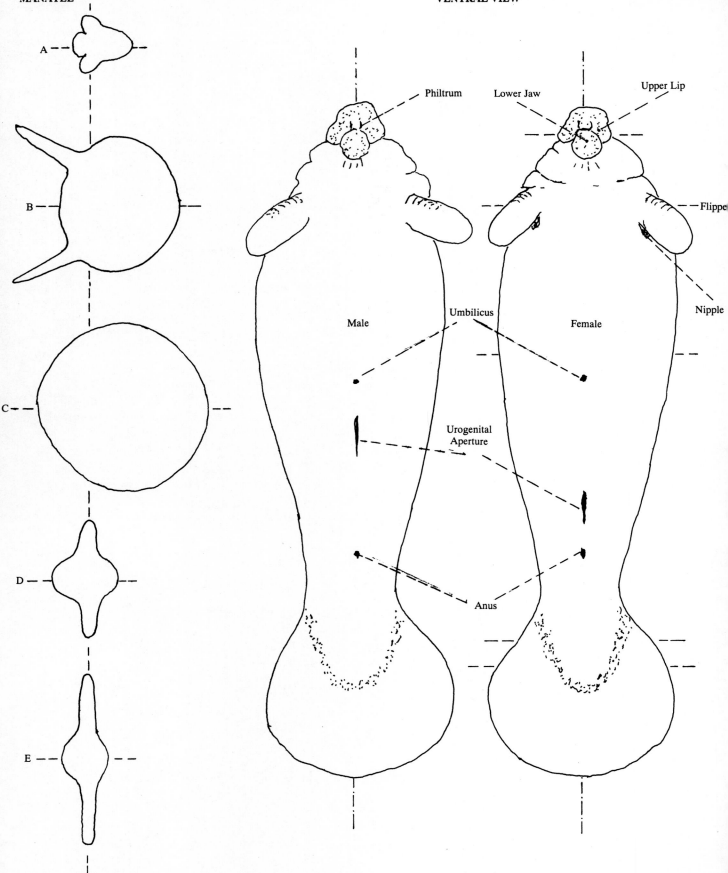

A

B

C

D

E

Philtrum

Lower Jaw

Upper Lip

Flipper

Male

Umbilicus

Female

Nipple

Urogenital
Aperture

Anus

LATERAL VIEW

DORSAL VIEW

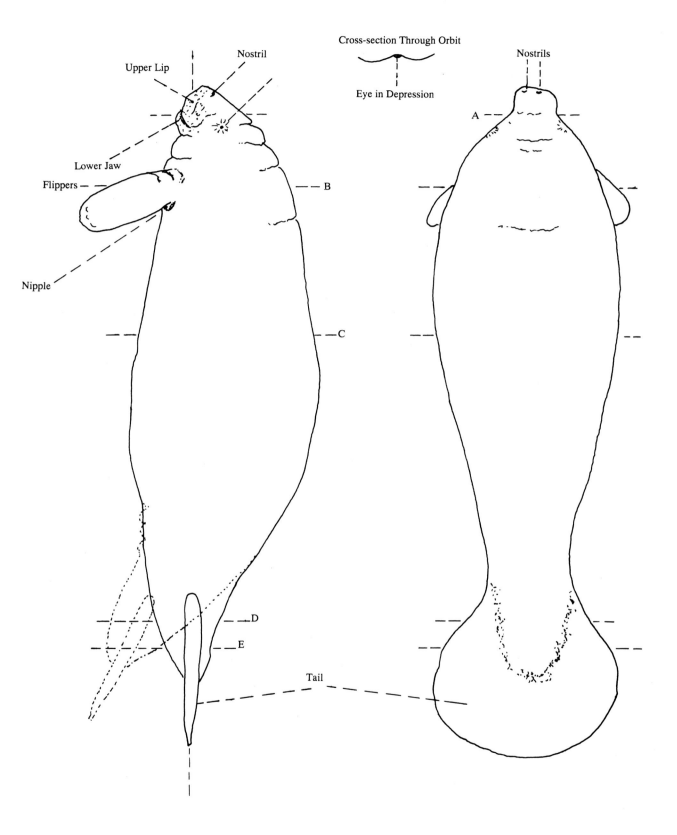

Cross-section Through Orbit

Eye in Depression

Nostril

Upper Lip

Nostrils

Lower Jaw

Flippers

Nipple

A

B

C

D

E

Tail

71

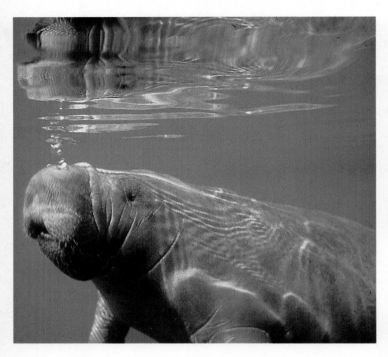

Lateral view of a manatee showing the anatomy of the head and mouth areas. It is in the process of sinking in the water after it had finished taking a breath of air. Crystal River, Florida.

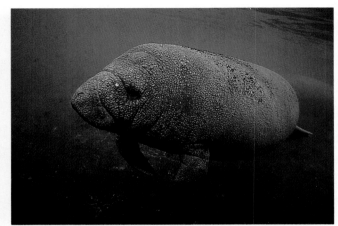

A view of a baby manatee, showing its head size to be proportionately larger than that of the adult. Crystal River, Florida.

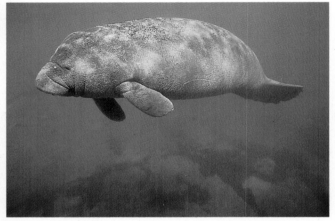

Lateral view of a baby manatee. Crystal River, Florida.

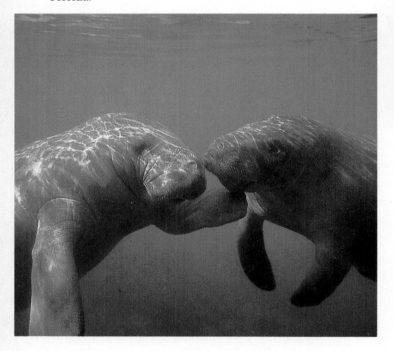

Lateral view of a manatee patting its mate on the head. It shows the flexibility of the flippers. Crystal River, Florida.

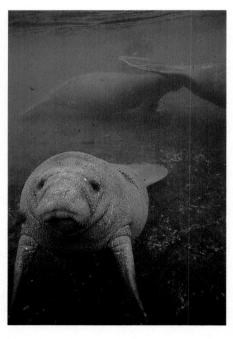

Frontal view of a baby manatee. Crystal River, Florida.

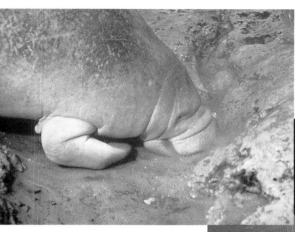

Feeding female manatee showing nipple caudal to base of front flipper. Crystal River, Florida

Ventral view of female manatee showing anus posteriad and urogenital opening located in front of it. The umbilicus is not visible. Crystal River, Florida.

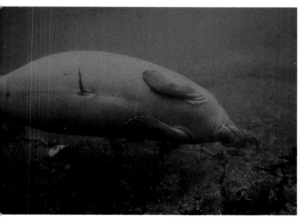

Ventral view of male manatee showing urogenital opening with a piece of algae hung in the opening. The umbilicus is visible in front of the urogenital opening, while the anal opening is shown as a black area close to the base of the tail. Crystal River, Florida.

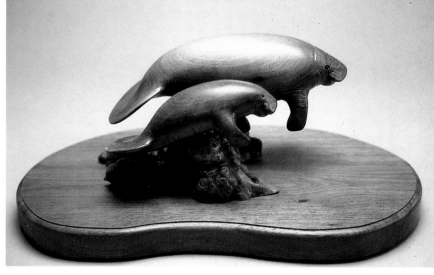

Wood Carving of Piety and Baby, made out of black walnut.

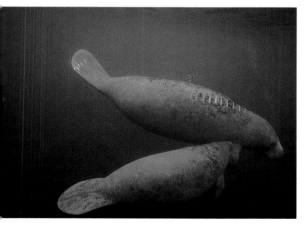

Mother manatee named Piety nursing her baby. Observe the propeller scars on Piety's back. This photograph was taken in January, 1991, and by March, 1991 the baby was also scarred by boat propellers. Crystal River, Florida.

CHAPTER XII
HUMPBACK WHALE
(ORDER CETACEA, SUBORDER MYSTICETI, FAMILY BALAENOPTERIDAE)
MEGAPTERA NOVAEANGLIAE (BOROWSKI)

The humpback whale is probably one of the most beloved and familiar whales in the world. It was a central figure in a popular futuristic movie. Its eerie singing has been recorded, marketed, and sold. Its behavior and antics have been depicted in numerous visual media, and are a significant *raison d'etre* for tourism.

Identifying characteristics. The long pectoral fins (Greek: *Mega*=large, *ptera*=wing) immediately identify this species, as a fin is up to one third of the body length. The head is covered with roundish callosities. Rows of overlapping keratinized baleen plates are attached to the margins of the upper jaws; these serve to separate water from food, as humpbacks do not have teeth. About two-thirds the body length behind the head, a small dorsal fin is present on a hump, a rounded elevation that manifests itself when the whale arches its back as it gets ready to dive.

Additional Anatomical Features. The humpback has a robust round body which tapers to a narrow vertically oriented tail stock with sharp upper and lower margins. The fluke (tail) is large and wide and its width may be up to one-third the body length. The fluke is horizontal and gracefully curved. The posterior margin is serrated with a deep median notch. The ventral portion of the whale's body has 14-24 ventral grooves which extend from the throat to the navel. The rostral portion of the head is covered by a series of roundish callosities which for the most part appear to be in rows. A medial rostral ridge is present, and also has protuberances. Additional callosities are present near the upper posterior margins and enlarged apical portion of the lower jaw. A single hair is located on each protuberance.

A medial V-shaped dorsal head ridge is located behind the rostral medial ridge. A pair of elongated blow holes are located behind the dorsal head ridge, which serves to deflect water around the blow holes while the whale is on the surface. The jaw margins curve strongly downward near the posterior part of the mouth. The eyes are located posterior to the downward curvature of the mouth and appears on rounded elevations. The eyelids are prominent.

The pectoral fins are highly mobile and have a series of fleshy knobs on the anterior leading edges, of which two are consistently large and prominent, with two to three small knobs between them. Additional small knobs are also found more distally. The knobs correspond to the underlying bony skeleton. The humpback whale has only four sets of "finger bones" (metacarpal and phalanges), as the "third finger" bones are missing.

The baleen plates or whale bones are keratinized plates, the same material which in other animals make up finger nails, hooves, and horns. In the Humpback Whales, there are up to 200 such plates attached to each side of the upper jaw, with the flat surfaces transversely aligned in a row from front to back on each side of the jaw. They measure up to 33 inches in length in this species. The buccal or outer edges are smooth, while the oral or medial portions are frayed with the strands having hair-like appendages. These hair-like strands are pushed against the tongue to prevent the prey from escaping, direct the small sea creatures into the pharynx, and allow excess sea water to be flushed out.

The genital opening is located behind the navel. In the female, a pair of mammary slits are located lateral to the genital opening. The mammary orifices are located deep within those slits. In addition, the female has a round lobe behind the genital opening; this lobe is not present in the male. The anal orifice is located posterior to the genital opening. In the male the genital opening is spaced farther apart from the genital opening than in the female.

Size and color. Humpbacks are large whales that reach 40 to 50 feet in length and weigh from 30 to 50 tons, females being larger than the males. When the calves are born they are about 12 feet in length and will grow to 24 feet in 4 months. The upper parts of the body are black or deep grayish black. The abdomen and ventral surface of the fluke manifest individualized patterns of white mixed with black. The unique pattern of the ventral fluke surface is used as an important criterion to help identify a specific individual whale. The ventral surfaces of the pectoral fins are often predominantly white, while the upper surfaces are usually black mixed with vary-

ing patterns of white, particularly along the protuberant leading edges.

Behavior. In the fall, the North American populations migrate to the warm waters of the Caribbean and Hawaii, where females give birth to their young sometime in November-December. The calves grow rapidly in the tropical waters because of the rich milk of their mothers.

In the wintering grounds, male humpbacks seek the privilege of serving as an escort and protector for the female and her calf. They will follow the female and fight other males in what is called the heat run. The successful escort will follow the female and calf but usually below and behind the female. The classical behavior of the female is to keep the calf above her, protecting the calf from potentially marauding predators such as sharks and killer whales. Calves are curious and will approach a skin diver. The mother, who is nearby, will quickly herd the calf away from the human intruder.

Humpbacks migrate to the North Atlantic Canadian-United States seacoast or Alaskan waters in the spring, where they spend the summer feeding and frolicking. In the summer feeding grounds, they move through the water on their sides with open mouths. The water is filtered out through the baleen plates, so that the food is concentrated. After closing the mouth, food is swallowed with a minimal intake of water. In those feeding grounds, they use their unique bubble-net cooperative feeding techniques. The whales group together under the leadership of a matriarch whale. They form a circle deep beneath the food prey, and blow, in unison, a ring of air bubbles. As the air bubbles rise and enlarge, the prey, such as herring, are frightened into forming a more concentrated group. The whales then swim to the surface, capturing the prey with their open mouths. As they reach the surface, the mouths begin to close, filtering out the water through the baleens. After the whales come to the surface with oral cavity and pharynx filled with water and food, they contract the muscles of their greatly expanded throats (helped by the throat grooves), and force water through the baleens leaving the krill and fish to be swallowed. Seeing this phenomenon is breathtaking.

They are a delight to watch as they bring their huge heavy bodies out of the water in the form of a breach. They will oftentimes do this 3-5 times in succession before stopping. Young humpbacks are comical to watch as they learn to breach. Mothers have been observed to stop the antics of the calves. Another behavior is for the whale to come gently out of the water showing a portion of its body in what is called "spy-hopping." Tail slapping is another fascinating phenomenon. Whale watchers use the loud noise and splashing to help locate the whale miles away.

Special carving/sculpting suggestions. After general shaping, be sure to leave a pair of rounded orbital eminences and enough wood to carve the callosities on the head and rostral region. Carving the callosities on the head may be difficult. The bumps can be delineated using round concave or oblong punches used in making eyes and carefully removing the wood around the callosities. They can also be created by punching round depressions where the bumps are to be located. The punches are made out of different sized round metal rods or nails, with the functional end shaped to a smooth semispherical surface. After marking the locations of the bumps, the carving is stabilized on a cradle before punching the wood, after which the wood is sanded smooth to a level where the round punched areas are barely visible. Steaming water drops are placed on the visible, depressed punched areas. After they have absorbed water, the depressed punched areas will rise, forming the bumps. This technique is adapted from a method used by traditional craftsmen who repaired the dents caused by items dropped on wood furniture. The addition of water or steam expands the compressed wood fibers. The third method is to carve each individual callosity using gouges or rotary cutting tools. Smoothing the areas around the callosities is the most tedious part of this latter technique. Small rounded scrapers are useful the smoothing process. Of course, one can avoid all of this delicate work by making very stylized Humpback whales that do not have these callosities!

In making the abdominal grooves, I prefer to place the shaped animal carving on its dorsal surface upon a cradle that I have made. I first mark the proposed grooves with a pencil, then starting from the midline (sagittal plane) work out laterally by burning in the grooves with a straight knife-edged burning tip. The knife-edge is important as it will readily burn across the grain, in order to keep the lines as even as possible. The burned grooves are deepened using fine triangular riffler files (eg. diamond embedded) or micro V-shaped carving tools, followed by rounded diamond riffler files or micro #10 veiner gouges.

After delineating the eyelids on the orbital elevations, glass eyes can be inserted by the methods described on page 13, Mounting Glass Eyes. Eyes and eyelids can also be burned in using the technique described in the Loggerhead Turtle section.

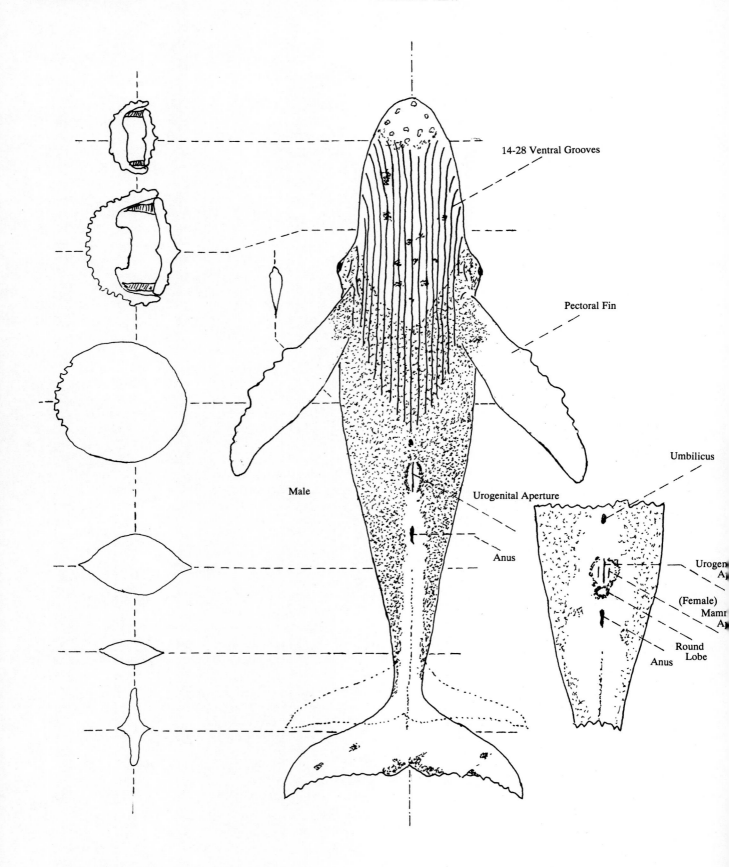

14-28 Ventral Grooves

Pectoral Fin

Umbilicus

Male

Urogenital Aperture

Anus

Uroge
A

(Female)
Mamr
A

Round
Lobe

Anus

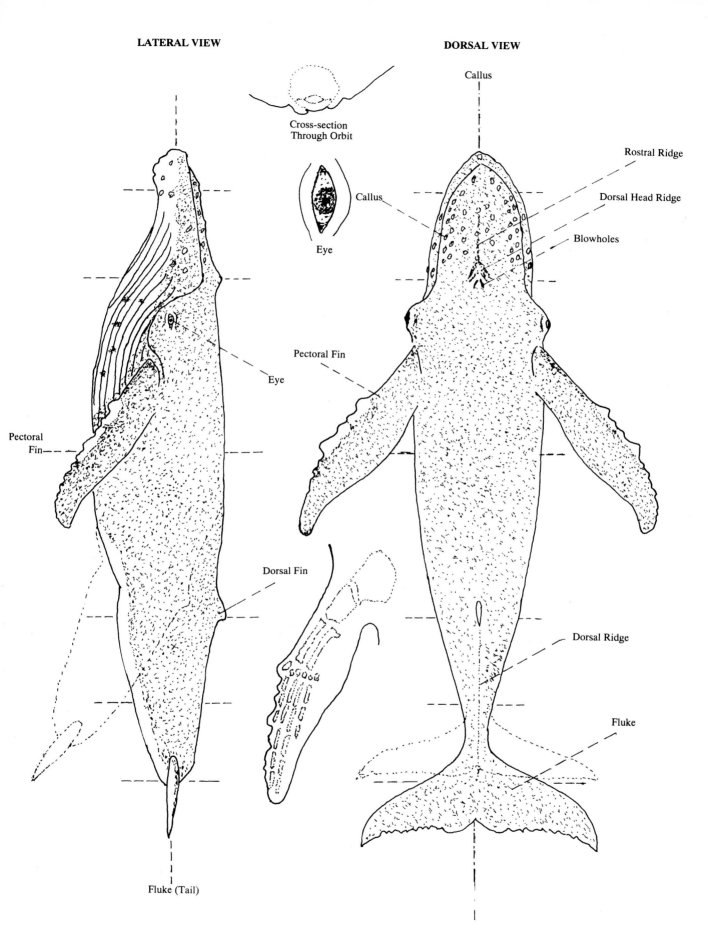

LATERAL VIEW

DORSAL VIEW

Cross-section
Through Orbit

Callus

Eye

Callus

Rostral Ridge

Dorsal Head Ridge

Blowholes

Pectoral Fin

Eye

Pectoral
Fin

Dorsal Fin

Dorsal Ridge

Fluke

Fluke (Tail)

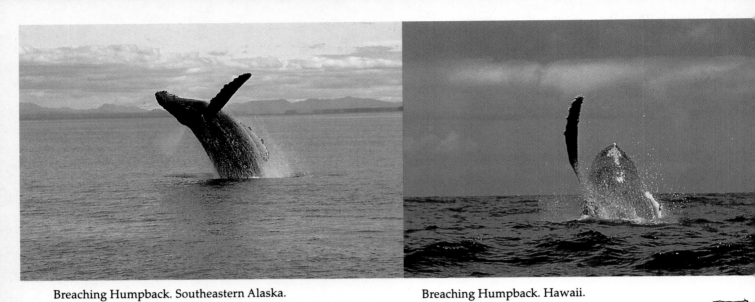

Breaching Humpback. Southeastern Alaska.

Breaching Humpback. Hawaii.

Breaching Humpback Whale pattern, lateral view.

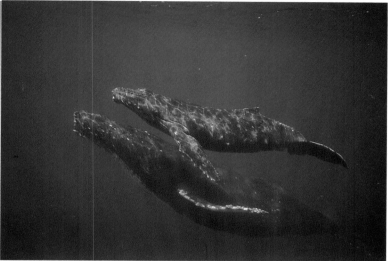

Underwater photo of mother and calf Humpback. Hawaii.

Carving of breaching Humpback. Made from a walnut log.

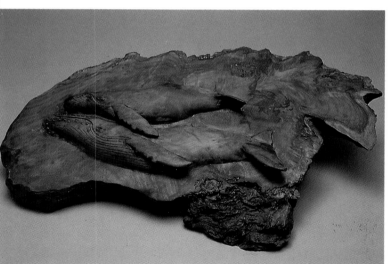

Relief carving of mother and calf Humpback, redwood slab.

Carving of mother and calf Humpback, walnut wood.

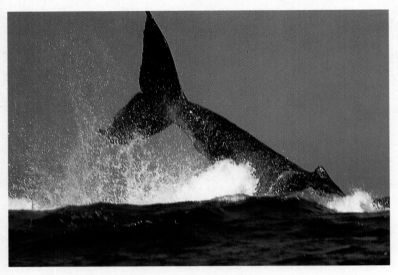

Diving Humpback showing fluke. Hawaii.

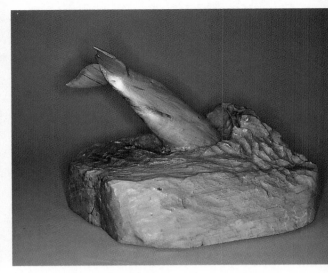

Carving of diving Humpback showing fluke. Carved of pecan wood.

Breaching Humpback Whale pattern, dorsal view.

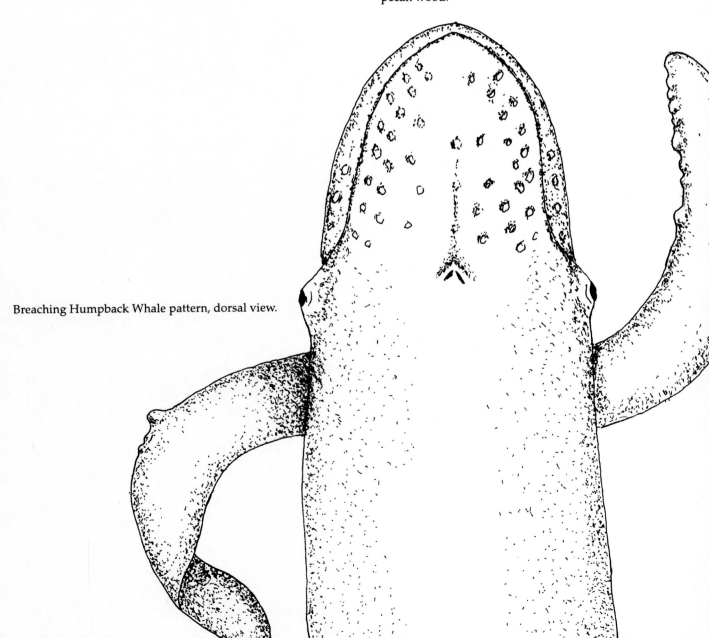

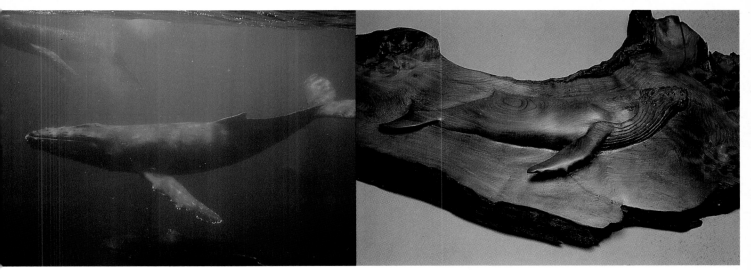

Underwater side view photo of Humpback. Hawaii. Relief carving of Humpback. Redwood slab.

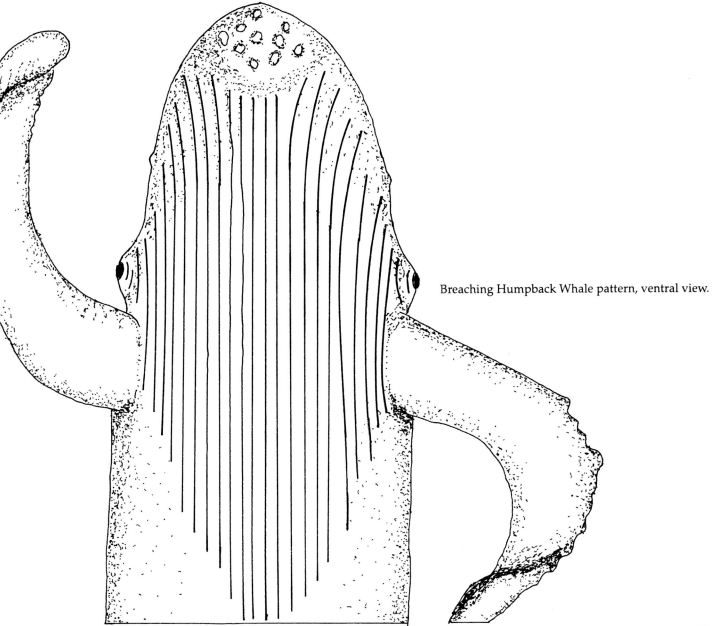

Breaching Humpback Whale pattern, ventral view.

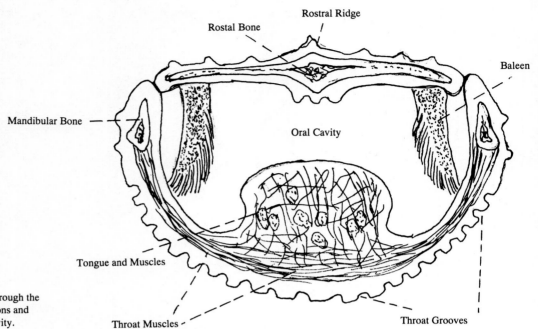

Rostral Ridge

Rostal Bone

Baleen

Mandibular Bone

Oral Cavity

Tongue and Muscles

Figure: Schematic Cross-section through the head of Humpback showing positions and relative shape of baleens in oral cavity.

Throat Muscles

Throat Grooves

Figure: Humpback Whale baleens seen from a lateral view

Baleens

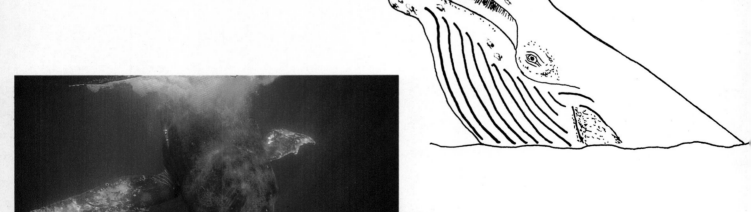

Underwater photo of Humpback showing head details and pectoral fins. Hawaii.

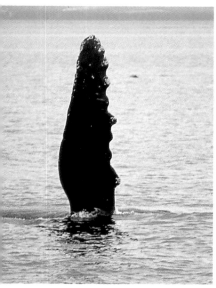

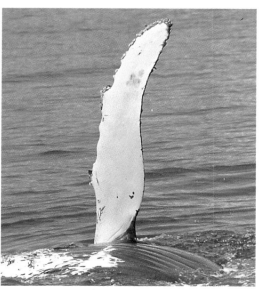

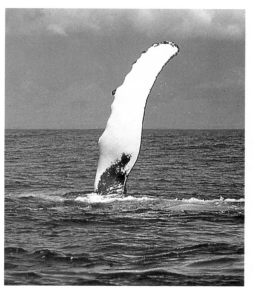

Dorsal view of pectoral fin showing pattern of leading edge bumps. This whale has dark dorsal coloration with scattered white specks. Southeastern Alaska.

Ventral view of pectoral fin showing leading edge bumps and white color pattern. Southeastern Alaska

Ventral view of pectoral fin showing different configuration and color pattern. Hawaii.

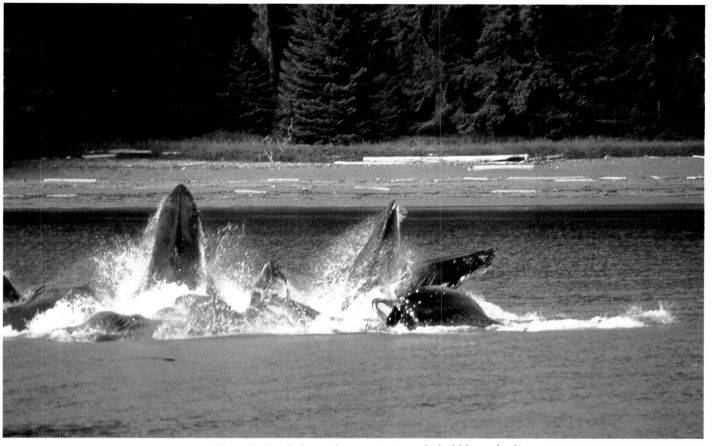

Humpback whales at the termination of a bubblenet feeding phenomenon. Their mouths are open and they are now swallowing their food prey, the herring. Southeastern Alaska.

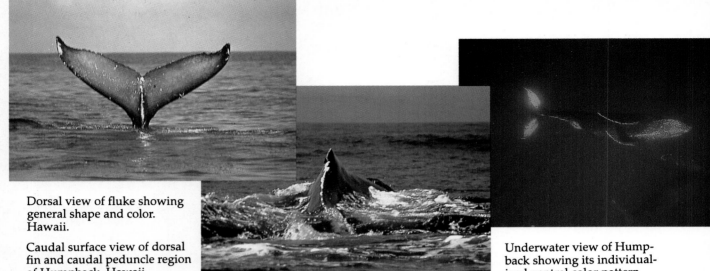

Dorsal view of fluke showing general shape and color. Hawaii.

Caudal surface view of dorsal fin and caudal peduncle region of Humpback. Hawaii.

Underwater view of Humpback showing its individualized ventral color pattern. Hawaii.

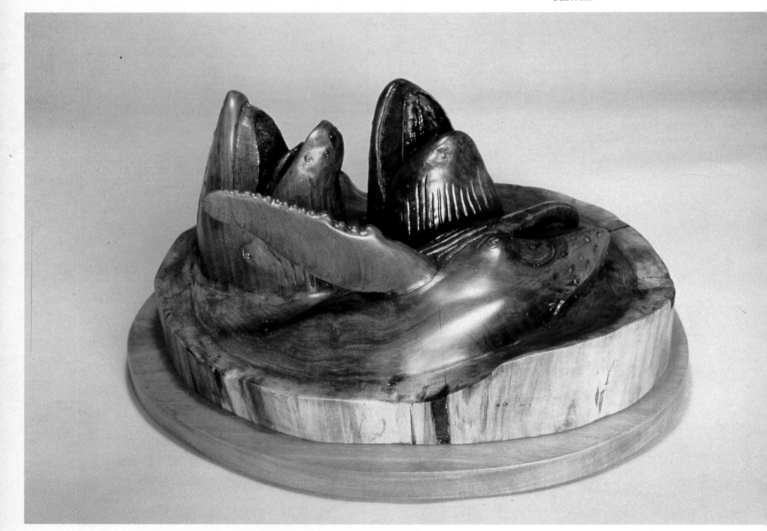

Sculpture entitled "Feasting" showing three humpback whales at the termination of bubblenet feeding. The design is based on a number of photographs taken in Southeastern Alaska in 1992. Black walnut, cross-sectional slab, single piece.

BUILDING THE CLAY
MODEL

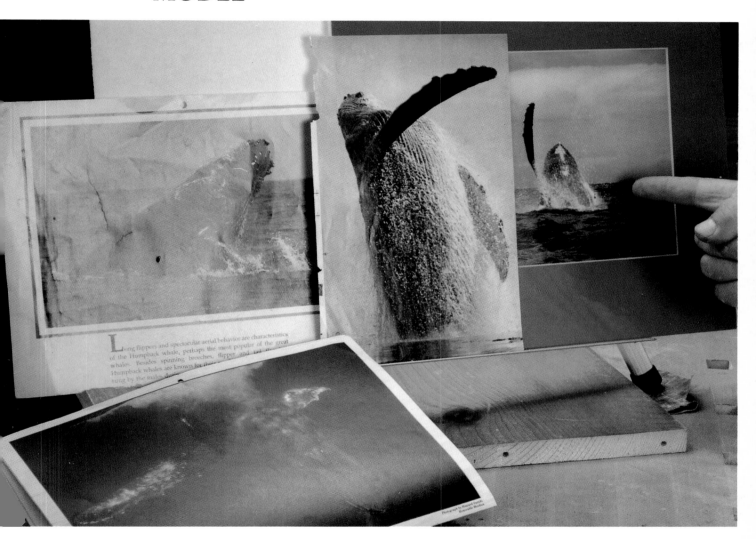

When making the model it is important to have as many
resources as possible. I use photographs I have taken as well
as those of others that have been published. The one on the
right is the inspiration for the sculpture I am doing here. It
was taken off of Maui, Hawaii.

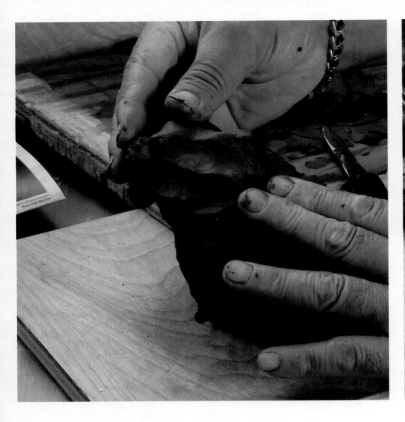

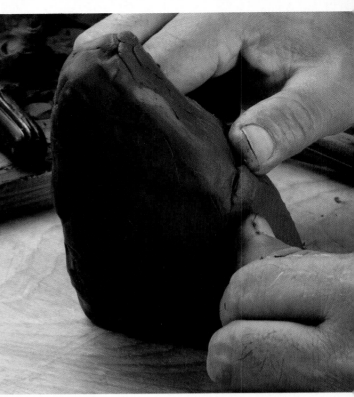

This is a petroleum sculptor's clay, which is malleable when it is warm and hardens as it approaches room temperature. If you are careful you can soften it in a microwave, but if it gets too hot it could ignite. Once softened, a 60-100 watt incandescent lamp will keep it pliable for shaping.

Take a ball of clay and add the eye orbit bulge.

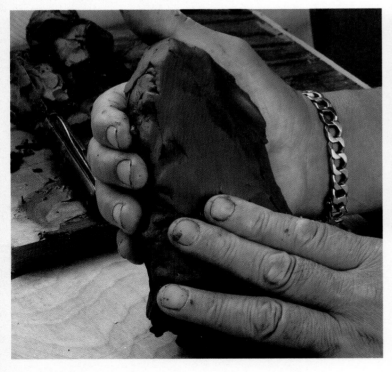

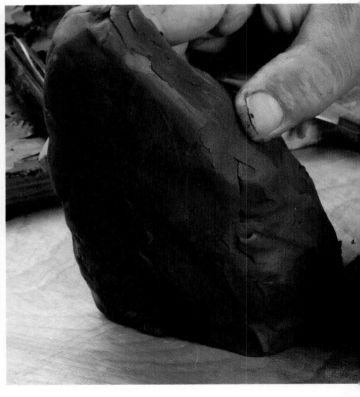

Roughly shape the head. The nice thing about clay is that you can add and subtract. In wood you can subtract, but you can't add. This is why the clay is so essential in the sculpting I do.

Blend it in.

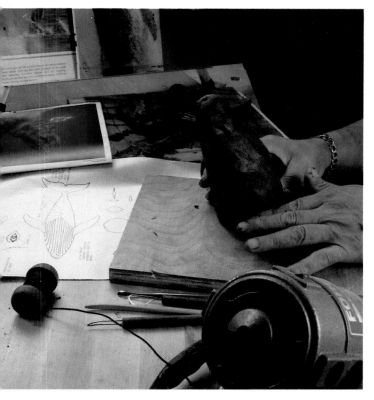

Reference to drawings are important for accuracy.

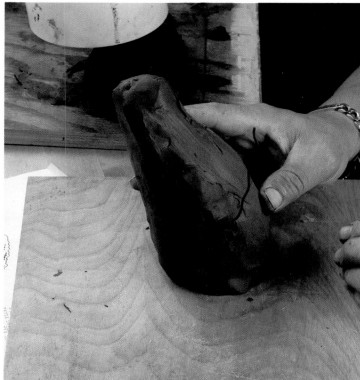

Insert a piece of pliable wire as an armature for the raised fin. Check the location of the origin with your drawings and photographs. The wire should go a couple of inches into the body, and have a slight crimp in it to help keep it from turning in the clay.

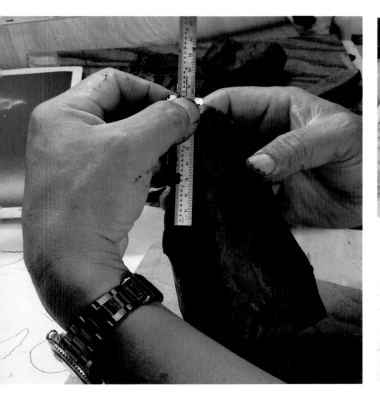

Measure to be sure the eye placement on the left and on the right is the same. With clay it is easy to move the eye.

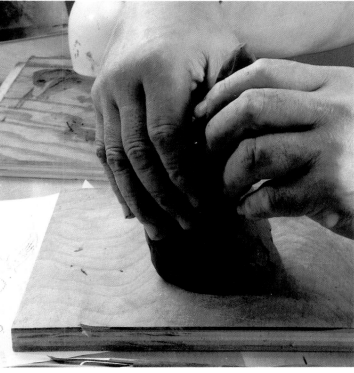

Work a piece of clay, roughly the shape of the fin, around the wire.

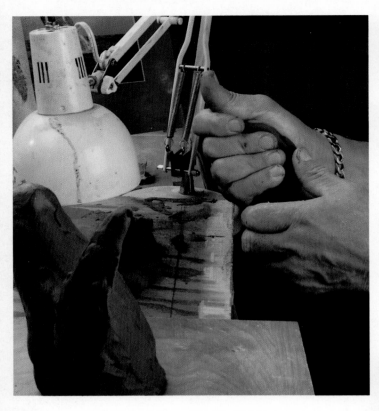

Shape the other fin.

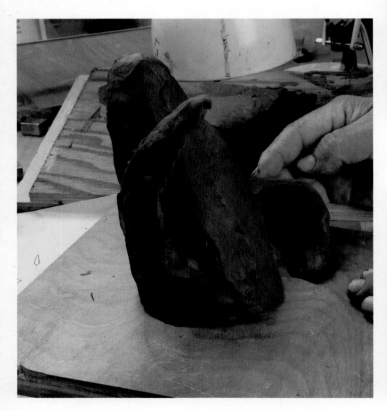

This fin is supported at both ends and does not need and armature.

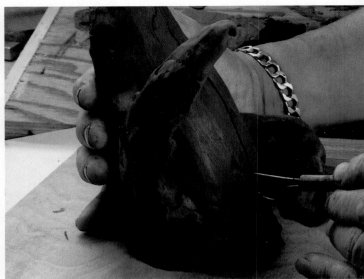

When the general shape is established, let it get back to room temperature, and apply details like the ventral grooves. The clay is firm, but pliable enough to allow for refinements.

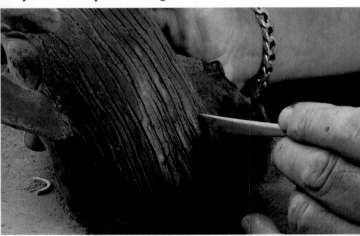

Continue to refine, using the tools that work best in a particular spot.

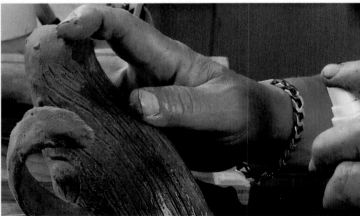

A spray of kerosene or other oil-based product softens the clay just enough to smooth it.

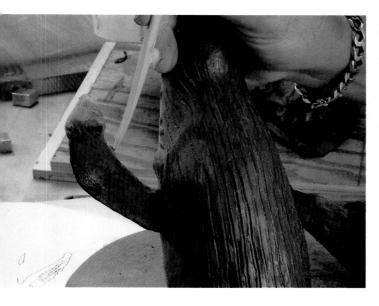

Refer to drawing and other resources, then add details like the bumps along the leading edges of the fins.

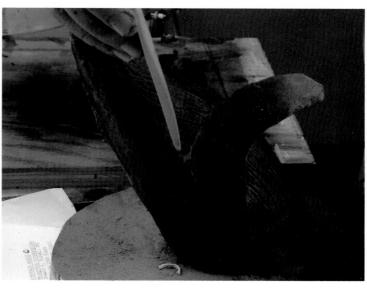

Add the eyes...

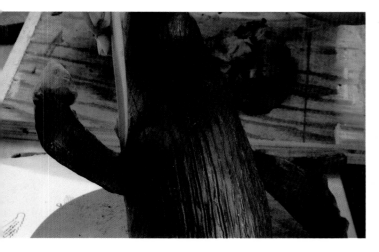

Be sure the origins of the fins are at symmetrical points in the body...

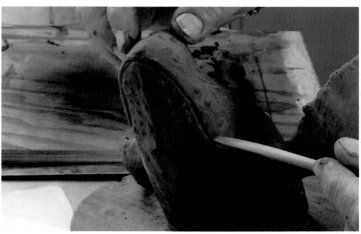

the line of the mouth...

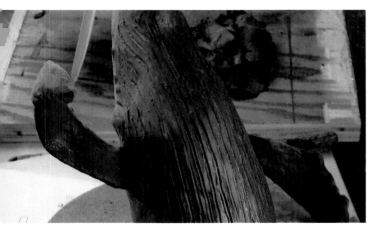

and that the fins are equal and at a correct length.

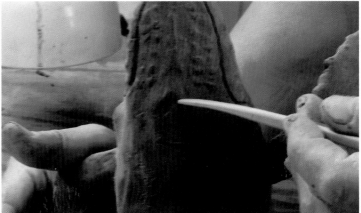

and the bumps and ridges of the top of the head.

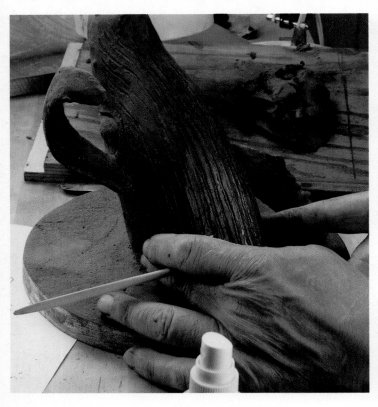

A final check...

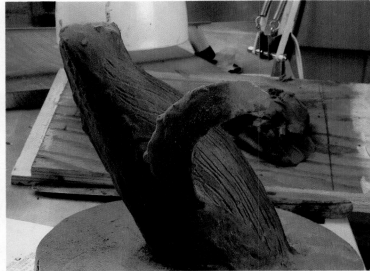

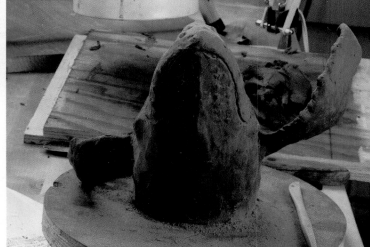

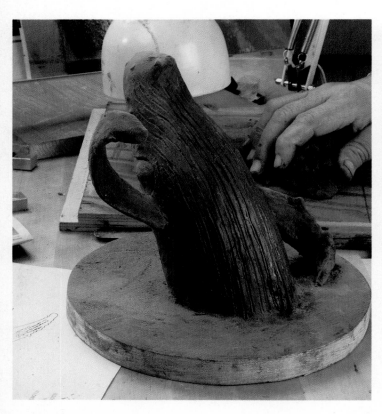

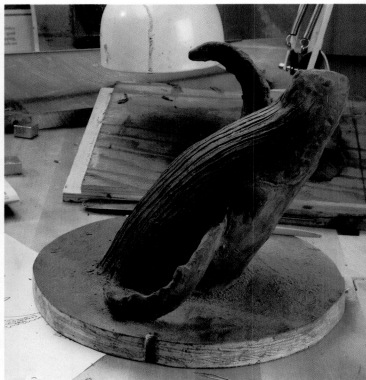

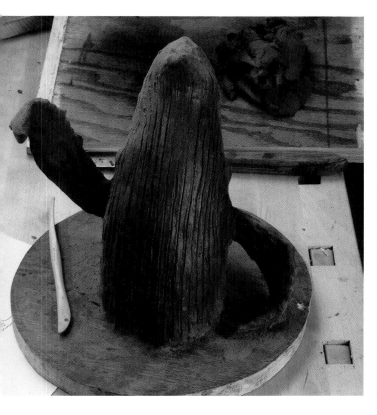

and the clay model is ready to use.

SCULPTING THE HUMPBACK

I've chosen a piece of walnut that has been on the ground for about four years. This is because I don't like to cut down live trees. You also get a darker color from a tree that has been on the ground for awhile. It is cut at a slight angle because the breaching whale is at an angle. After I cut the wood I seal the end grain with Sealtite 60™ or a latex paint. I have added a 2 x 4 to the bottom so I can secure the piece to the table for the rough cutting.

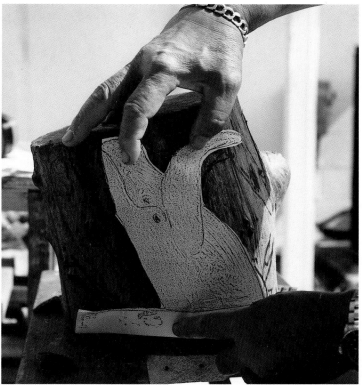

The pattern goes on like this and is traced.

I'll leave an area here at the front for the left fin of the whale, which will wrap around to the front.

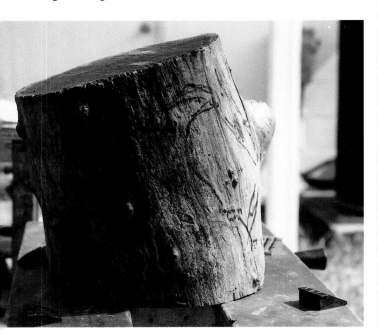

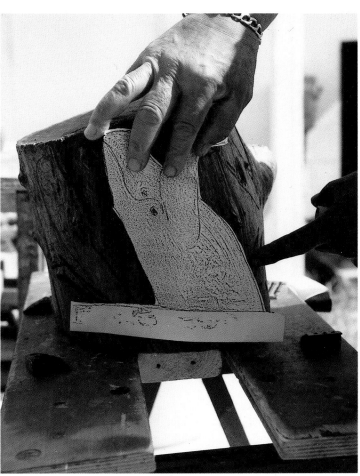

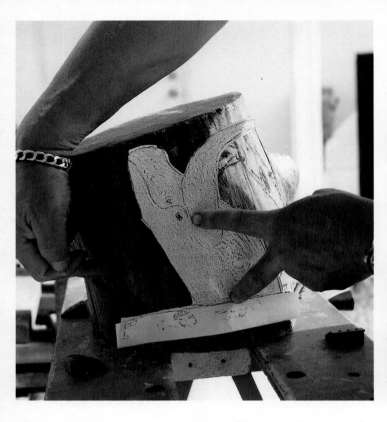

At the back and all around there will be waves. Leave wood for it.

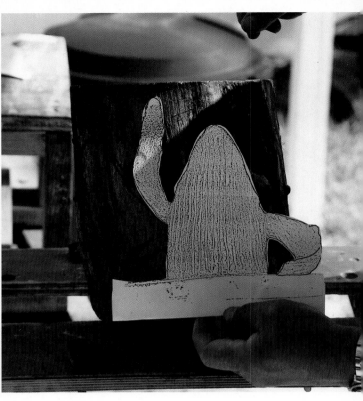

The front pattern. I don't draw it in, but it is important to get a feel for how it will look before I do the rough cut, and to make frequent reference to it.

Make sure that the top view fits on the wood.

I'll begin by cutting off the lump that's on the side of the log.

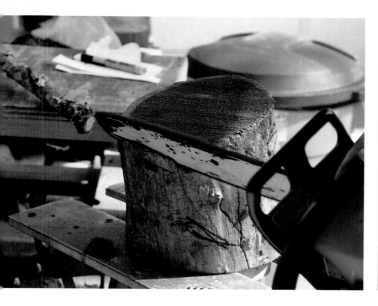

The first cuts are the toughest for me because I don't want to take off too much. I usually take small cuts until I establish the basic shape. Begin by cutting the angle of the whale's back.

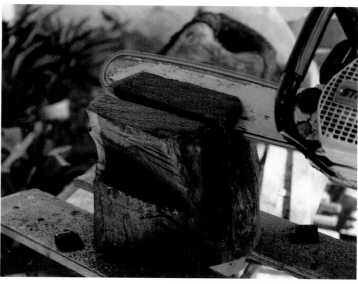

Take out a wedge between the underside of the head and the top edge of the raised fin using small cuts.

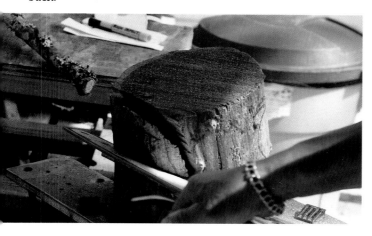

Come back to that cut at the angle of the wake.

Progress.

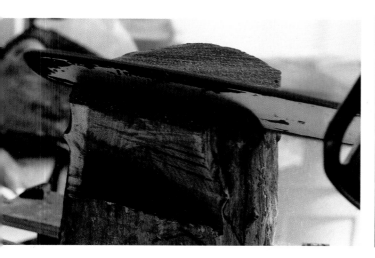

Here you can see the result. Now I continue to rough cut down the underside of the head.

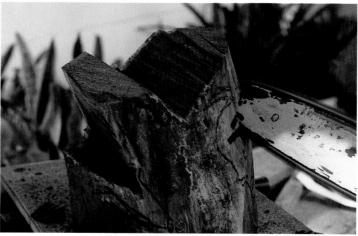

Come in under the fin. You are just creating the basic line, so don't take away too much yet.

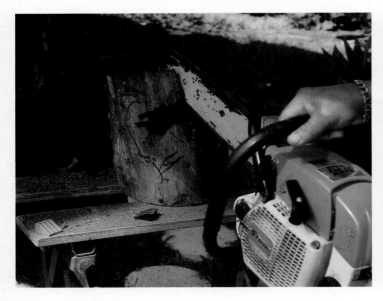

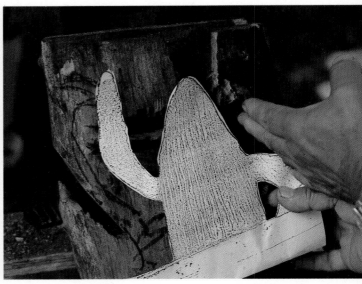

Next I want to establish the center. This will define the raised right fin.

I want to cut off this area beside the body and over the lowered fin. I'll cut down this way...

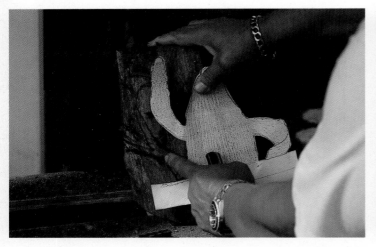

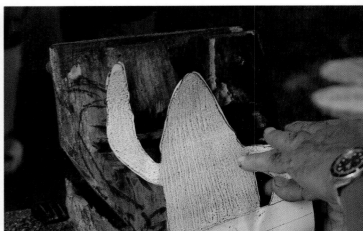

Holding the front view against the wood, I can see the shape of the fin and where I need to come into the side of the body.

and back in from the side.

Make a cut that establishes the line of the underside of the raised fin.

Working from the head side of the carving, cut down the sides of the head...

and in over the lowered fin. Again, this is only a rough cut; don't take away too much!

By checking with the clay model, you can see how the form is beginning to emerge from the wood.

Cut away the block on the other side of the head, coming in from the side...

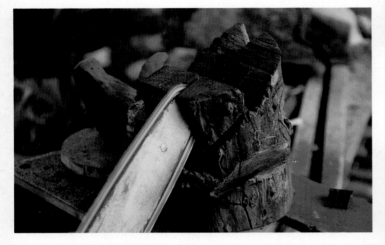

and deepening the cut along the side of the head. The chunk may not fall off yet, but be patient.

Cut away the mass in front of the left shoulder and over the lowered fin.

I'm making the final removal of the pieces with a chisel and mallet.

It doesn't look like much yet, but the whale is beginning to come out of the wood. This is the view from the front of the head...

this from the side of the raised fin...

this from the top of the head...

and this from the other side.

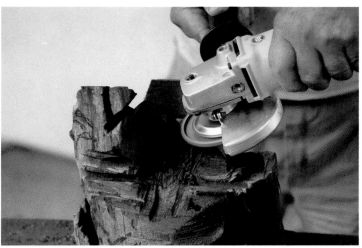

A power grinder allows me to take away more of the rough wood, while giving me more control.

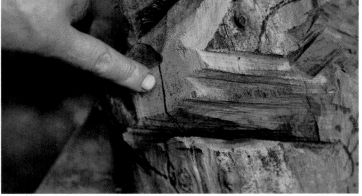

I have discovered a crack in the wood in the area of the lowered fin. It may or may not penetrate into the final carving. If it does I'll talk about fixing it later.

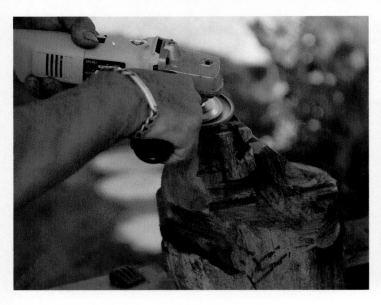

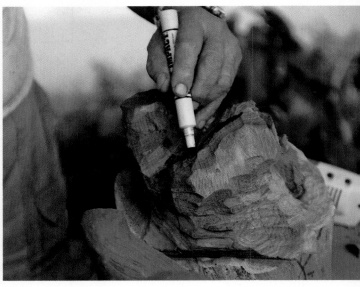

Refine the rough carving with the power grinder.

Redraw the plan view lines of the raised fin...

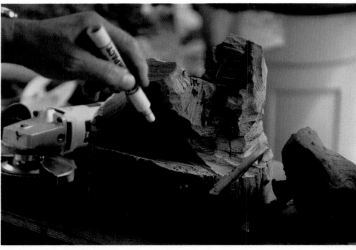

With this tool you have enough flexibility to set the rough contours of the whale.

Make continual reference to the clay model and to the drawings. This will keep you from being too aggressive at this early stage.

the center of the head...

and the lowered fin.

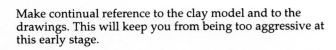

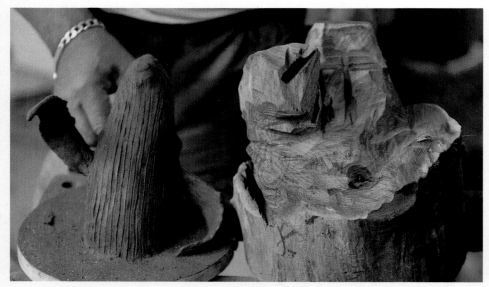

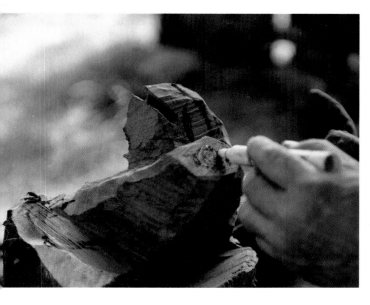

The point of the head is somewhat blunted, so darken an area that will be conserved for this.

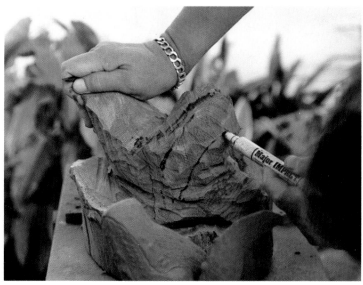

As the waste is reduced, mark the profile of the raised fin...

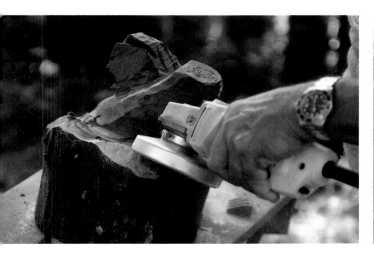

With the grinder you can reduce the wood around the lines you have just set.

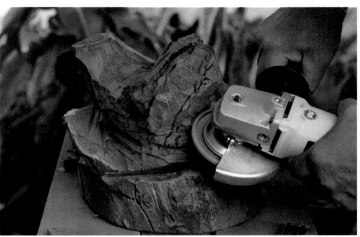

and remove the wood beneath it.

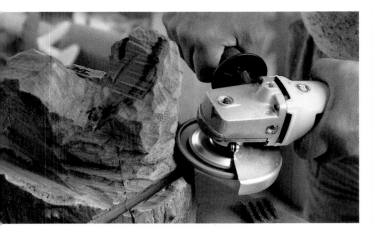

The edge of the grinder can effectively cut some of the deeper contours.

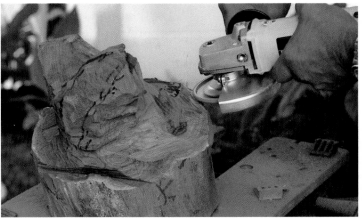

Remove the wood around the lowered fin, but don't go too deeply into the log.

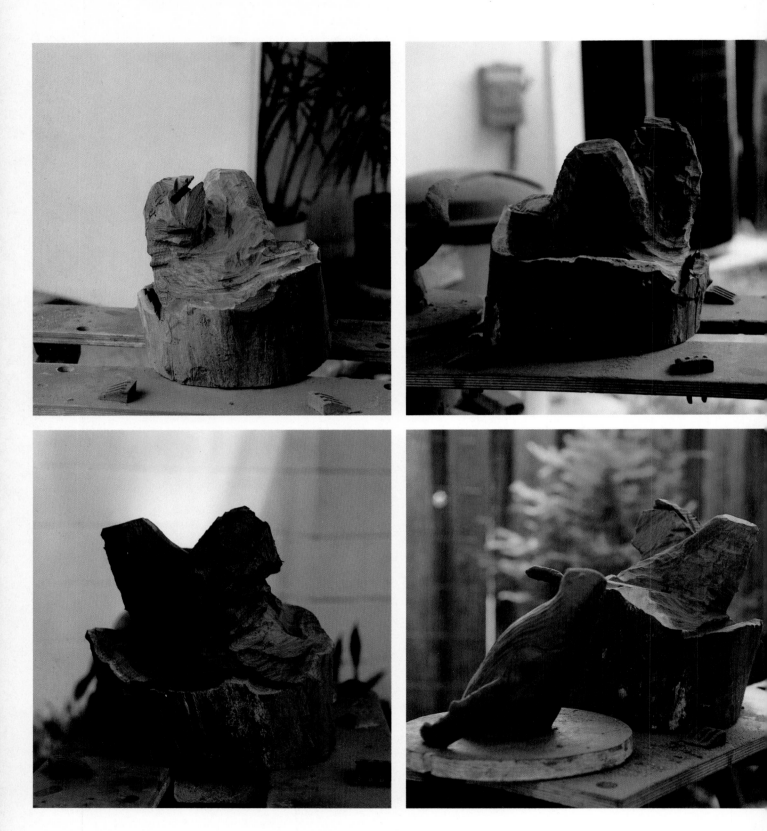

The rough cutting is done.

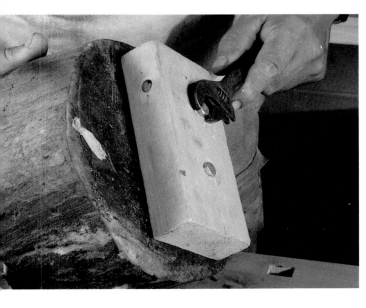

Remove the holding block from the bottom.

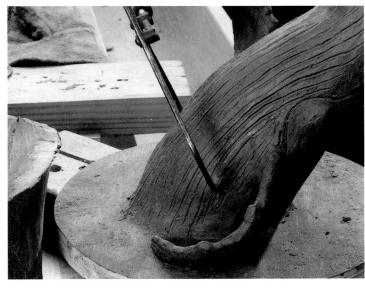

Measure the bottom of the body...

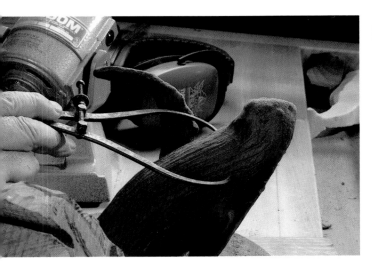

Transfer the measurements from the model...

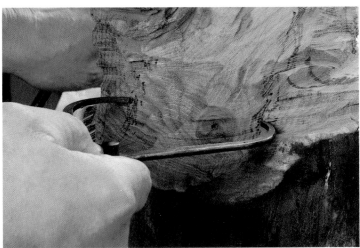

and transfer it to the wood

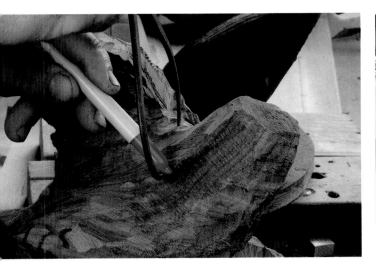

to the wood, using calipers and marking.

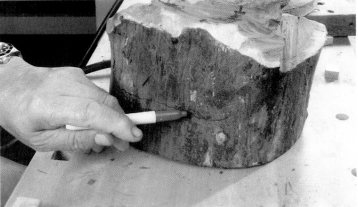

With the model propped up to the same height as the sculpture, I transfer the ocean level. This is the level of the board on which the clay model sits. Remember the wake created by the whale will be higher than the ocean level.

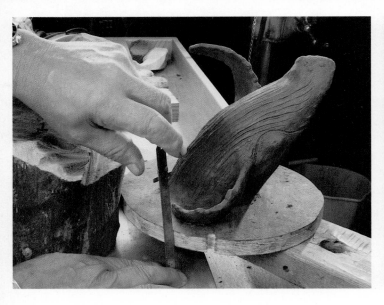

Measure from the table top to get an approximation of where the fin comes off the body.

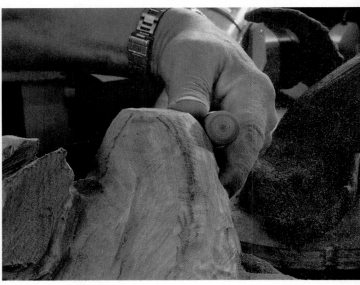

Don't work in one area too long. Keep moving around the piece.

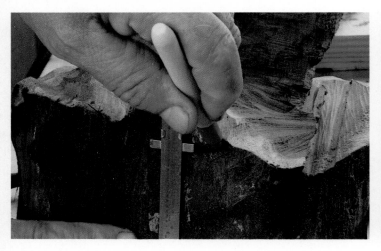

Transfer the approximate height to the wood.

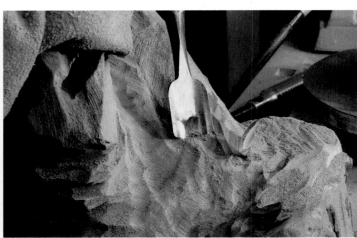

You may find that another tool will do as well or better. This is power chisel removes a lot of wood quickly.

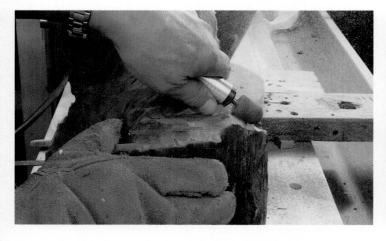

Begin to reduce the size with a 3/4" silver Kutzall ball-end cylinder.

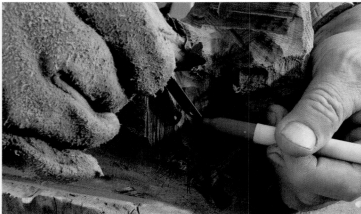

Take a measurement from the model of the origin of the front edge of the right fin.

Continue to take away the waste wood, working down to the correct shape.

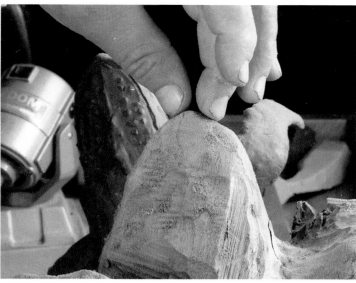

The top of the head is straight coming to a point. The surface is basically flat.

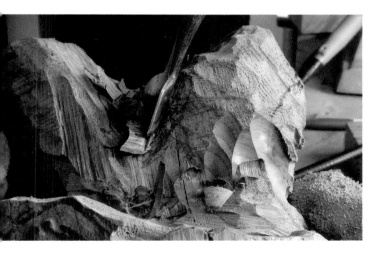

Work into the crotch of the fin.

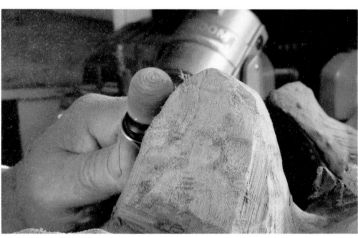

Continue to refine the shape.

I don't know yet where the origin of the fin will be on the body, but I know enough to rough it out.

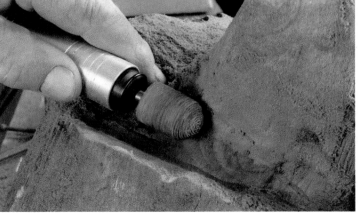

I need to get at least deep enough to take away the saw marks.

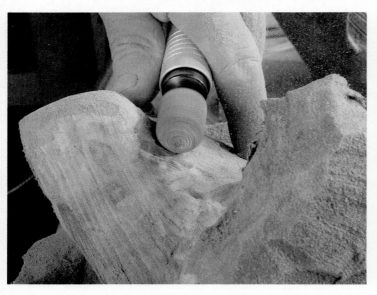

Move to the underside of the head. I am just beginning to shape the chin.

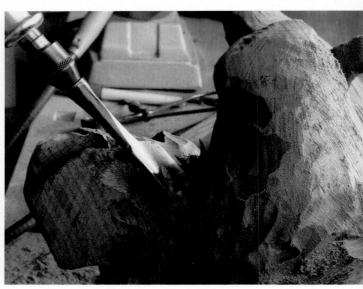

Open up between the fin and the head.

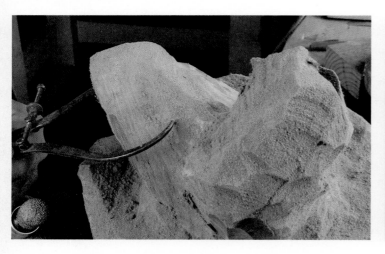

Check your progress often, using calipers to compare the carving with the clay model.

Shape the lower body. Here I start to open up the area between the body and the lowered fin.

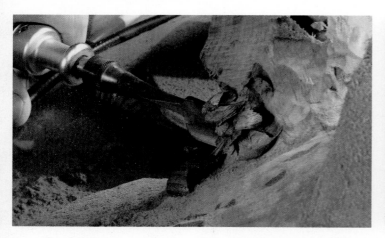

Carefully begin to take away the underside of the raised fin. I still don't know where it is finally going to be situated, so I don't want to go for the final shape yet.

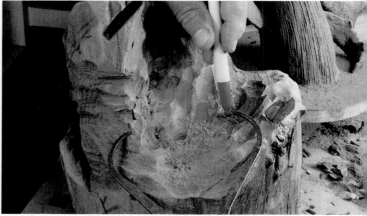

As I progress, I constantly stop to measure and remark the body lines I have removed.

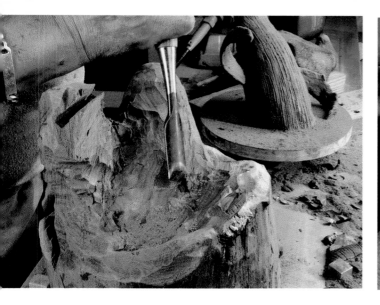

I switch to a flatter gouge to continue shaping the body.

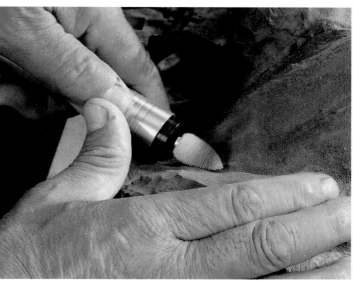

Switch to a pointed Kutzall to get into the deeper areas like here between the body and the fin.

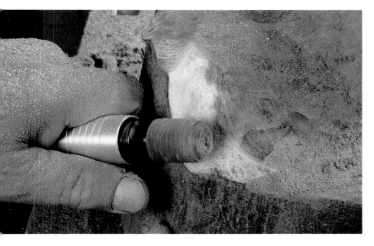

The white wood is sap wood. Because the tree was on the ground for four years, the sap wood is rather punky. In the living tree this was the part through which water and nutrients were transported. It was more porous and, therefore, more prone to insect infestation and rot after the tree died.

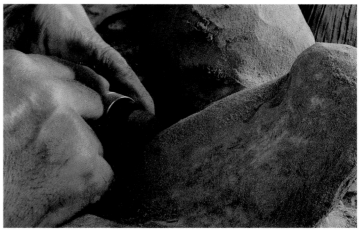

and on the other side.

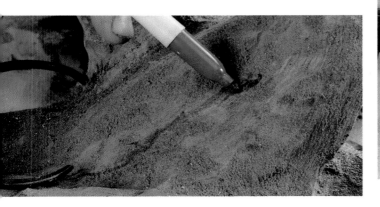

Again, remark as you carve.

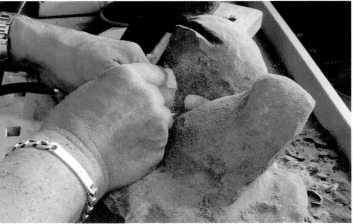

Continue moving around the piece. You don't want to work too long in one place. Be sure to leave wood for the eye and for the various bumps on the back.

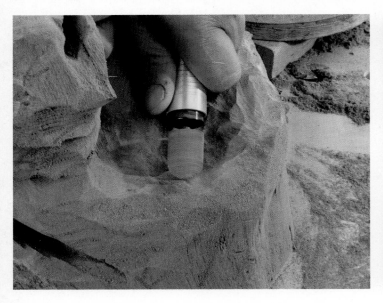

Return to the round end cylinder cutter to remove the wood inside of the lowered fin.

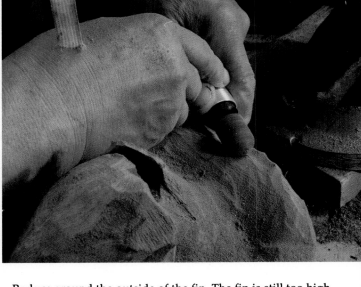

Reduce around the outside of the fin. The fin is still too high, but it is easier to define the lateral margins before cutting it down. Continue around. You may be tempted to do this with a chain saw, but my experience is that the chain saw is too aggressive for this, and that it is better to take the time to go gradually.

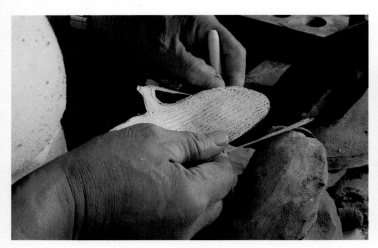

At this point I need to use the pattern to get a better feel for the lines of the fins. Holding the top view pattern above I mark the outline...

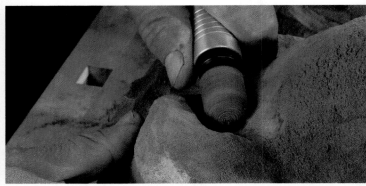

Deepen the outline of the fin.

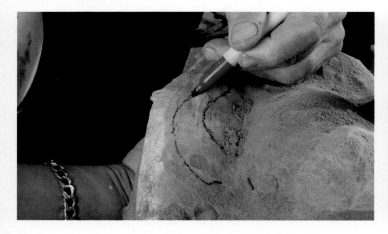

for this result. This is still just an approximation, but it helps me see how far I need to go.

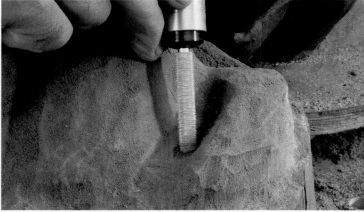

As you go deeper you will need to switch to a narrower cutting cylinder.

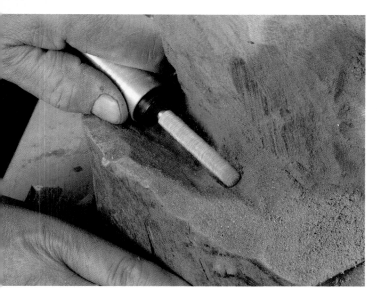

With this same cylinder you be begin to form the wave around the body.

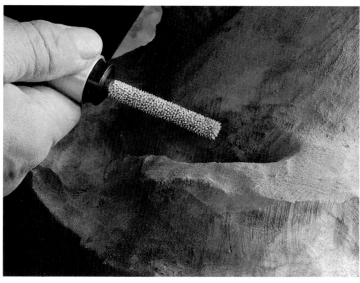

Blend the body into the spaces.

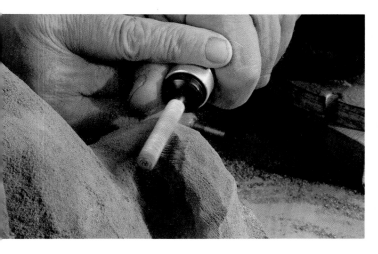

Begin to lower the top of the fin.

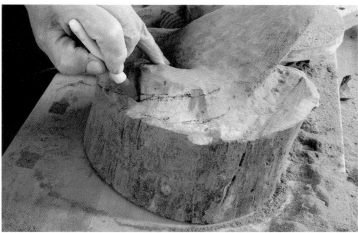

Mark the angle of the top edge of the lower fin. As you can see I have a long way to go.

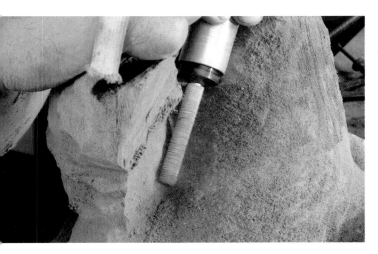

Deepen the spaces between the fins and body.

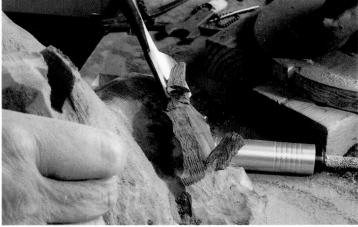

The power gouge takes away this excess wood easily.

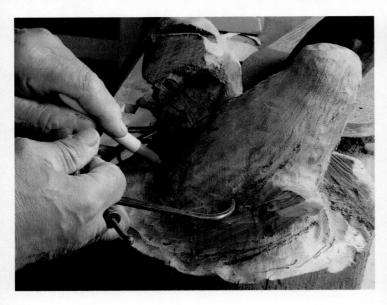

Measure and remark the body. I am getting a lot closer to the final size.

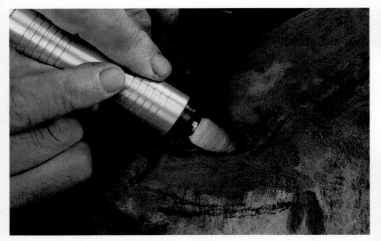

Cut along the side of the body to reduce its diameter to the line you have drawn.

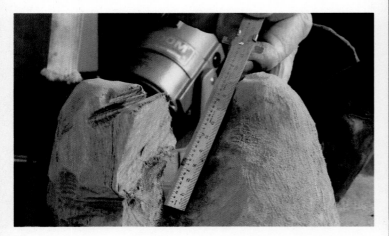

Reestablish the distances from the nose to the origins of the fins. The left fin needs some adjustment.

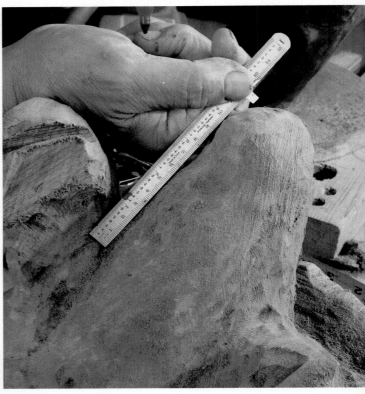

Switch to a fine taper to get deep between the body and the fin.

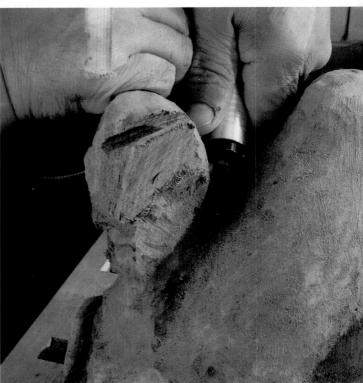

Much better.

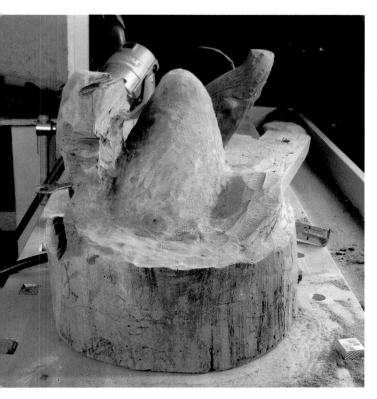
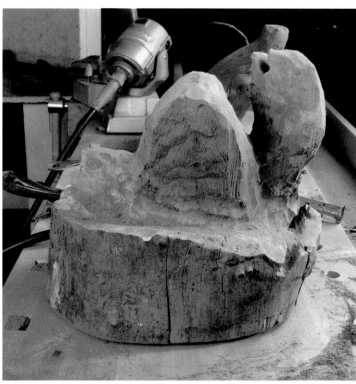
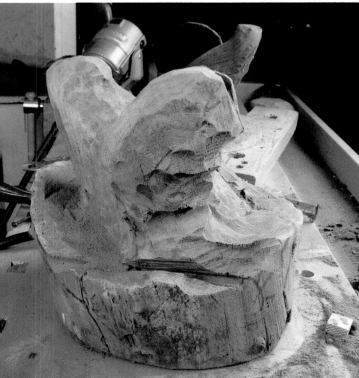
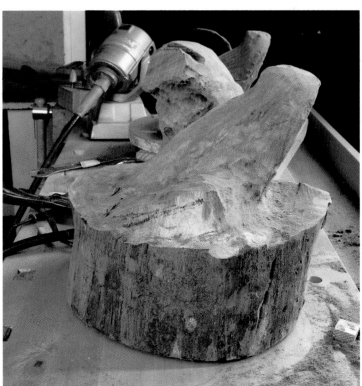

Progress.

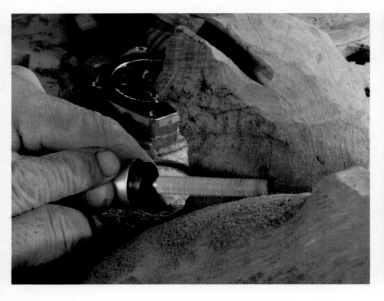

Shape the under side of the fin.

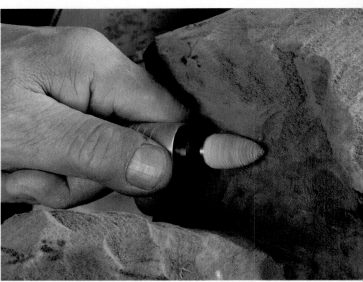

Switch to a pointed tool to cut between the body and the wave.

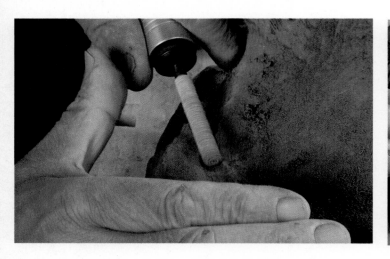

Reduce the area under the fin and the lower body.

Progress.

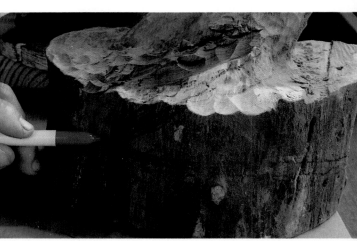

I still have a long way to go. The fin needs to go down to here or a little lower.

Take the outline of the fin down to the ocean line, but don't undercut yet. You want to wait until the final decision about the position of the fin.

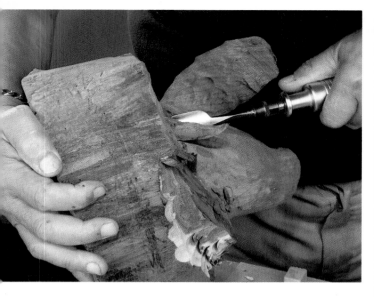

Continue on the body, exposing more body as you cut to the water line.

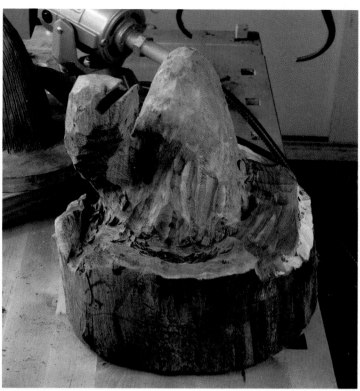

Progress. Things are still a little fat.

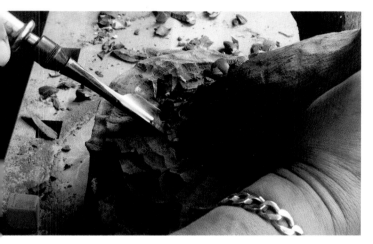

Work the water back toward the body, remembering the wake that the whale is making. This is going across the grain and can be pretty rough going. Be patient.

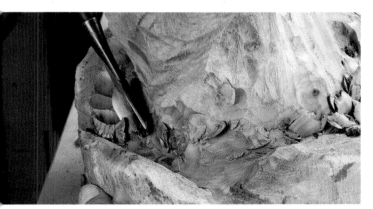

Continue around the back. The saw mark I made with the chain saw in the first roughing out process gives me a level to seek.

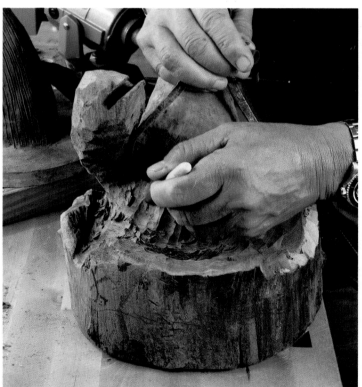

I need to redraw the line for the width of the body.

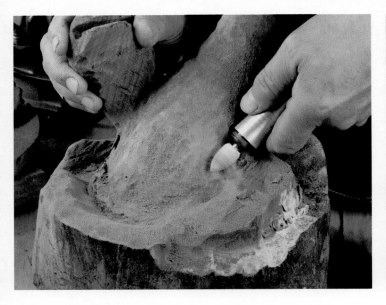

Switching to a rotary grinder, I can take off some more body width.

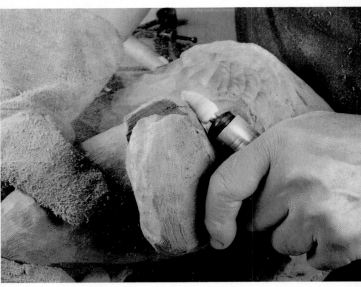

As you narrow the body you also narrow the fin. This helps keep everything in proportion.

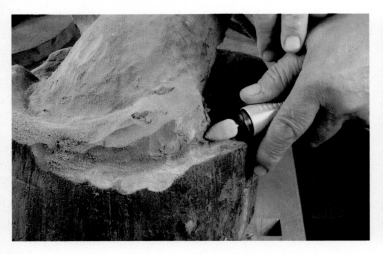

I can also refine the outline of the fin and bring it lower.

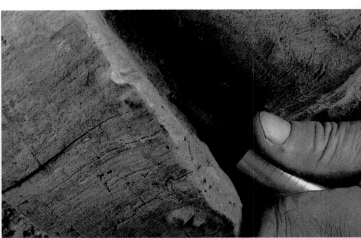

Continue to work toward the proper depth, I need to switch to a narrower bit to get at the back of the whale.

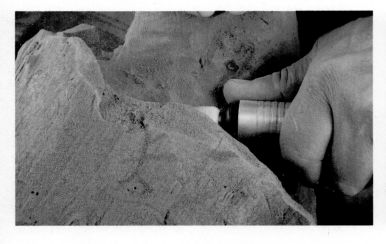

Remember to keep moving around. I'm trying to get the body down to the water line.

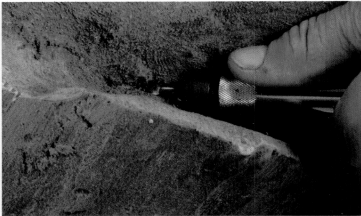

A small flame-tipped steel cutter gets in even further. This is in a #8 type holder, which is narrower and can get in deeper.

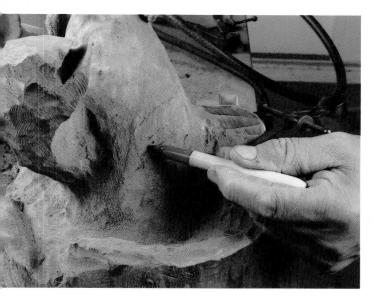

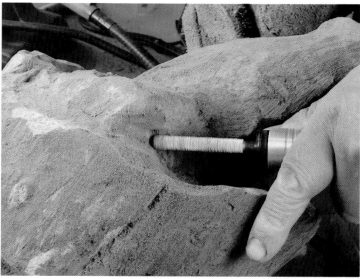

Again I need to do some more thinning. This is a long process and cannot be done all at once. With the back carved down to the water line, this time I can measure the model from back to front with the calipers and use that to get an idea of how much to remove from the belly of the carving.

Begin to establish the general position of the lowered fin. With undercutting I'm trying to bring it parallel to the line of the body.

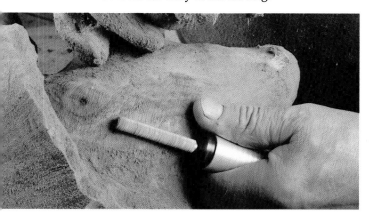

A roll-type cutter reduces this area well.

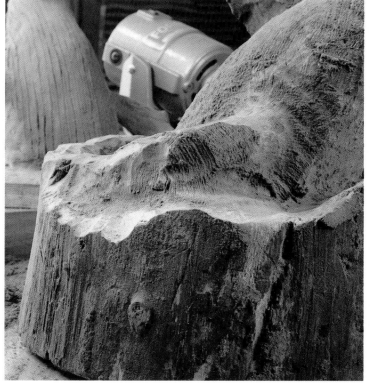

The lowered fin is becoming delineated.

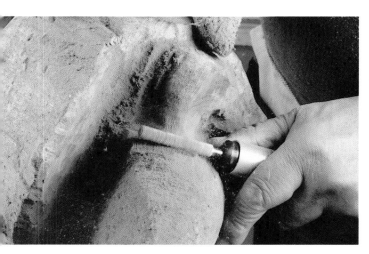

At the same time I can reduce the width.

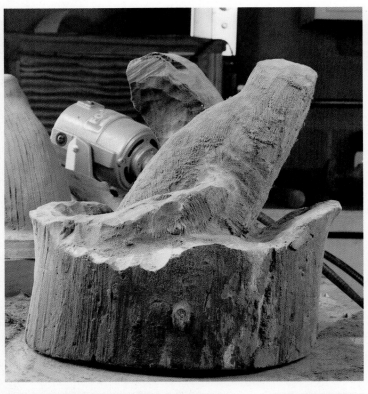
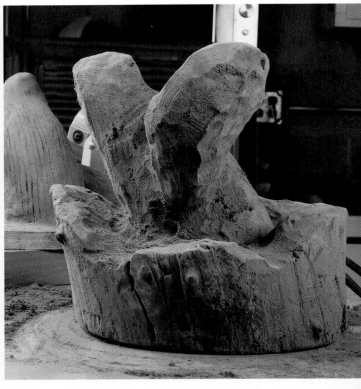
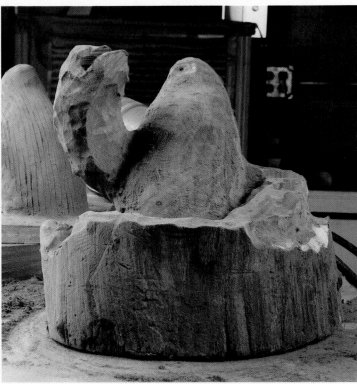
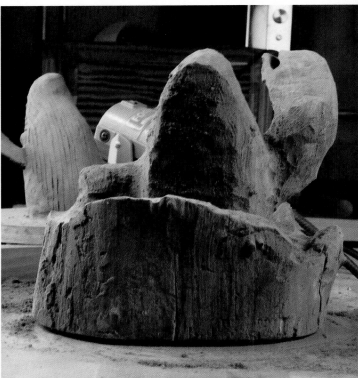

Progress.

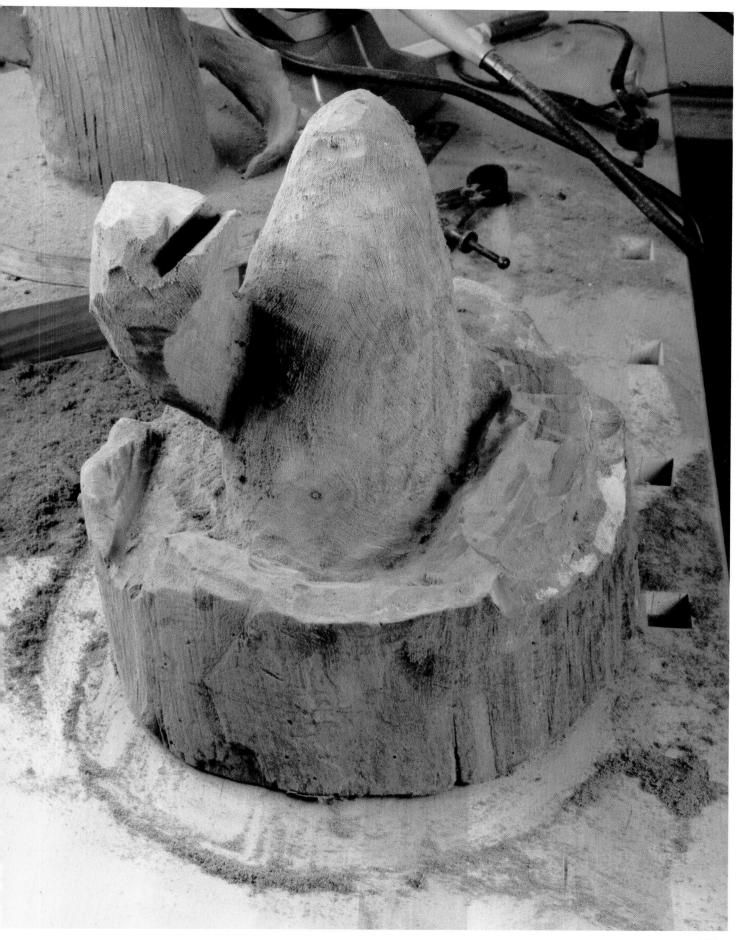

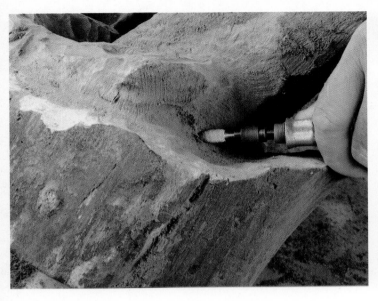

I've switched to a smaller cutter to get into the crevices. I'm not married to a particular cutter. Instead I use the one that will work in a particular circumstance.

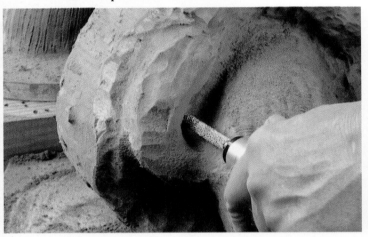

Shape the inside of the lowered pectoral fin.

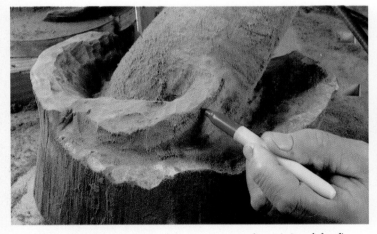

Measure from the tip of the rostrum to the origin of the fin and compare with the model. It needs to come down just a little more. Mark the level.

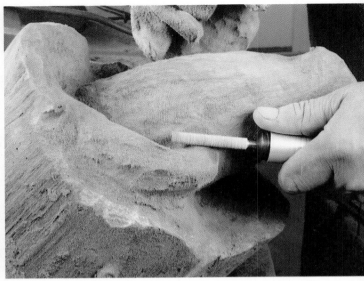

Bring it down gradually. It is better to leave too much wood than too little. I cut back like this to determine the attachment position of the pectoral fin. Don't thin the fin for now. I still have work to do on the belly and its final dimension will determine the line of the fin.

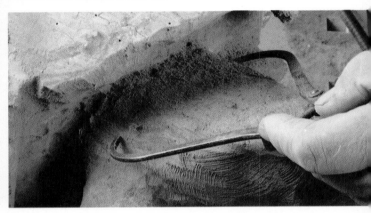

Transfer the width of the back from the model to the carving. I'm a little wide, so I can afford to narrow it down.

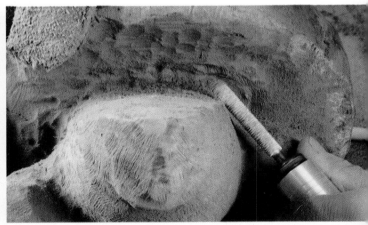

Narrow the body. The back of the head stays flat and sides round into it slightly.

Take a measure of the front of the head from the model and transfer it to the carving.

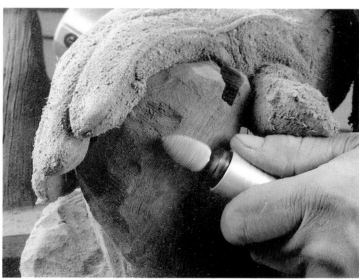

As I get closer to the final body size, I can begin to take away some of the excess wood around the raised pectoral fin.

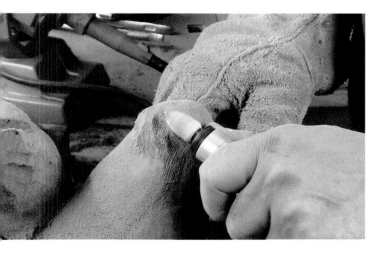

Carve it. The head comes to what can best be described as a blunt point. I have tried to maintain the basic shape throughout the carving.

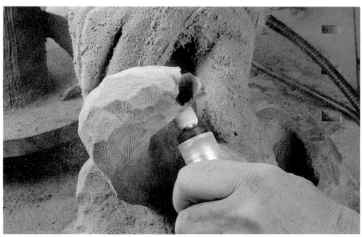

With the line emerging, I can finally get rid of the lobster-like claw that has been bothering me from the beginning. Before the final lines became clear I couldn't remove it for fear that I might need the wood for the fin.

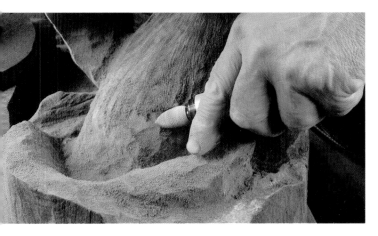

Again come back to the belly and trim some more.

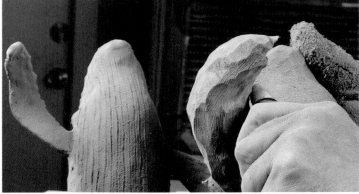

I'm working on the undersurface of the fin to establish the general shape and contour.

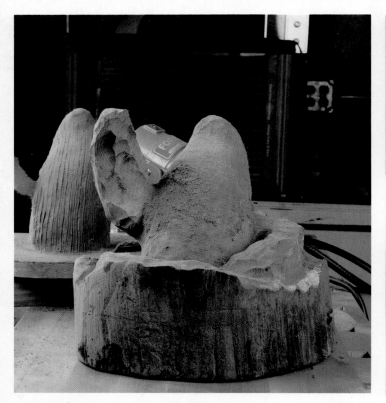

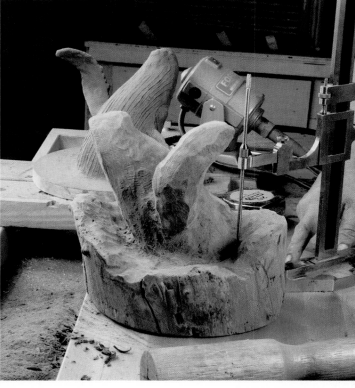

This is an army-surplus depth gauge. It sits on the table and reaches in so I can be sure the depth of the carving is relatively the same around the whale at the water line.

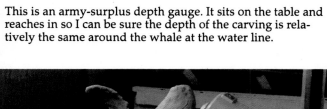

Progress.

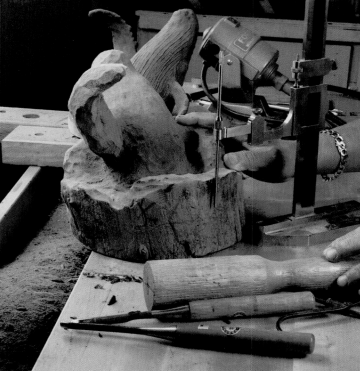

It can also be used to set the water line evenly around the outside of the piece.

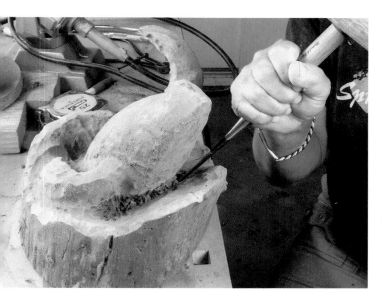

I switch to a gouge to get into the acute angle between the back of the whale and the water. You can't get the measuring device in the middle of the back, so set the two sides and work between them.

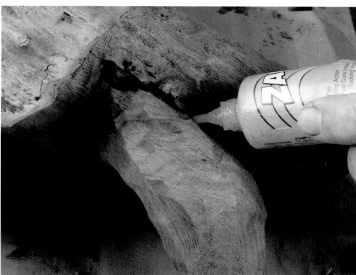

Apply a liberal dose of glue to the crack and let it dry from 10 to 15 minutes.

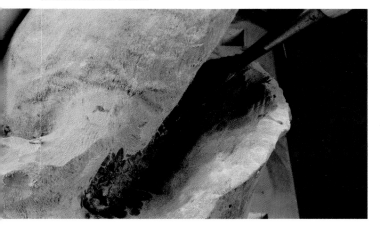

This is getting pretty close to the final level.

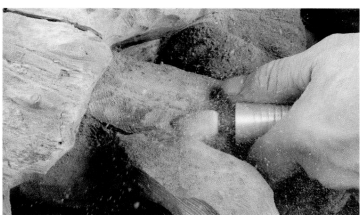

When the glue is dry you can cut the excess away. I usually apply glue several times to the same spot as I trim away more wood.

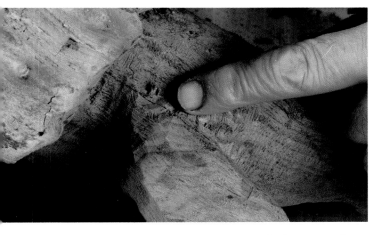

I have a crack here at the base of the fin, which you may have noticed earlier. It could cause structural weakness so I'm going fill it with cyanoacrylate glue (super glue). I use the thin kind that soaks into the grain.

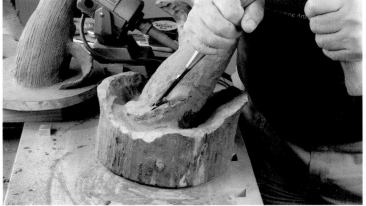

The origin of the lower fin is correct, so I can begin to define the slope.

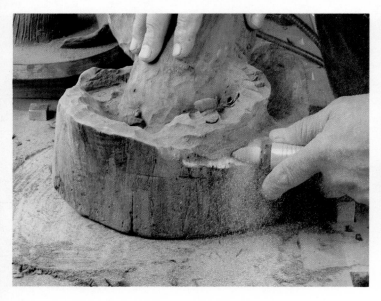

I go back to power tools to bring the side of the fin down to the water level.

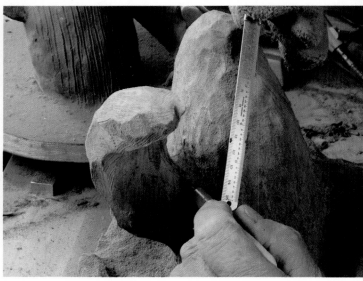

Measure the origin of the raised fin on the model and transfer it to the carving.

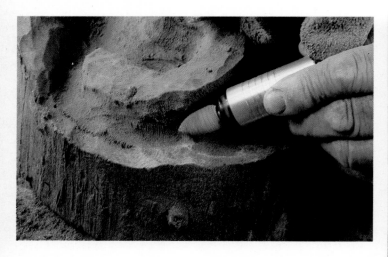

Define the outer margins of the fin. While I'm going in a little, I'm not quite undercutting yet.

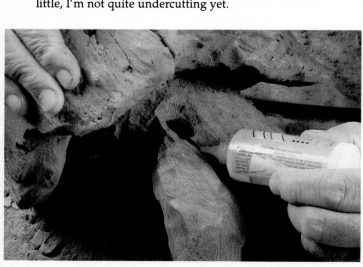

Apply a second coat of glue to the crack.

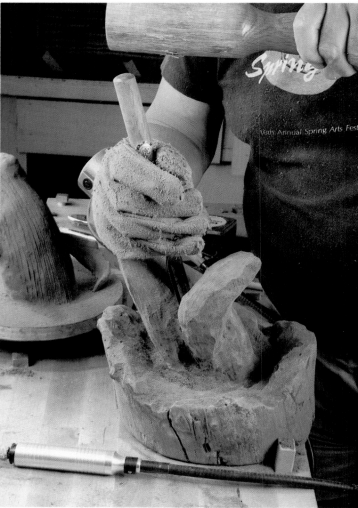

The acute angle between the fin and the body makes it a good spot to use a hand gouge. This is a fairly flat gouge with about a #2 curve.

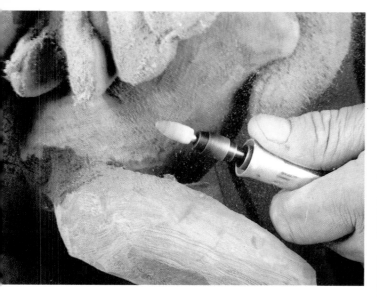

After working on it with the hand gouge, it became clear that the pressure might be too much for the fin, so switched to a narrow rotary bit.

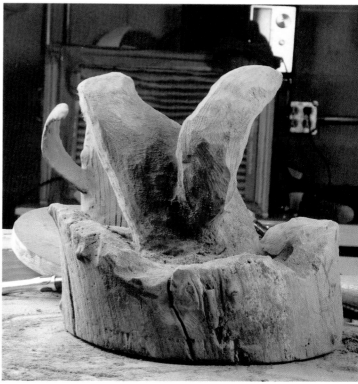

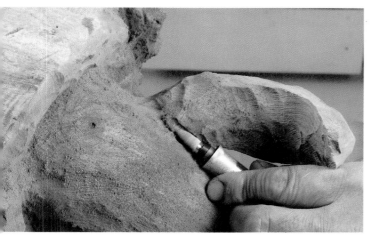

The fin is a little too far forward on the body, so I take away from the underside to move it back.

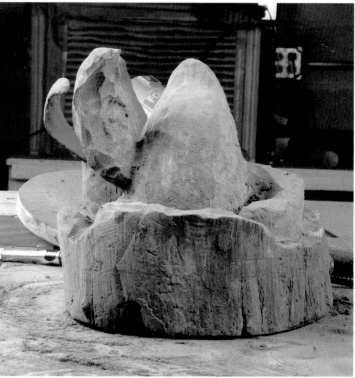

Progress.

Gradually the fins are made thinner and thinner.

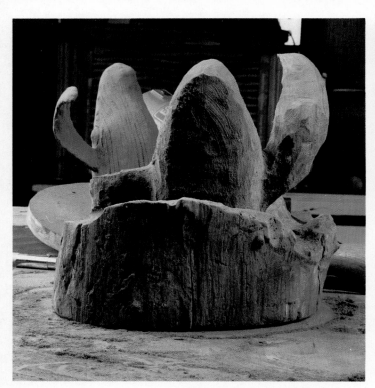
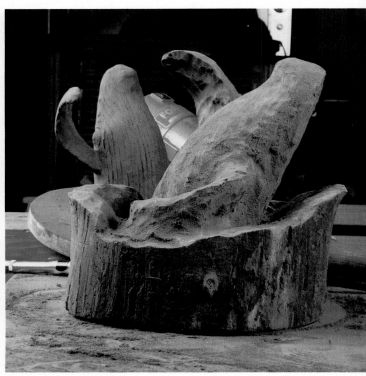
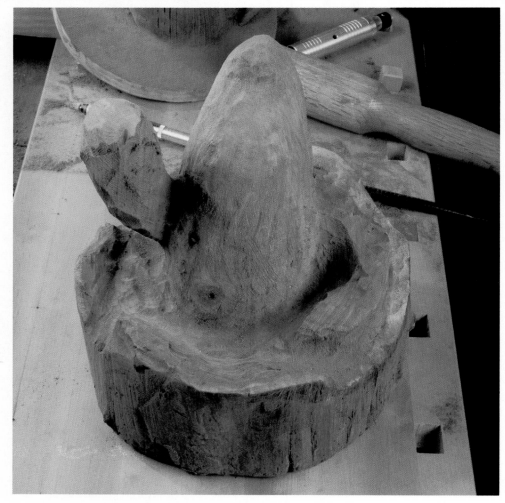

Progress

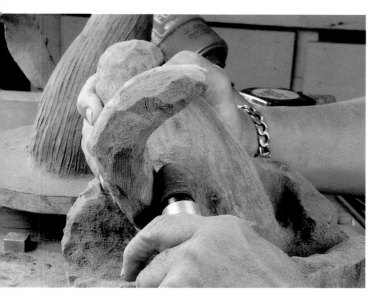

Now that I am pretty sure where I am going, I can switch to a more aggressive cutter to get there faster.

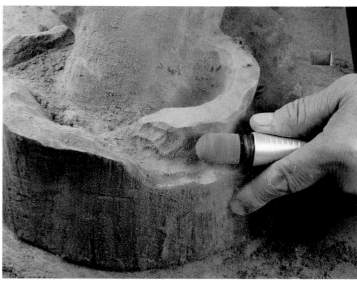

Shape the lower fin. This may not be the final shape, but it will be a lot closer.

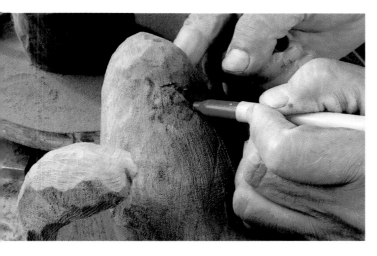

I've checked the dimension under the jaw and found that it needs to be thinned.

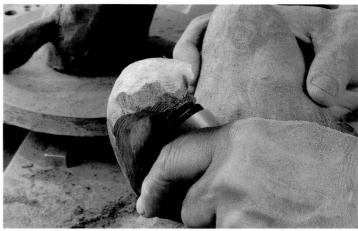

The same is true of the raised fin.

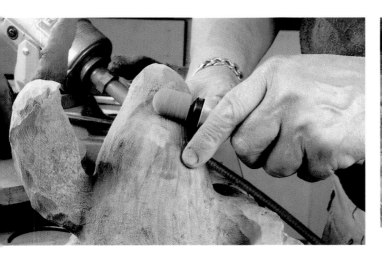

This can be done with the same cutter.

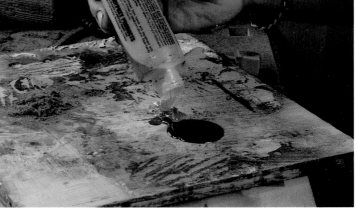

There are several cracks in the base that need to be filled before I carve the water. I use a slow setting two-part epoxy mixed with dust from the grinding.

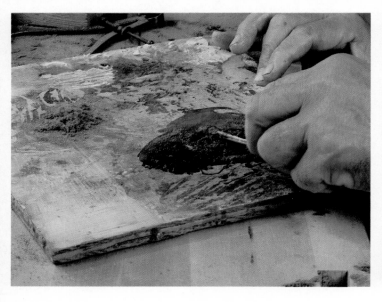

Mix the glue thoroughly first, then add the dust. Like a Chinese cook, I add it until the color is right.

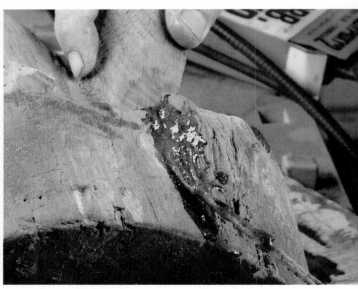

As it settles I add more glue. I keep an eye on it for the first hour or so, adding more as necessary.

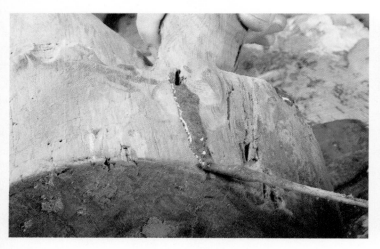

Work the mixture into the crack. Because it is slow-set epoxy it will flow into the crack before setting up.

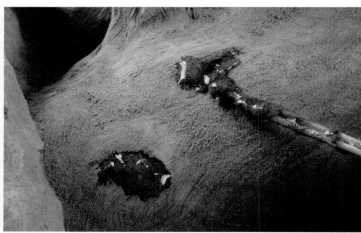

The same mixture can be used to filled blemishes. These are the pith of branches that grew out of the original tree trunk.

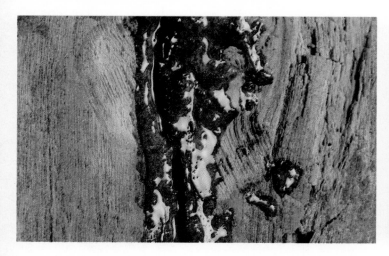

Here you can see how it settles.

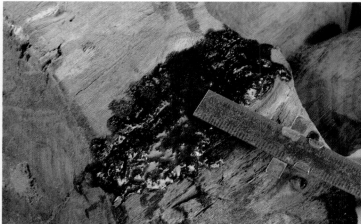

In the morning light, the mixture has set and is ready to carve.

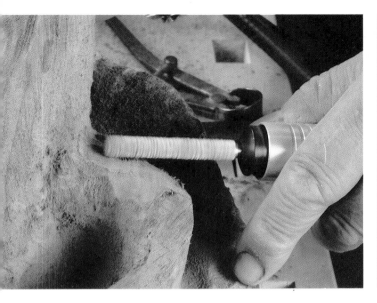

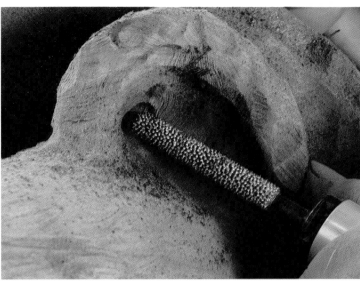

The lowered fin needs to be a little further back on the body. There are some things you can fudge, but the distance from the top of the head to the origin of the fins has to be accurate because the placement of the eyes is dependent on it.

On the bottom edge, thin until you create a hole. I could have used a drill, but this way I have much more control.

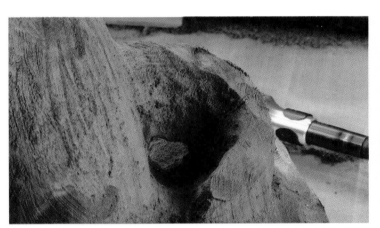

With the origin set, I can begin to thin the fin to its final thickness. Looking at it from the side I see that it is too far toward the back, so I'll reduce it from the back side.

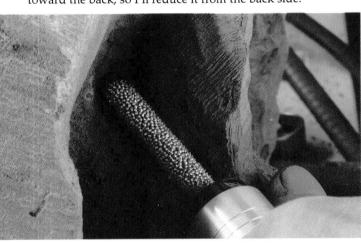

Finally I can undercut as I shape the pectoral fin. I've waited until now to be sure the fin was in the right position.

Progress

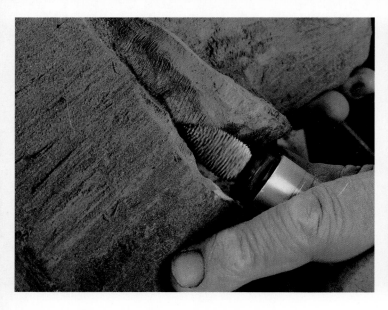

Continue undercutting around the side of the fin. The flame cutter lets me get under here nicely.

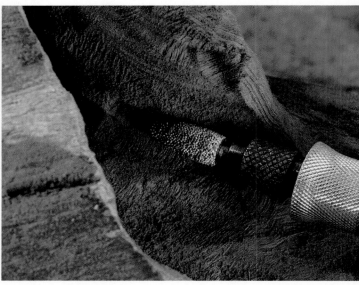

Gradually shape the back of the fin so it is in alignment with the body. The origin of the fin is on the horizontal line of the body.

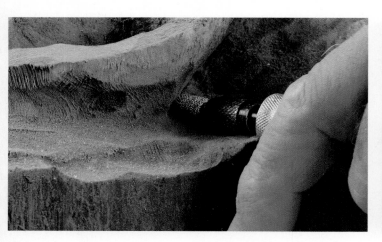

Switch to a smaller bit to get deeper under the fin.

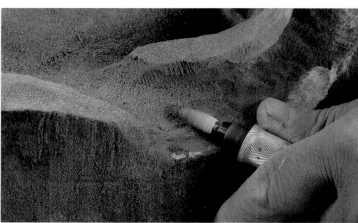

Bring the water line down. The fin is coming out of the water, so the water will not be flat. Instead it will have waves that show the effect of the motion. These will develop as I carve.

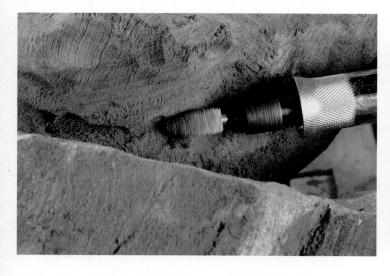

Shape the body to blend with the opening.

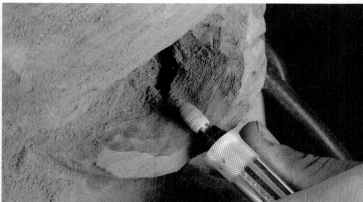

Continue thinning the fin. I don't want to work on the end yet so I can set the right length of the fin during the final sizing.

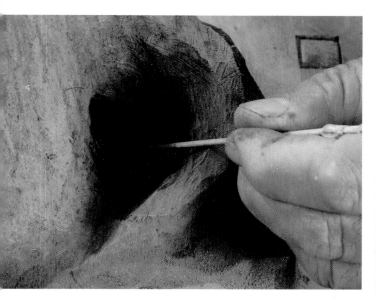

Sometimes as you are carving you will hit a spot that is somewhat rotted and soft. I harden these up using epoxy, usually the slow-drying variety. For photography purposes I've used a 5 minute variety.

Tip: if you get epoxy clogging your cutting tool, soak it in lacquer thinner for a few minutes and then brush it with a wire brush. **Be careful though!** Breathing the fumes of lacquer thinner will damage your liver much faster than whiskey. Use only in well-ventilated areas and avoid breathing the fumes as much as possible.

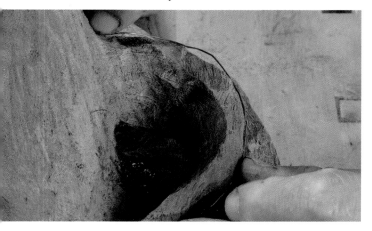

To establish equal lengths for the fins I use a length of wire to measure one...

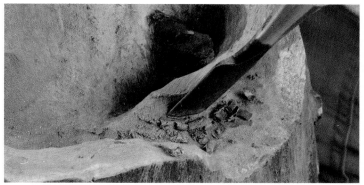

Clean around the fin with hand gouges.

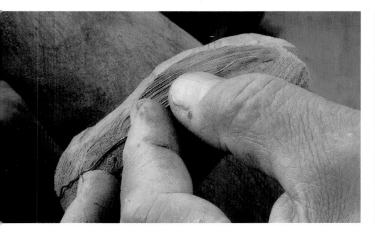

and transfer it to the other. I'll need to take a little off the right fin.

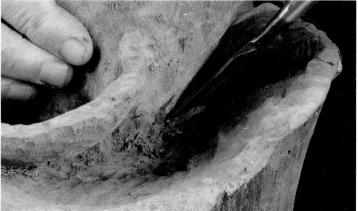

This area behind the body is hard to get at. It requires slow, tedious work at every stage.

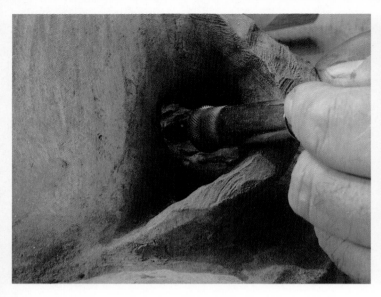

The body is still fat under the fin, so I'll reduce it with a flame cutter.

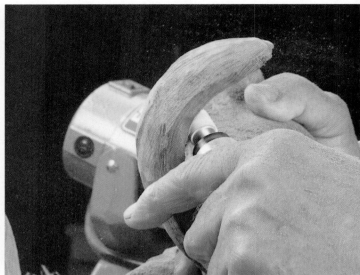

While thinning the raised fin, I want to give it a nice artistic, yet realistic, curve.

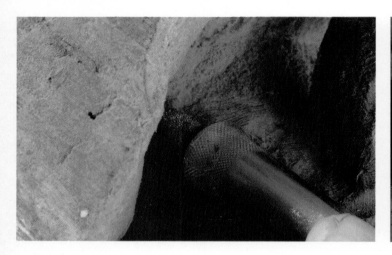

Now that things are opening up I can begin to round the upper sides into the back. Before this I didn't have access.

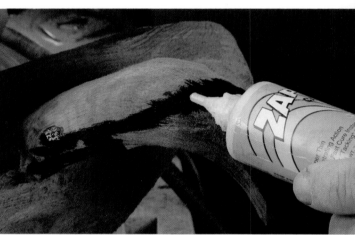

Before thinning this raised fin further I want to reapply super glue to the crack. I may do this several times in the process of carving.

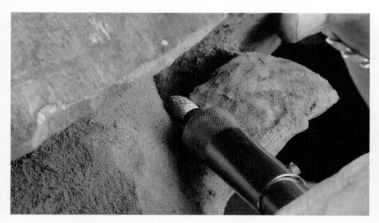

I still need to work on the fin origin so it goes with the line of the body. At the same time I work on the taper of the fin so it comes to a thin edge at the back.

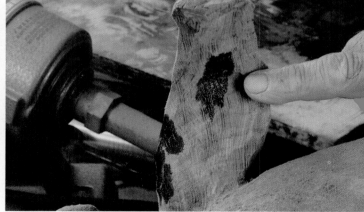

The glue followed the crack through to the other side.

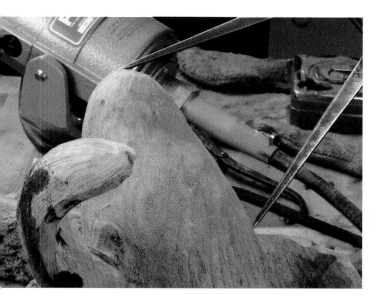

While I wait for the glue to harden I'll measure the origins of the fins again, this time with a caliper.

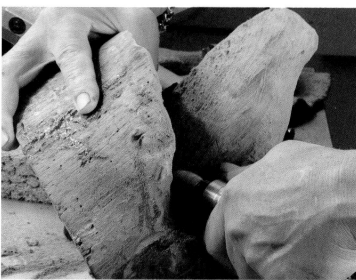

Looking straight down the body I make adjustments for symmetry. They are minor and might not be necessary if they didn't mess up the line of the fin.

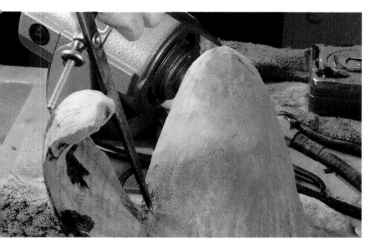

The raised fin still needs to come a little further back on the body.

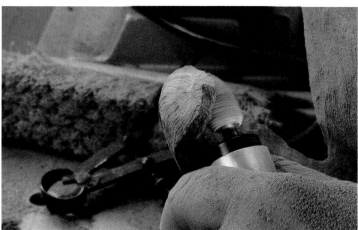

When all the alignments are correct, continue to thin and shape the contour of the fin.

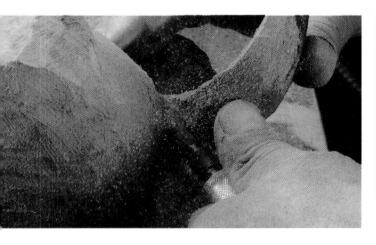

Take it down to the right dimension.

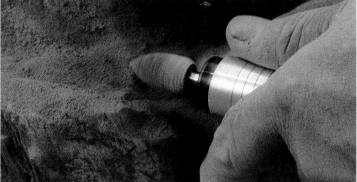

I'm finally able to get rid of the chain saw mark I made at the beginning to set the water level. That chain saw cut is important because it forces the carver to go far enough to make the sculpture work.

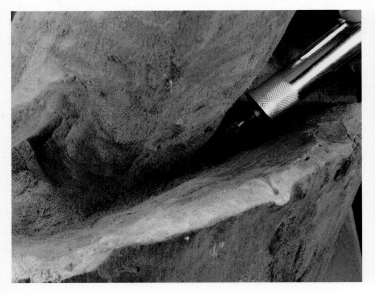

To get to the area behind the back I switch to a small Kutzall taper.

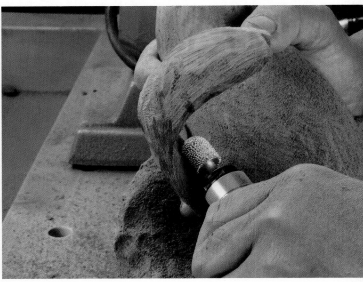

Thin the raised fin as well.

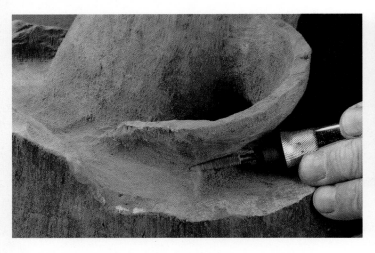

Use the same bit to undercut the fin.

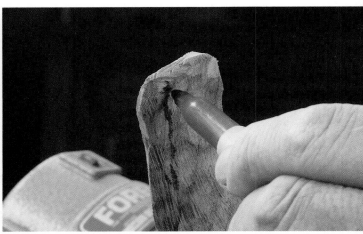

Refer to the model to establish the trailing edge of the fin. It is thin at the tip...

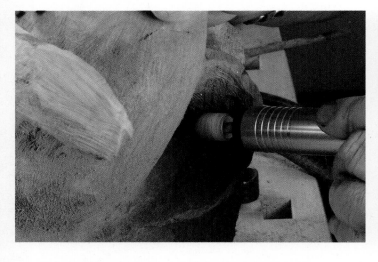

A large ball nose cutter is used to thin the fin even more.

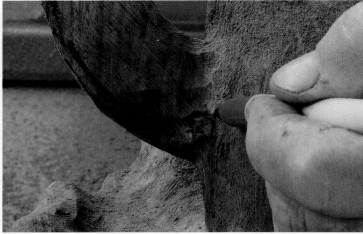

and broadens out toward the base.

The leading edge is done in the same way, measuring from the model and transferring it to the carving. Measure from the origin to the first big bump.

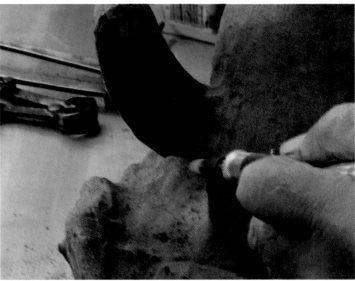

Use a smaller Kutzall ball nose cutter to shape the trailing edge. It is narrower as it joins the body...

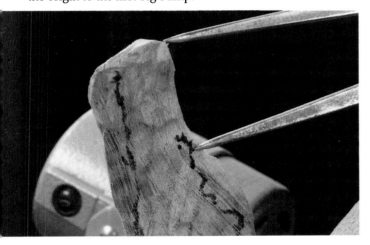

This is followed by two smaller bumps and another big bump.

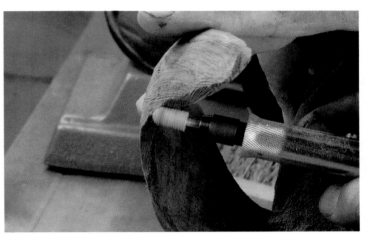

and at the end. Work the whole edge to get the general configuration.

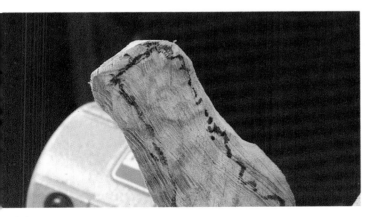

From there it is a series of small bumps ending in a curve to the back edge. As you remember, I needed to shorten this fin just a little to match the other. This is included in the drawing.

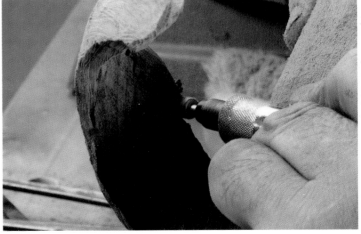

Do the top in the same way.

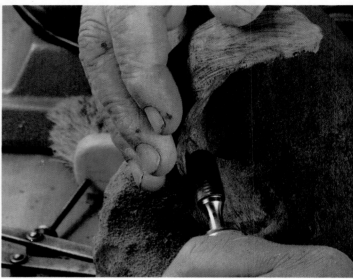

I'll go over the smaller bumps now to get the overall shape and come back later with a smaller bit to define them more closely.

Switch to a finer bull nose cutter to thin the fin. I am at the point now where the Kutzall is too aggressive and may damage the work. Later I will switch to an even finer diamond cutter.

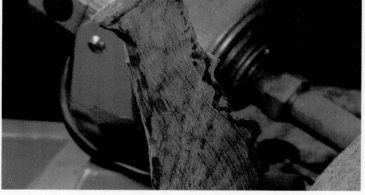

I have the shape defined...

but in the process of cutting I've exposed the thickness of the edge.

The crack needed regluing, which I did from both sides. I also remarked the tip of the flipper.

Use a knife to set the sharp angle at the fin origin.

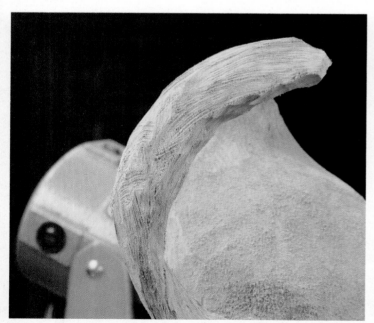

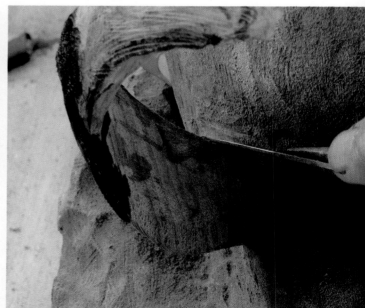

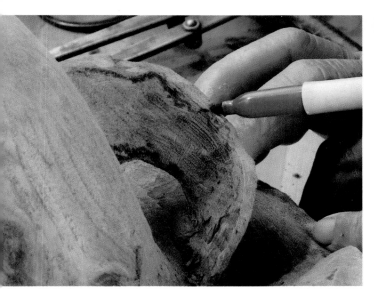

Mark the bumps on the leading edge of the lower fin. Some of these bumps are associated with the joints in the fin bone structure.

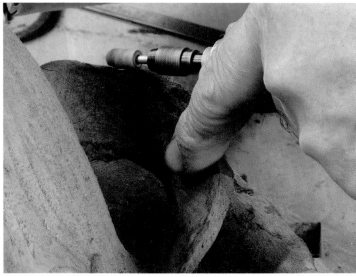

Roughly shape the leading edge.

Before setting the profile I need to thin the fin. With a slightly bent gouge I come down the surface of the fin...

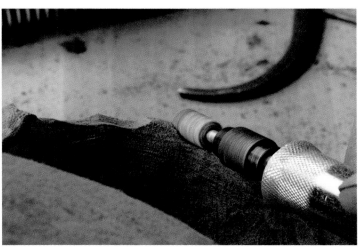

It is important to set the big bumps first. If you try to do them all at the same time, they tend to all look the same.

then come back to it from the water line to clean it up.

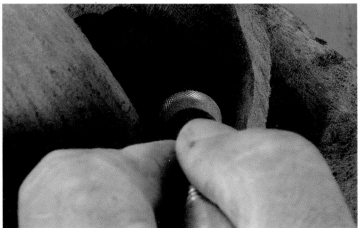

Carve to the bottom line as well.

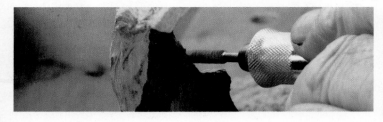

With a smaller bit, roughly define the location of the smaller bumps.

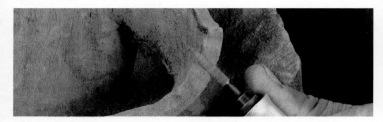

Do the same on the other fin.

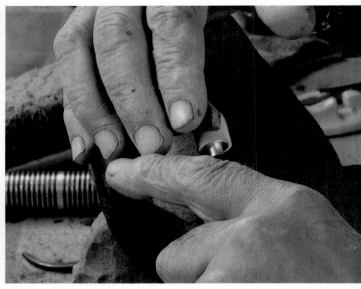

Now I can thin the edges and generally work on the esthetics of the piece. My right hand is stabilizing and supporting the wood so it doesn't break while I'm working on it.

The result. Even this slight detail gives the work some life.

Compare the widths of the two fins to make sure they are nearly equal. Adjust as necessary.

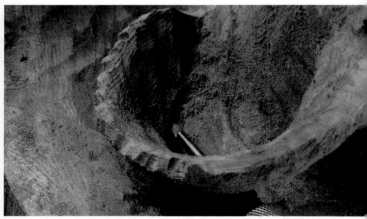

With a thinner hand tool and a small carbide flame cutter, define the water line where the fin enters it. I don't want to cut too deeply or roughly.

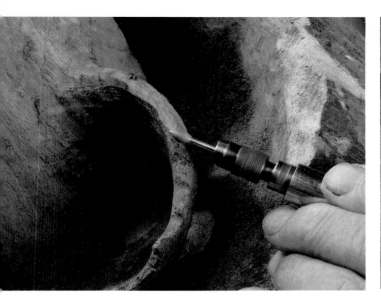

The same tool with a smoother diamond bit can be used to round the bumps on the edge of the fin.

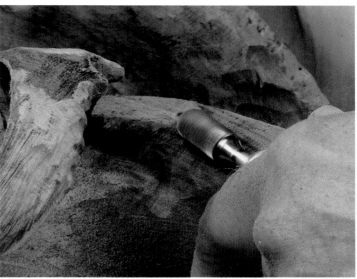

Blend the body back to depression you've made around the eye. The carbide bit takes away the rough surface left by the Kutzall. This is the beginning of the refining process.

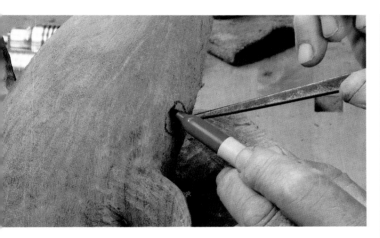

Take the measure from the model of the distance from the nose to the center of the eye. It is slightly above the line of the fin. Mark the eye orbit around the point. I need to establish the eye before the final shaping of the body.

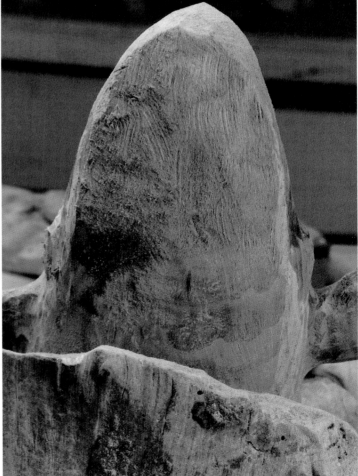

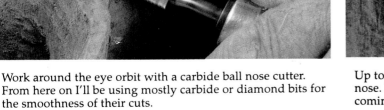

Work around the eye orbit with a carbide ball nose cutter. From here on I'll be using mostly carbide or diamond bits for the smoothness of their cuts.

Up to now I've had a gentle taper of the head toward the nose. In fact the nose is straighter forward from the eyes, coming in significantly just in front of the eye orbit.

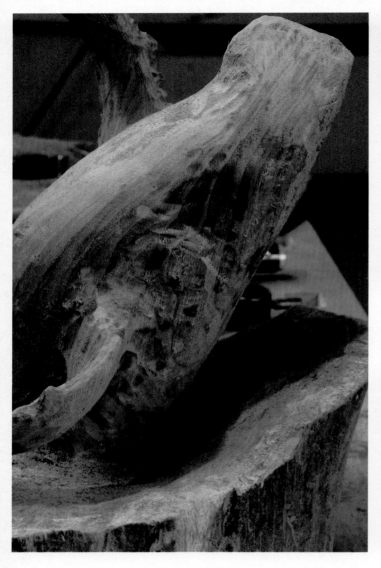

Remember to support the fin as you sand. The sander exerts less pressure than the cutter, but there is still a danger of breakage.

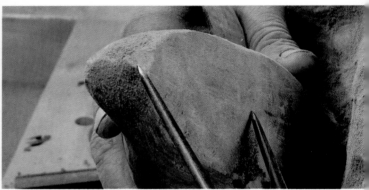

Slowly the eye bulges begin to emerge, as the nose and body are reduced around them. It is hard to see the eye from the side at this point, but it is beginning to take shape.

Going from the model to the carving, transfer the measure of the distance from the end of the head to the center of the dorsal head ridge in front of the blow hole.

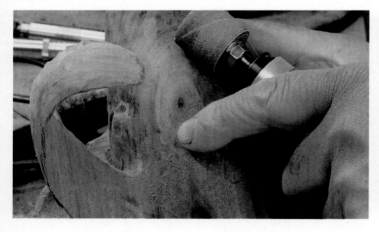

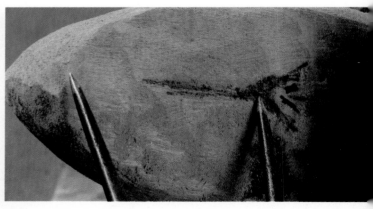

I can do some preliminary sanding on the belly and fins with the sanding drum. Some of these areas will have detail added, but I need to get rid of some of the cutter marks before going further.

The medial rostral ridge runs down the center of the head, where it bifurcates into the dorsal head ridge. These ridges divert water away from the open blow hole, so the whale won't get water up its nose. The blow hole consists of the two slits behind the dorsal head ridge.

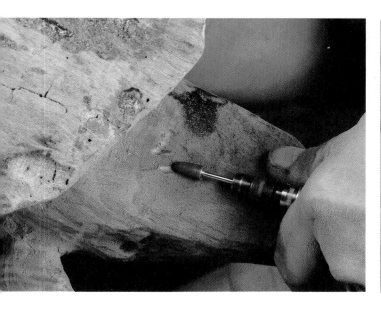

Switching to a rounded cone ruby cutter I mark out the location of the ridges by going around their edges.

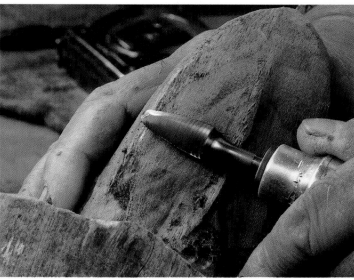

On one side of the ridges I have to switch to a cone bit so I can go with the grain. The cylinder won't clear the ridge.

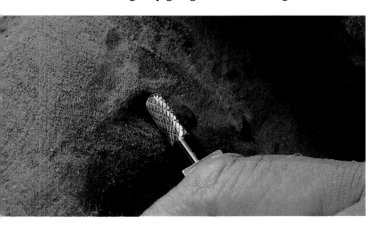

That ruby bit was not aggressive enough, so I'm switch to a 1/4" carbide ball nose.

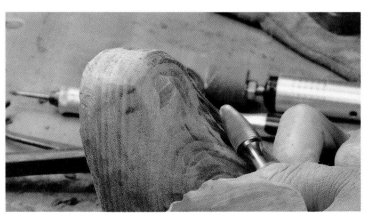

Continue to work on refining the work, taking away the Kutzall marks and thinning the whale.

Lower the rest of the rostrum so the ridges are elevated.

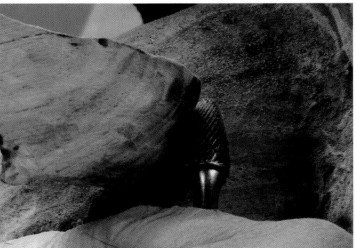

On the fins I refine the taper while smoothing the surface.

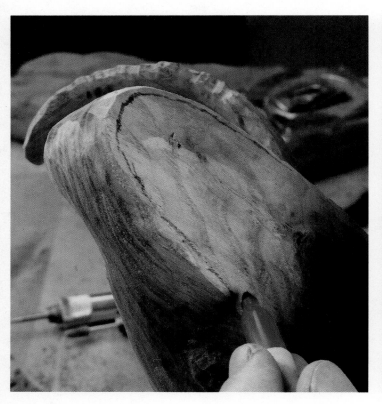

The mouth line comes around the front edge of the rostrum...

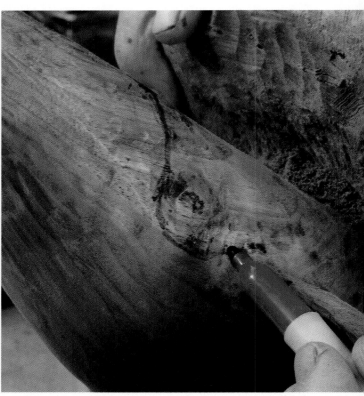

The eye is located here on the orbital bulge I carved earlier.

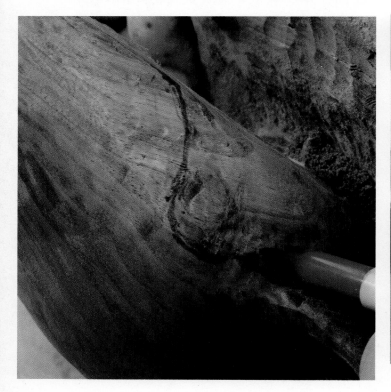

then curves down and ends under the eye, with a groove continues to a point above the fin.

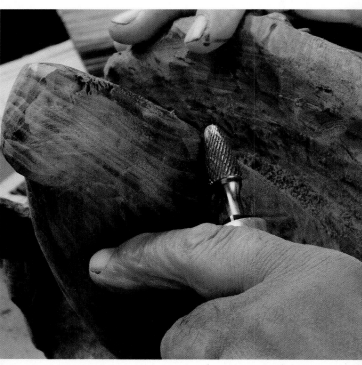

Drawing the eye sometimes makes other things more obvious. Here I saw that the head needed to be rounded in front of the eye. Don't be afraid to make corrections as you go.

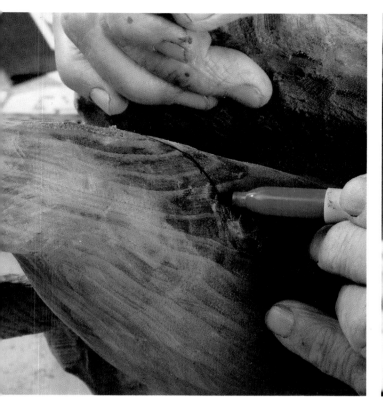

Rounding the lateral configuration of the mouth area. Much better. By the way, this was the second or third try!

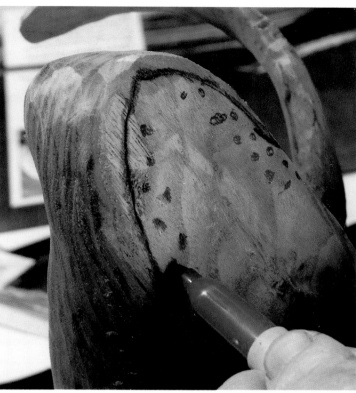

On the outside of the rostrum there are bumps that follow the mouth line in pairs, with the inside bump being a little forward of the outside bump.

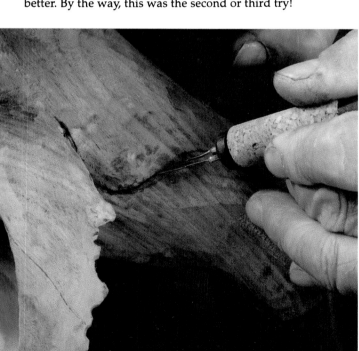

To define the mouth I use a wood burner with a 3/16" spear point. I use a wood burner because I want to retain the location of the mouth after the sanding step that follows on the rostrum and the side of the mouth.

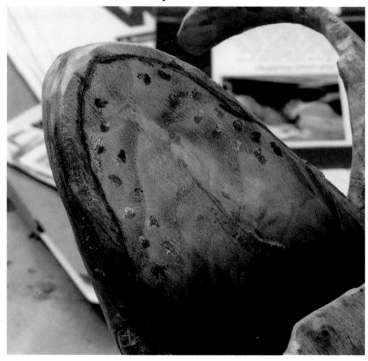

The pattern is like this, going back to the point where the mouth line turns down.

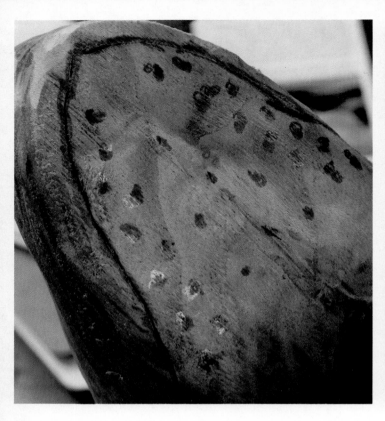

There are also bumps along the medial rostral ridge and a few scattered between the ridge and the mouth line.

The technique for bringing the bumps out involves the principal of wood expanding when it is soaked with boiling water. I begin by compressing the wood fibers using a tool with a rounded tip. I have several of these in a variety of sizes and shapes. They are made from rods, nails, and other materials depending on the size, and are ground and polished to a round tip.

There are a few bumps on the lower surface of the mouth, particularly toward the back.

The work is placed on a cradle to protect it while I drive the punches into it.

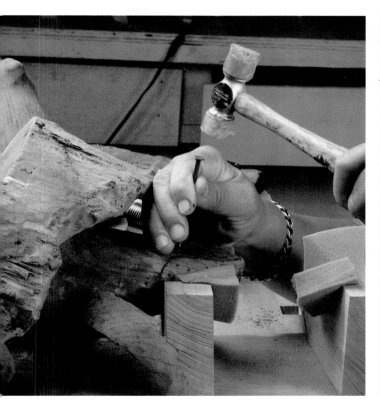

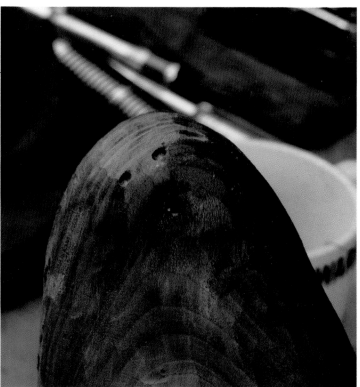

I usually practice on a scrap piece of wood from the same carving before working on the sculpture itself. To form the bump I drive the punch into the wood so it makes a depression but does not break the fiber. The punch for this project is made from a 12p nail, not galvanized.

These are randomly placed.

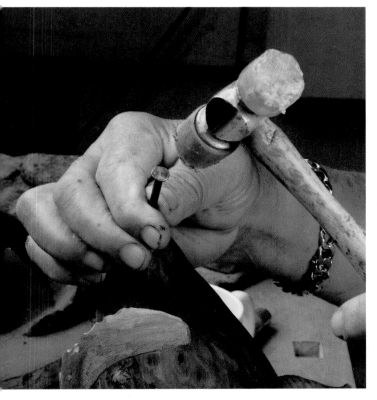

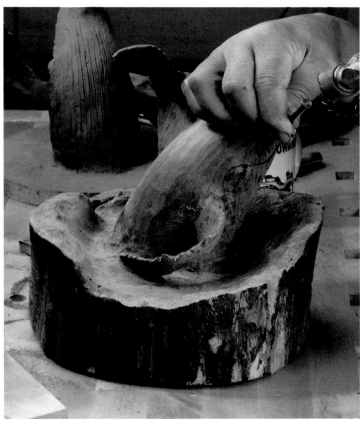

Add a few bumps to the chin.

For the side bumps it is easier to take the piece out of the cradle.

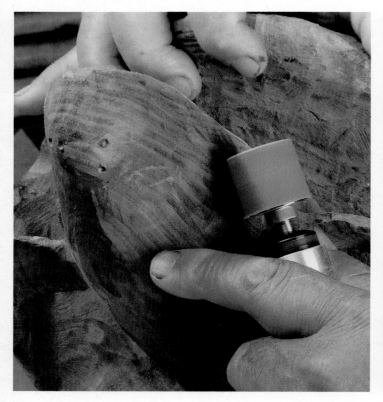

Next sand away the wood around the bumps so that you can just see the depressions you made.

After sanding I scrape the sanded areas to make them smooth. The edge of a sharp knife makes a good scraper.

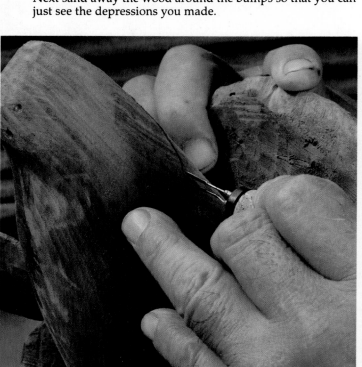

The mouth line will be taken away by the sanding. I stop to reburn it before I can't see it. I may have to do this a couple times during sanding.

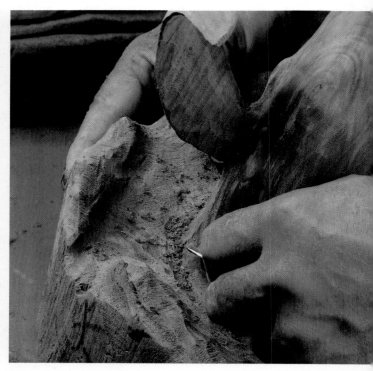

I continue to scrape the whole whale. The knife goes over depressed areas, making them smooth.

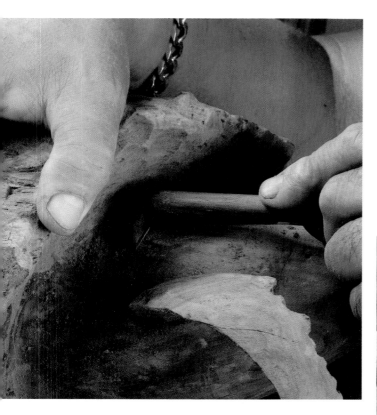

This bent scraper allows me to get into tight areas that the knife wouldn't.

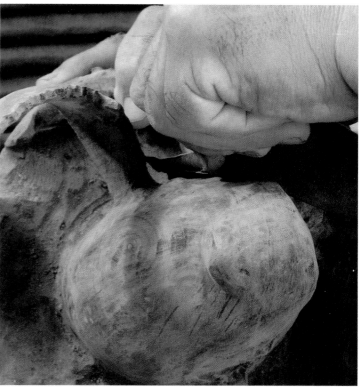

Take away any pencil marks at this point.

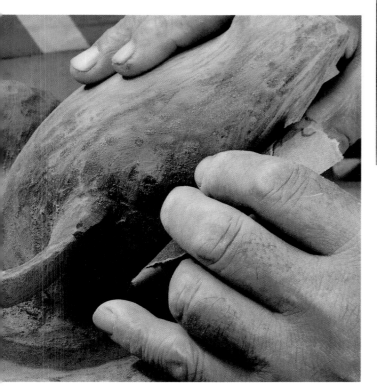

Follow the scraping by sanding with 180 grit paper.

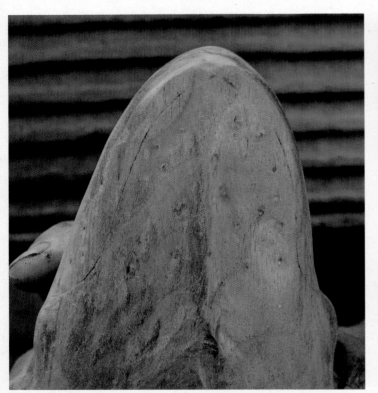
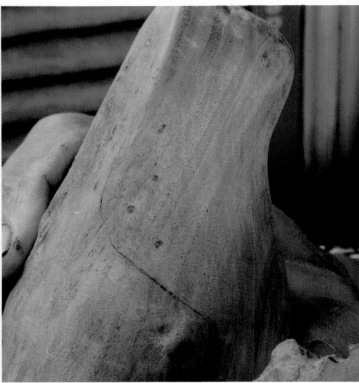
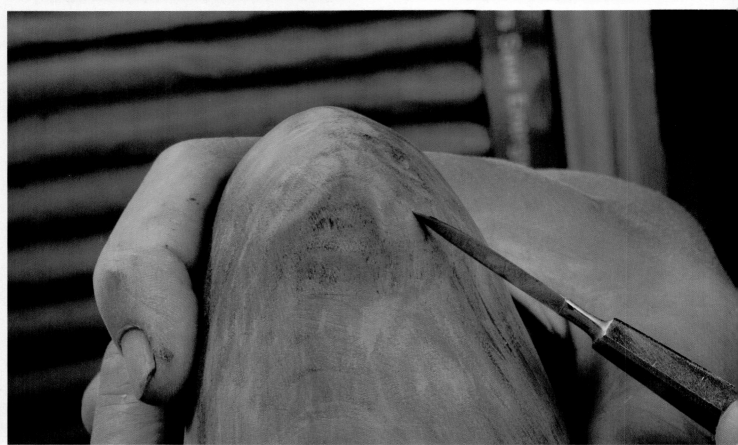

At the end of sanding and scraping the depressions for the bumps are still visible, but the surface of the wood has been brought down to their level.

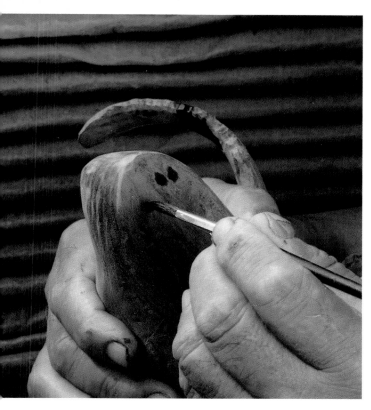

With a small brush put a drop of boiling water on each of the bump depressions.

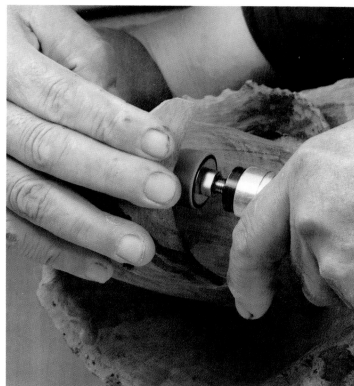

Taper the trailing edge of the fin with a sanding drum. The drum doesn't exert as much pressure as a cutter, so I like it for this fragile fin. Nevertheless I keep applying counter-pressure with my other hand.

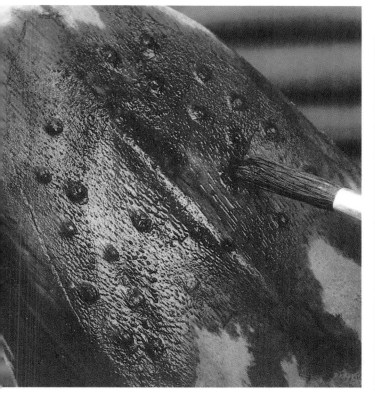

Because the bumps were compressed before sanding, the restored wood now rises above its sanded surroundings. Let it dry.

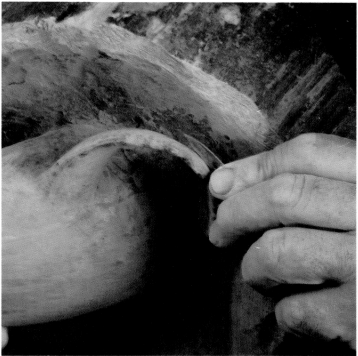

Follow this with scraping and a sanding with 100 grit paper. This takes away the sanding marks from the drum and other imperfections.

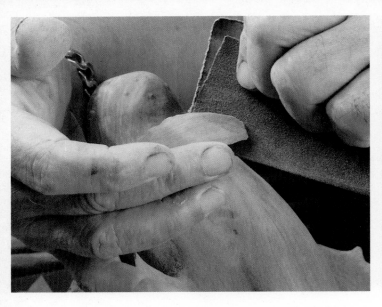

Use the paper to round the leading edge of the fin and smooth the surfaces. This paper has a stiff cloth back so it will take away the high spots without going into the depressions.

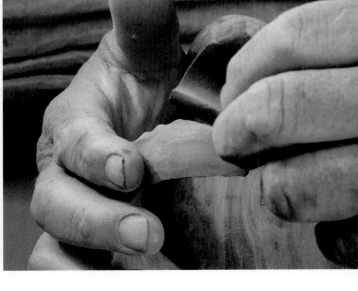

Finish it up with 150 grit paper.

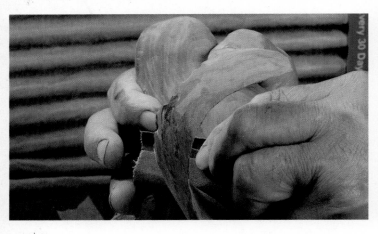

Some sanding can be done on the bumps to reestablish their round shape.

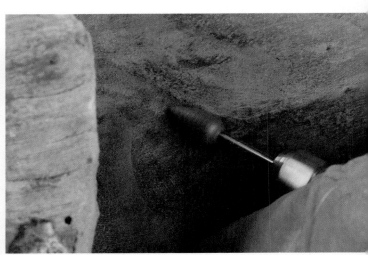

Deepen the area behind the dorsal head ridge, to make the ridge more pronounced. If you have a reversible rotary tool, it is useful in this spot where the angle of the back means you hit end grain if you cut in the wrong direction.

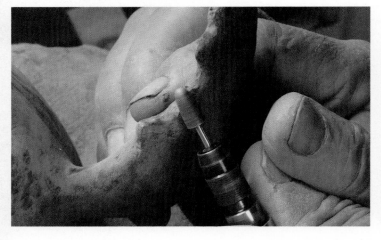

This is followed with a ruby cutter to finish them, putting a round tip on them.

Next go along the sides of the dorsal head and medial rostrum ridges.

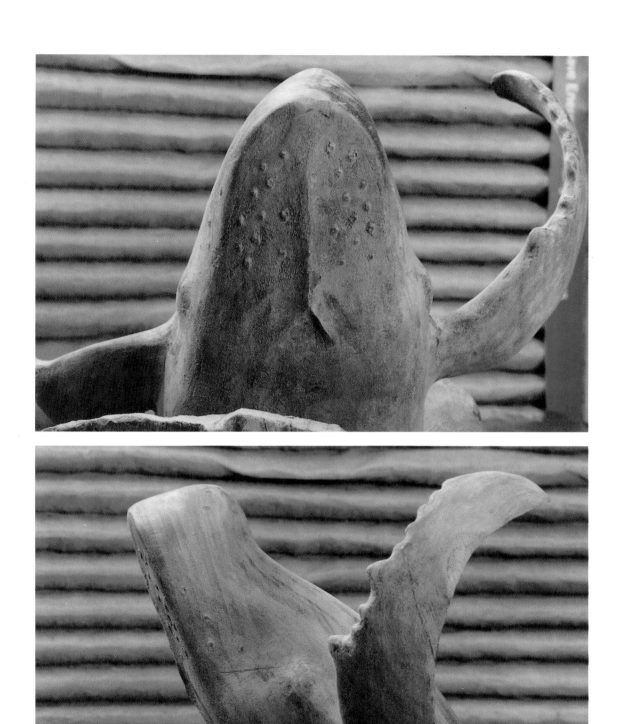

Progress. The ridge has become more prominent and better
defined.

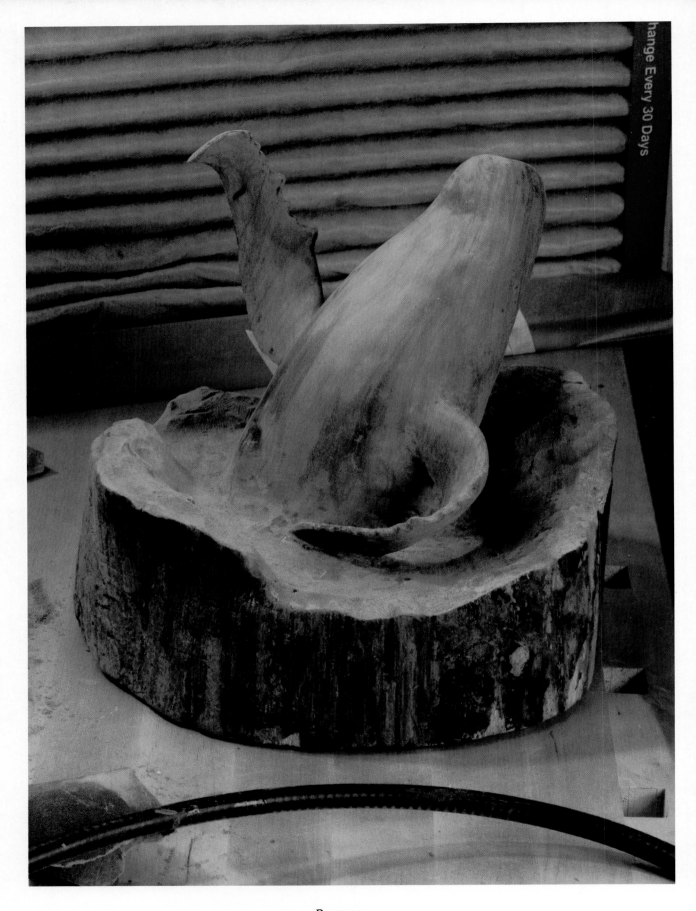

Progress

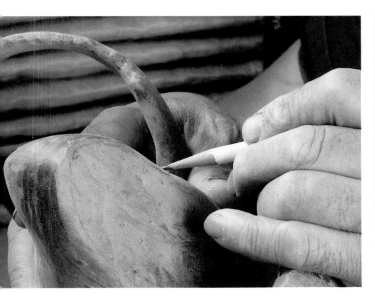

I make the line of the mouth with a small flame tip diamond cutter, following the old burn line. There is enough of the line left that I can remark it with pencil.

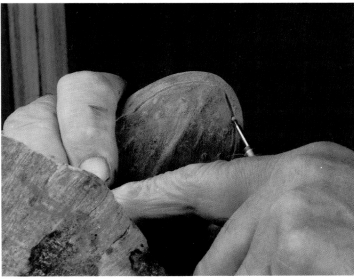

Go over the line again, taking it to its final depth if possible. You may have to do it again, but don't force it.

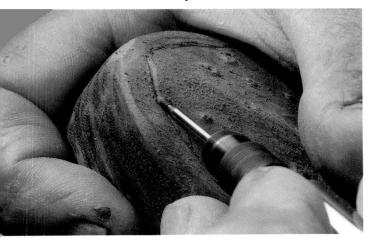

Follow the line with the cutting tool. The tool is the width that I want for the line, about 1/16", which lessens my worry about making the line too thick by mistake. I begin with a shallow line, which I will deepen later. This way if I make a mistake on the original line it is easy to fix.

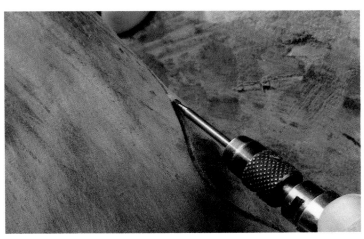

The tool is held at this angle for making lines. The body of the flame tip runs in the groove while the point takes the line deeper. This gives me a lot more control than if I tried to make the line with the point.

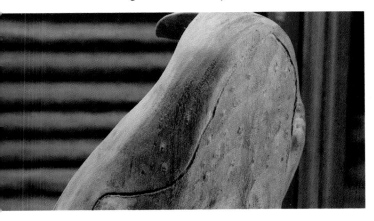

The initial cut.

Mark the blow holes.

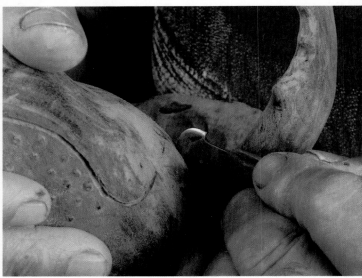

Cut the line with the same cutting tool you used for the mouth line, then deepen them with a finer tipped tool. The whale is exhaling at this point in the breach, so the holes are open. This is the result.

and scrap until it is as clean as you can make it.

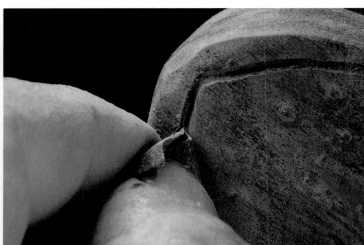

While I'm sanding I want to take away the sharp edges of the mouth line.

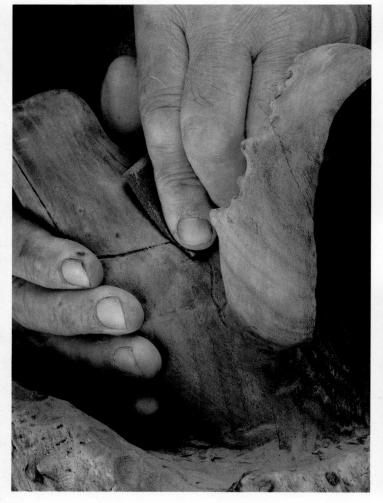

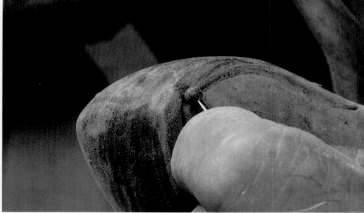

Before burning the eye I want to get the eye bulge very smooth. This is the last clear shot I'll have at it. Sand...

Alternatively you can use a ball cutter by hand and without power, as a file to round these edges.

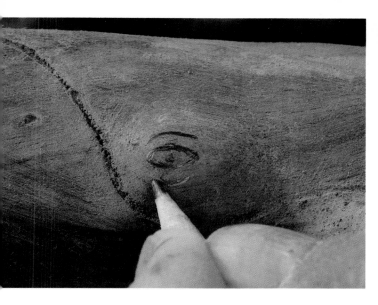

Draw the eyeball and the lid lines above and below.

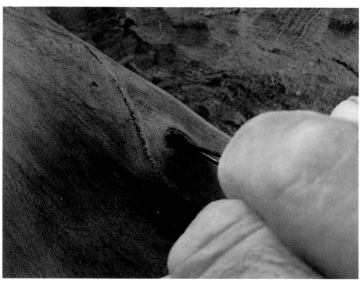

Undercut the upper eyelid. This gives shape to the eye ball.

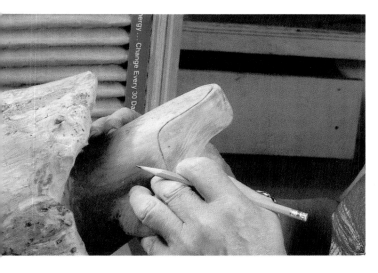

Look down the head to be sure the other side is at the same level. Draw it in place.

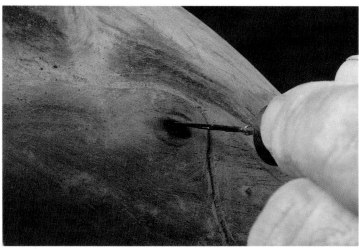

Do the other lid in the same way. The angle of the burning tip takes it under the lids while the side of the tip shapes the eyeballs. The heat should not be too high. I usually set it in the mid-range.

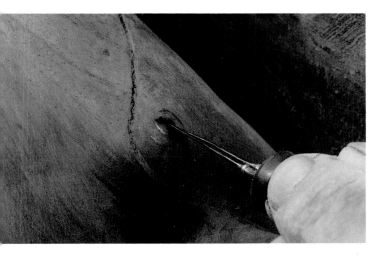

Outline the eyeball with the burner.

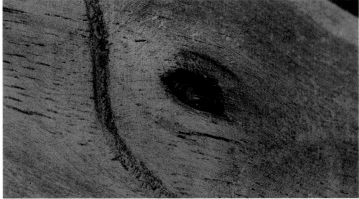

The result of the burning.

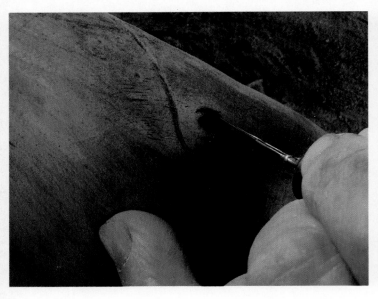

Burn the outer margins of the upper and lower eyelids.

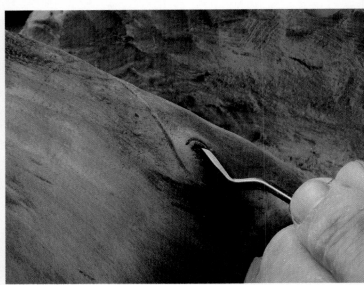

With the chisel I make the eyes round while undercutting the lid.

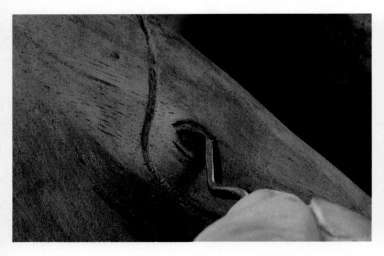

I clean up the eye with micro-chisels, a skew and a bent straight chisel. I begin with the chisel and undercut the margin of the burned area, giving it a three-dimensional look. At the same time I've removed most of the carbon. Do the same on the lower lid.

Progress.

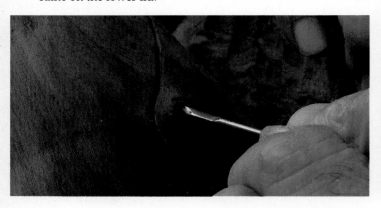

The skew gets into the front and back corners to remove the carbon.

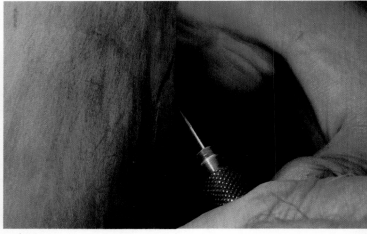

Use a tiny round diamond bit to make and indentation for the pupil. This is a 1mm ball.

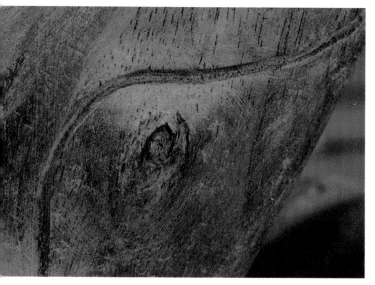

The result.

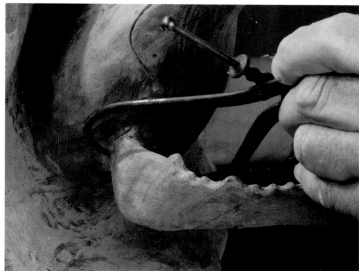

Use calipers to make sure the fins the same thickness at the body.

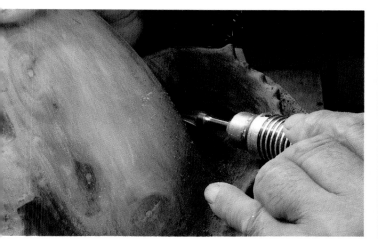

Before the adding the ventral grooves, I need to make any final corrections in the body shape.

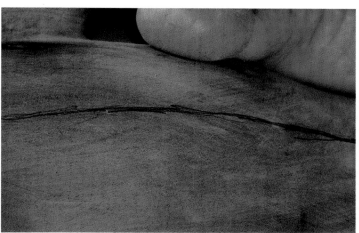

When the body is smooth draw a center line.

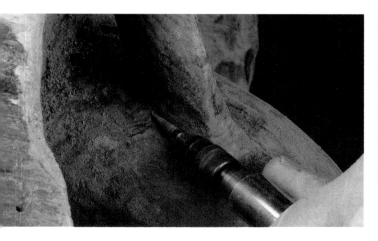

To taper the trailing edge of the lowered fin at the body, I need to use a fine cutter.

Out from this line there are from 14 to 28 ventral groove lines on the whale's belly. The whale feeds by taking in huge quantities of water and then forcing it out through the baleens, trapping food in its mouth. The grooves allow for the expansion of the throat and belly. Muscles underlying the grooves contract and water is expelled between the baleens.

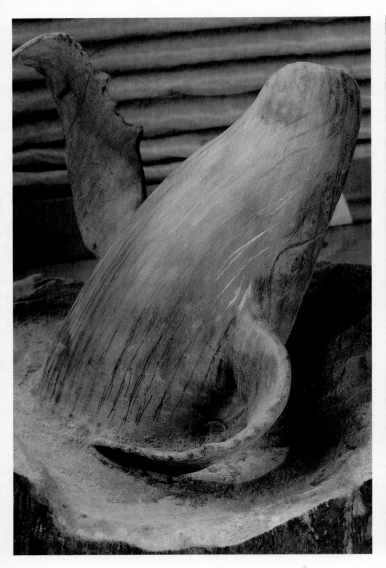

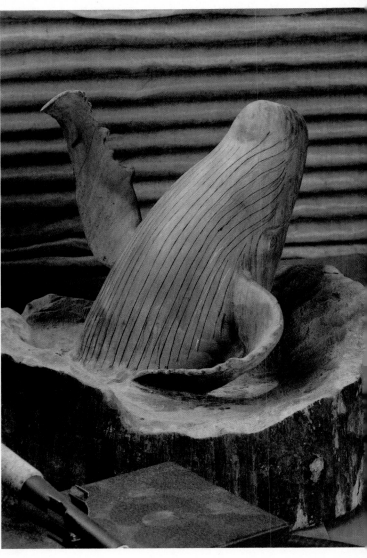

The lines are not continuous, having to stop and start to work around the contours of the body. These give me an approximation of where to burn. They will be clearer to you later. By marking first with pencil you can count the grooves and easily correct any mistakes.

Progress.

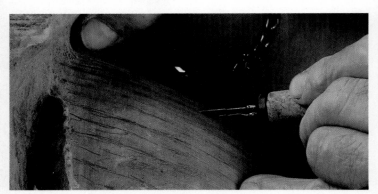

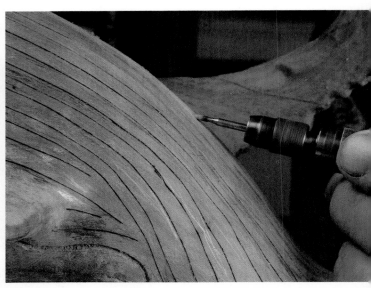

Follow the lines with the burner. This creates a guide for the cutter. Without this the rotary cutter could easily stray into places I don't want it, particularly going across the grain. The burning doesn't need to be deep to do its job. By burning I also get a line that I can clearly see while cutting the groove.

Follow the grooves with a small flame bit.

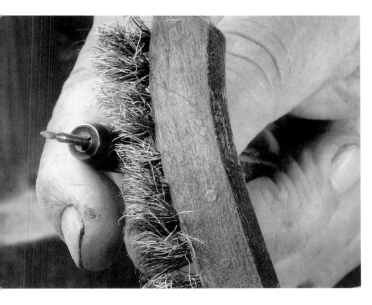

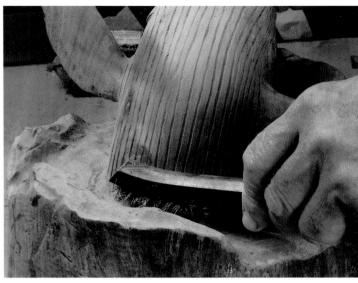

A build up of burned wood in the bit will cause it to burn as it cuts. Stop and clean it regularly.

Brush away the debris.

When the cutting is finished, lightly sand.

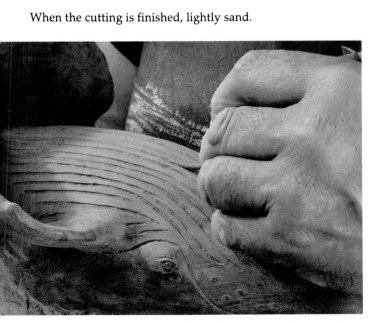

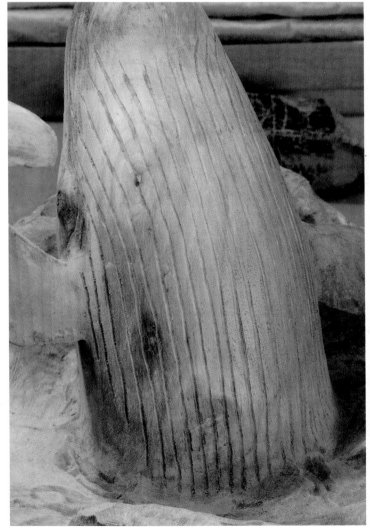

A round diamond riffler run down the grooves will smooth off the rough edges and make them a little more uniform.

The result.

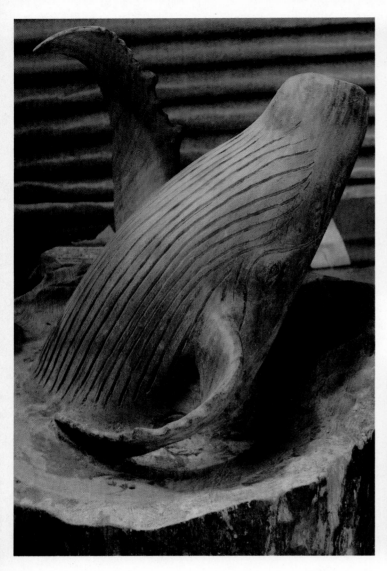

As I'm doing this, one of my goals is to get rid of most of the worm holes and other effects of the log sitting on the ground for so long.

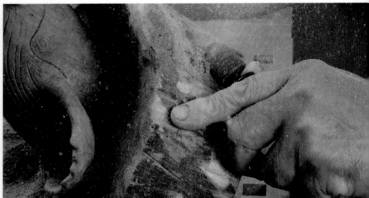

I can now start working on the setting. The whale is creating a great splash, which I make by undercutting around the base. I use a combination of power chisel...

Progress.

and a large ball nose cutter to take away the excess.

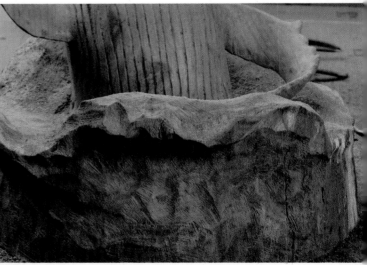

Now I need to switch to a smaller cutter to undercut the waves more.

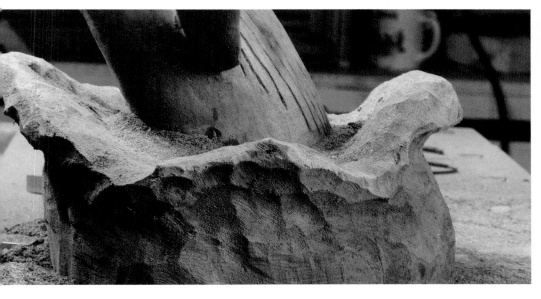

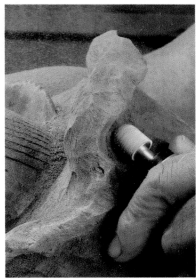

Another view of progress

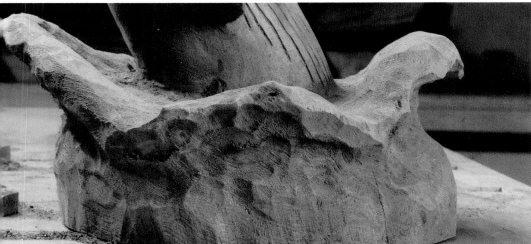

The base is coming to life. With the roughing done...

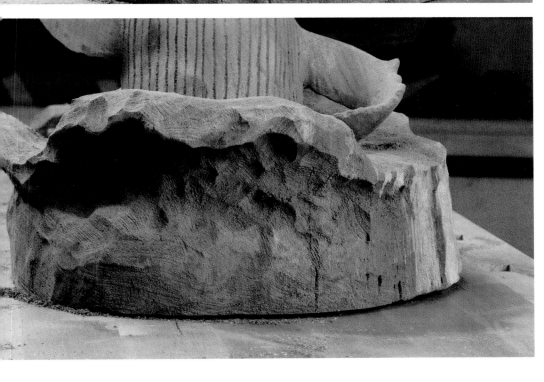

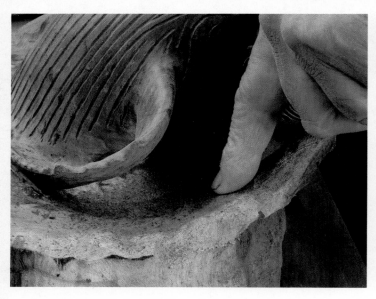

I switch to a carbide cutter for smoothing. When working behind the whale with the rotary tool you need to use extra care so you don't nick the body.

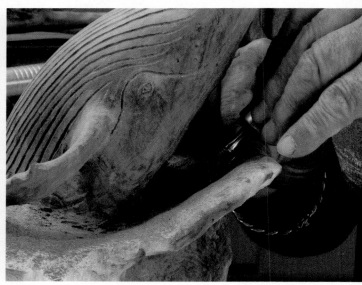

I still need to smooth out some Kutzall marks in this area.

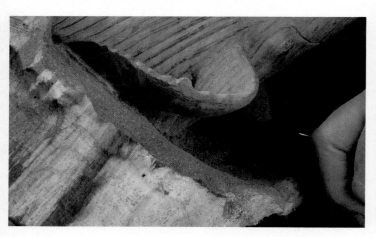

I'm trying to get rid of the Kutzall marks all over the base.

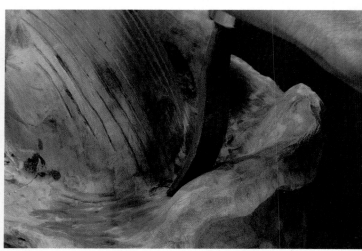

Continue all around the whale.

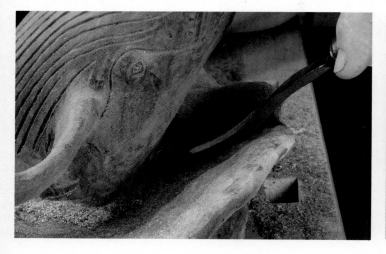

A bent gouge with a slight curvature (#12 or #13) gets down into the crevice between the back and the wave.

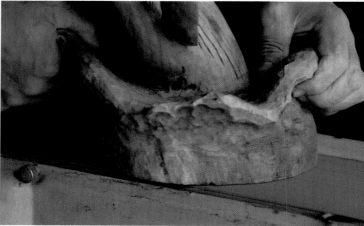

Sand the base until it is flat.

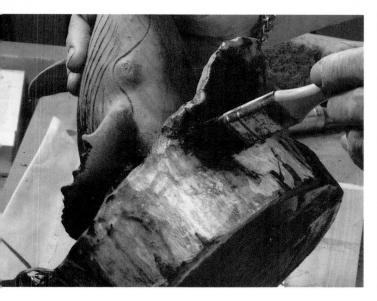

Brush the piece with a very generous coat of nitro-cellulose based sanding sealer. This does a couple things. It helps keep the grain together for future sanding, and it lets me see where the carving needs more work. The sealing also cuts down on the movement of the wood, helping to prevent future cracking and checking.

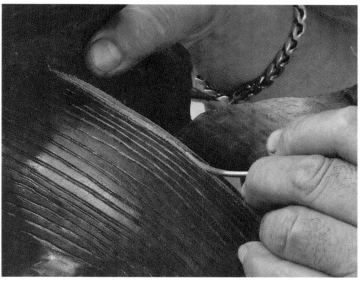

The riffler file will help straighten them out and also even the bottoms of the grooves. I want to make the grooves as even as possible.

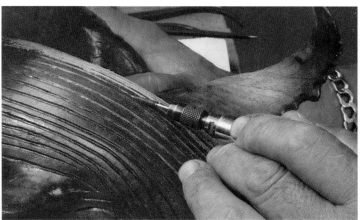

If you don't have a riffler you can put a narrow rotary taper in a handpiece and use it *without power* in the same way.

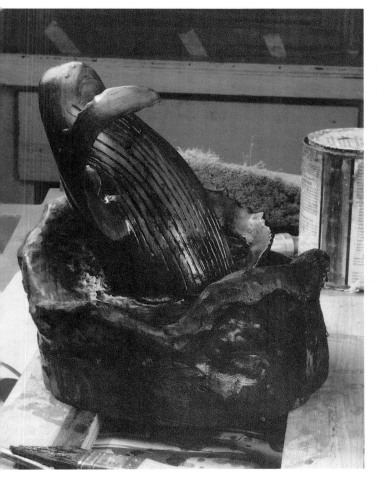

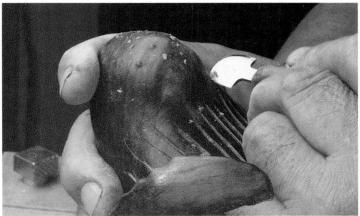

The sanding sealer reveals areas that need further refinement. I see now that the ventral grooves are uneven in places.

As you see scratches and other imperfections scrape them away.

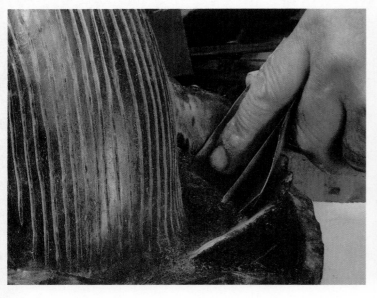

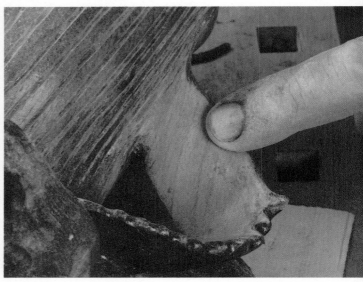

The scraping combined with sanding with 180 grit paper takes me a lot closer to the surface I want.

A resanding shows that the scraping worked.

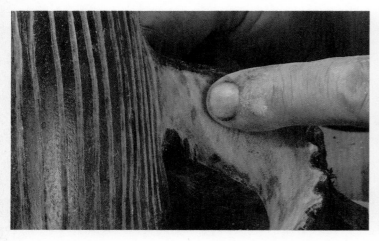

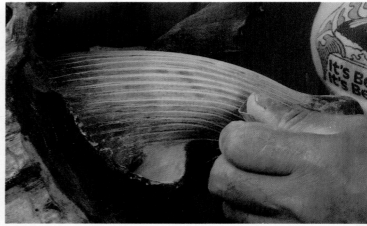

The sanding reveals the uneven spots in the surface. they show up as color differences, either dark like these, or light where a depression holds sanding dust.

Continue the same procedure over the whole carving. Sand...

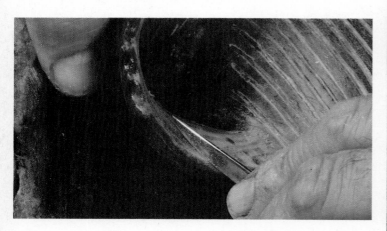

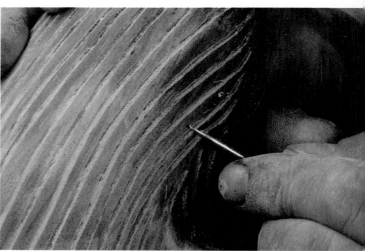

I blend these away by scraping. The scraper needs to be sharp or it will tear up the wood.

scrape away scratches, depressions, and imperfections...

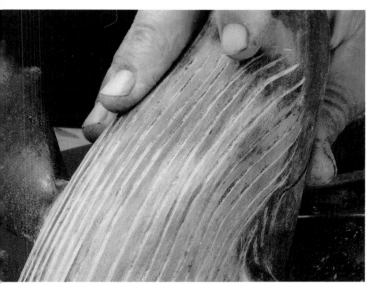

and resand. Repeat until the surface is as smooth as possible.

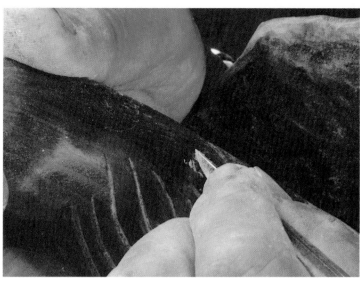

Scrape carefully between the bumps.

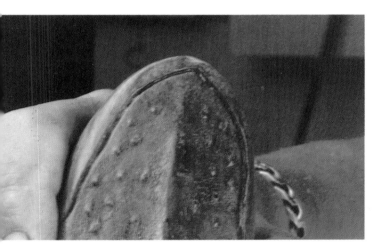

In the areas of the bumps, the grain was raised in the wetting process.

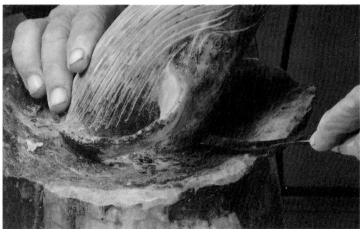

There is still time to fix any difficulties with the carving. This area at the back is a continual problem. Sharp hand tools give me a clean cut.

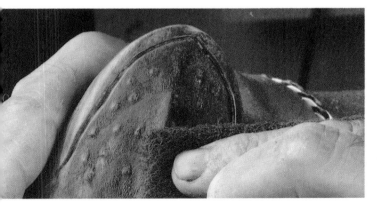

Now that the grain has been strengthened with the sealer, I can smooth the background without damaging the bumps. I use a fine grade Scotchbrite™ pad instead of sand paper in this area. It is much gentler on my bumps.

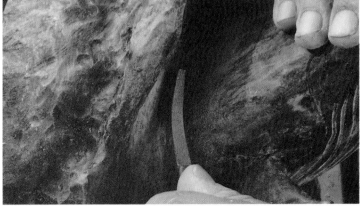

I hate to use this riffler because it is so rough, but to get at this area to fix the imperfections I need to.

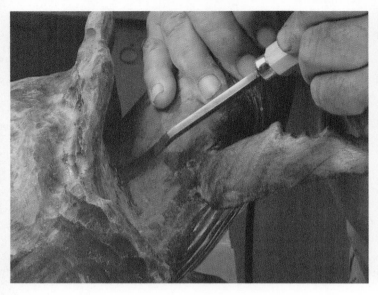

This back bent gouge (#34) also helps do this shaping.

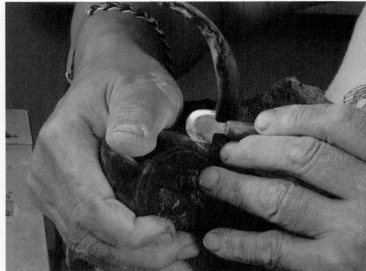

I've had a series of handled scrapers made in a variety of sizes and shapes. A lot of what I scrape here is the sealer, but it also has some of the fine pieces of raised grain.

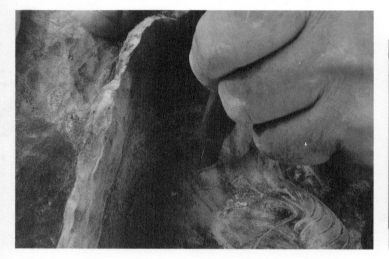

The scrapers I use are sharpened like knives. Furniture makers put a burr on theirs, but their purpose is remove an even layer of wood over a large surface. Mine is to simply refine and smooth a much more concentrated area. When using a scraper you will find that if you are going the wrong way in relation to the grain you will have a rough finish. You need to stop and switch directions. Any cutting tool with a good edge can act as a scraper, and you may need to use a variety of them in your carving. Here I am using a 1/4" straight chisel to scrape in a tough spot.

Work around the bumps with a small scraper. There is no particular challenge here, but it is tedious. I'm trying to remove the excess sealer.

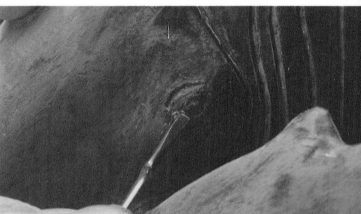

Remove the excess sealer from the eyes by scraping with micro chisels. If there is any imperfection in the eye, I can correct it at the same time. In this micro work you need strong light and shadows to see what you are doing.

When the sanding and scraping is complete, clean up the dust. I use a little lacquer thinner to make my paper towel tacky.

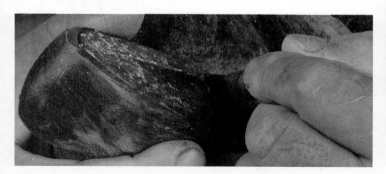

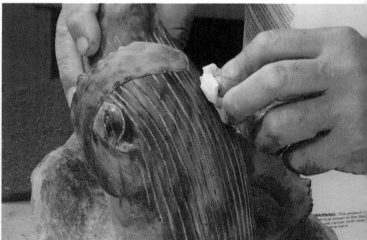

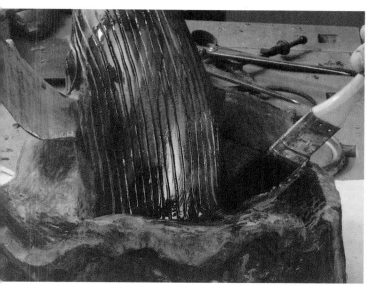

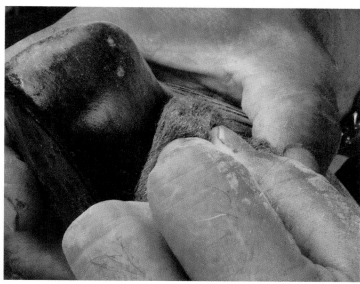

Apply a second coat of sanding sealer. It doesn't take as much as the first coat because the wood is not absorbing as much.

Steel wool over the bumpy areas takes away the excess sealer without damaging the bumps.

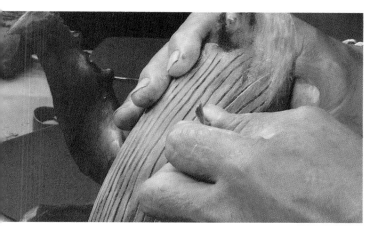

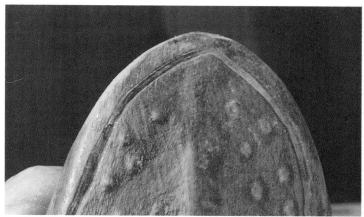

When the sealer coat has dried, move to 220 grit paper and sand again.

Here on the rostrum you can see the effect of the steel wool. The right side has been rubbed, the left hasn't.

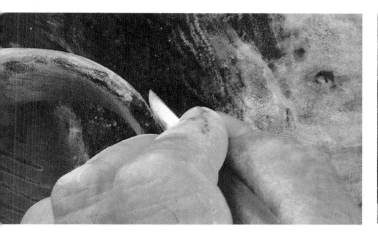

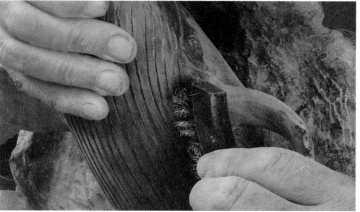

While the defects are getting more minor, there are still a few of them to fix.

I didn't put much sealer on the eye for this coat, so all I need to do is brush away the dust.

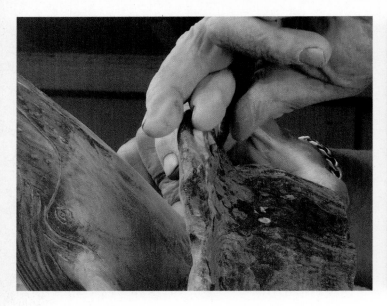

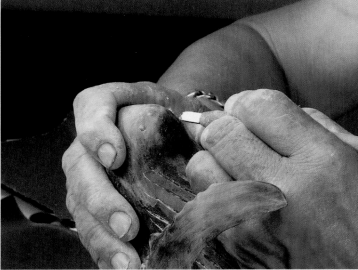

Before I put on the next coat of sealer I want to clean up the water carving a little more. I don't need to have it smooth, in fact it looks more realistic rough. I do want to take away any roughness left by the rotary cutter.

Smooth around the bumps and fix any defects.

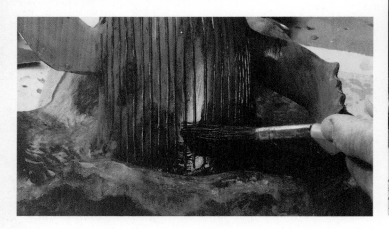

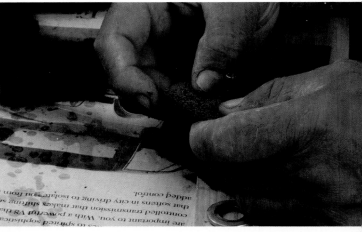

Wipe the piece clean and apply another coat of sealer. This time, though, I've thinned the sealer with some lacquer thinner to make it more fluid. I just want to coat it slightly. It will fill, but won't build up.

I learned to make a finishing tool from my friend Henry Rosenthal, a carver from Wisconsin. I put a hole through six pieces of ultra fine grade Scotchbrite™, about 2 1/2" square. These are then stacked on a mandrel that will fit into my rotary tool holder.

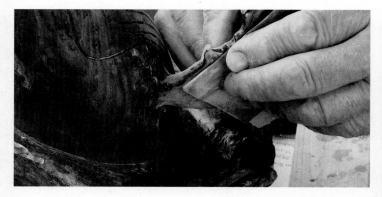

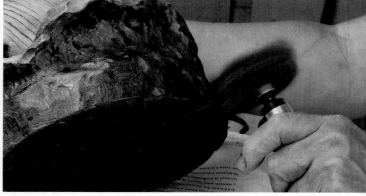

Sand the piece with 400 grit paper. You don't want the rotary tool to touch the delicate areas, and only minimally on the whale at all.

The rotary finisher is used primarily on the base.

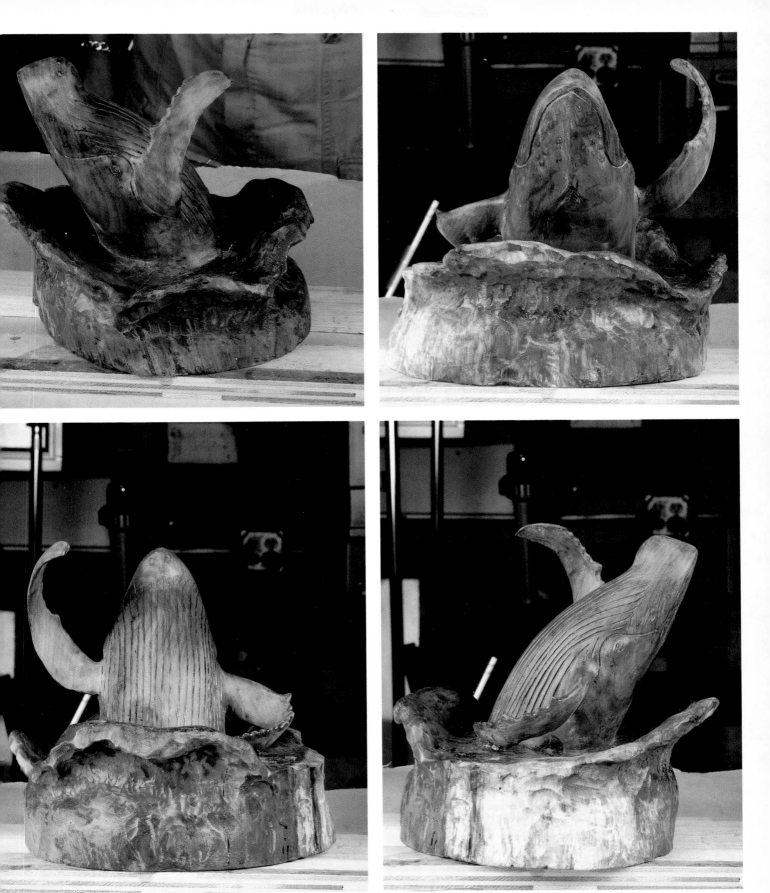

Ready for lacquer.

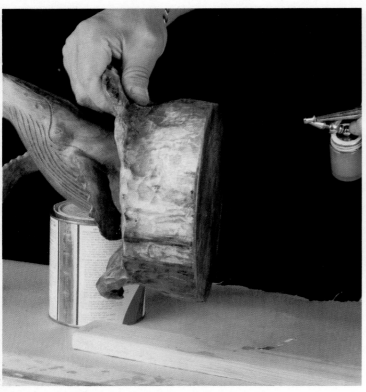

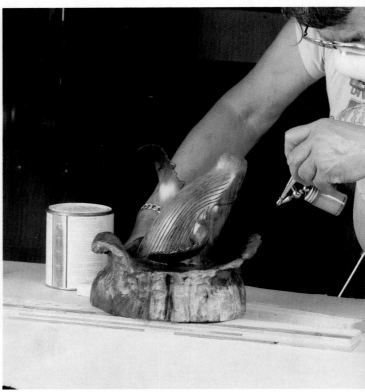

I apply the lacquer with a Paasche™ airbrush driven by a 3/4 horsepower compressor. The lacquer is not good for your liver. Use in a well ventilated area and wear a respirator. I keep the windows open and work near an open garage door with a fan running. To top it off I wear a mask made for use with lacquers. I bought it at an auto supply house. Start at the bottom...

Keep turning the piece as you work.

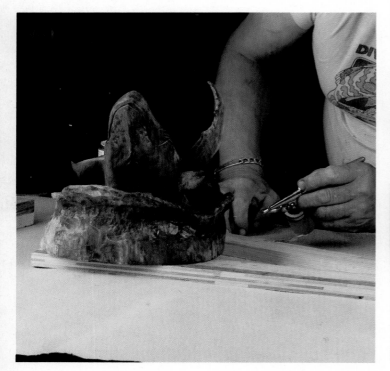

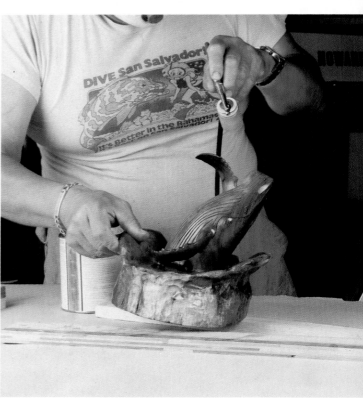

and work your way up.

You want complete coverage, but with a thin coat.

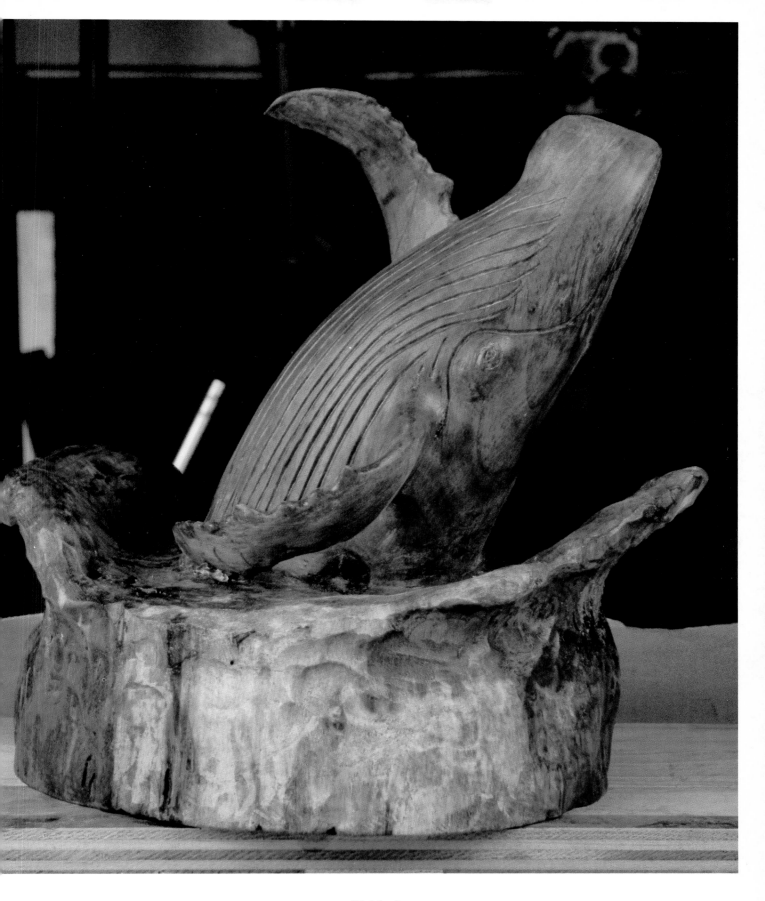

Finished.

Clean-up any imperfections that may show up with the lacquer. Even though the piece seems finished, it can still use some touch up.

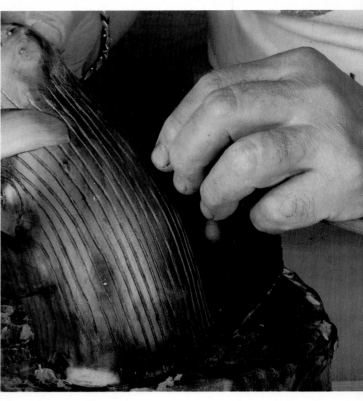

Wrap a piece of Scotchbrite™ around an edge tool or toothpick to clean the bottom of the ventral grooves. Brush them clean with a toothbrush.

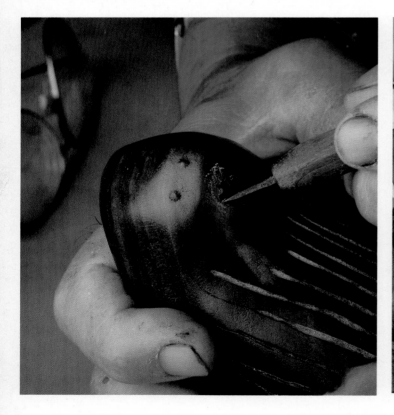

Scrape around the bumps. Remember that to do this delicate work it is important to have sharp tools. Sharpen them often.

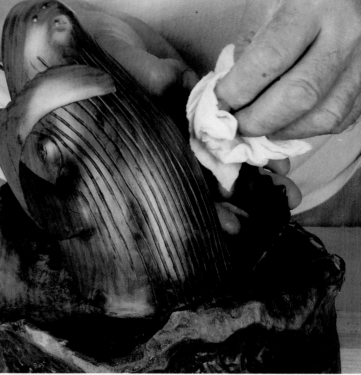

Wipe away the dust with a dry cloth. At this stage there is not much dust, and to use thinner or other liquids to make the cloth tacky would harm the finish.

I've also cut a base from 6/4 (1 1/2") stock. With the mass of the sculpture I needed something heavy at the bottom. I simply cut it irregularly to fit the irregularity of the bottom of the sculpture. I've sanded it with sanding sealer, drilled holes for 2 1/2" deck screws which will secure the sculpture. Now I'll add a lacquer finish.

You may need to repeat the lacquering process for one or two more layers. I have a pretty good finish, so I move to the next step. I apply a paste Minwax™ formulated for dark woods with an ultra-fine Scotchbrite™ pad. This applies the wax and gives a final smoothing. I believe wood sculpture should be touched and that there should be an almost sensuous feeling.

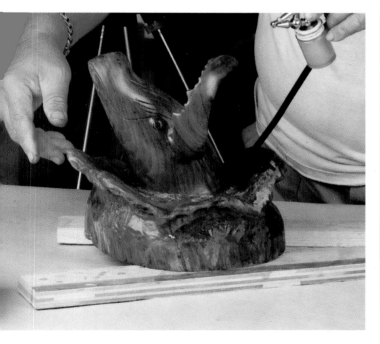

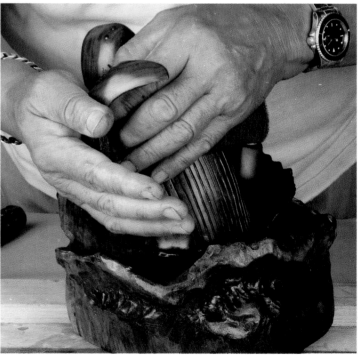

Spray the sculpture with a second coat of lacquer. Remember to seal the bottom again. Even though this is not seen, it is a way that moisture moves into the wood causing it to expand and contract, which, in turn, causes cracking.

Do the same with the sculpture itself.

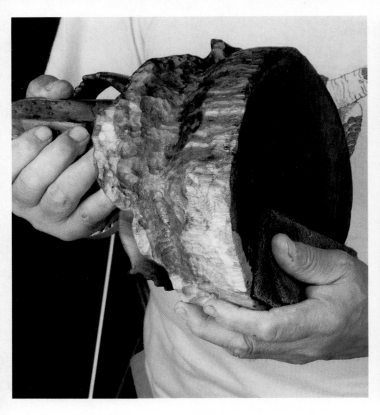

I also wax underneath. This is because the wax also protects and feeds the wood, and, even though it doesn't show, the base needs this protection.

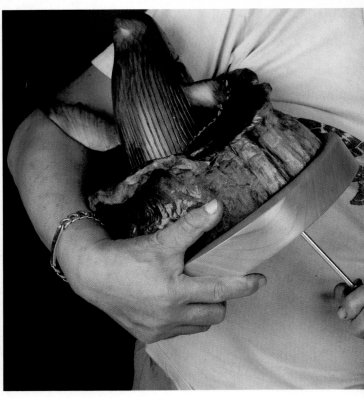

Attach the sculpture to the base.

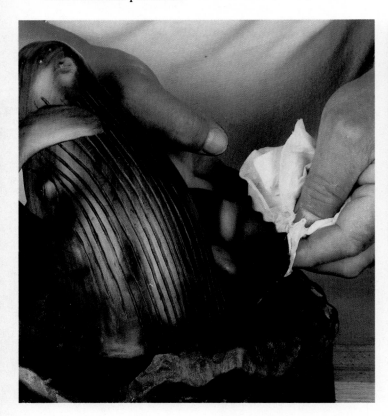

When the wax has dried, buff it with a clean cloth or paper towel.

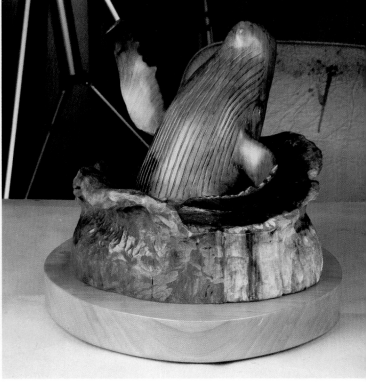

Finished.

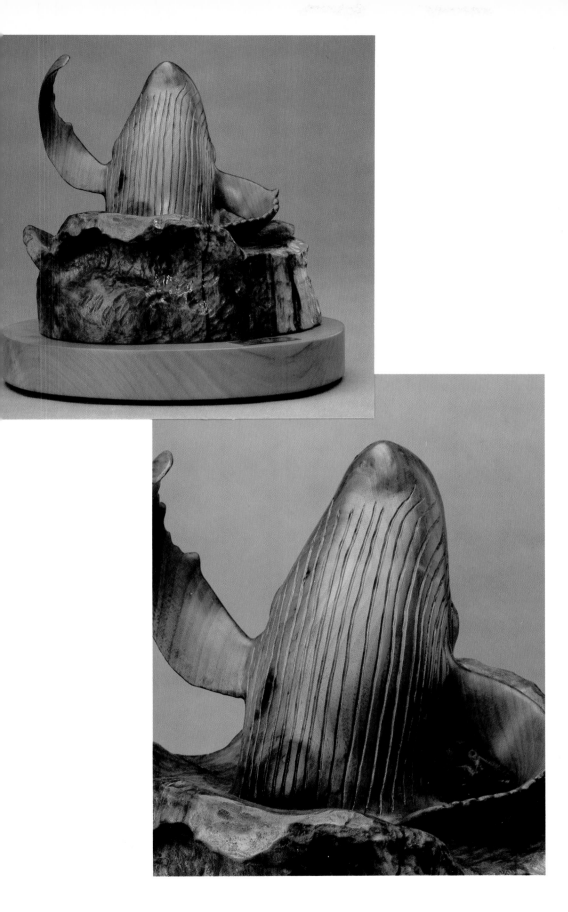

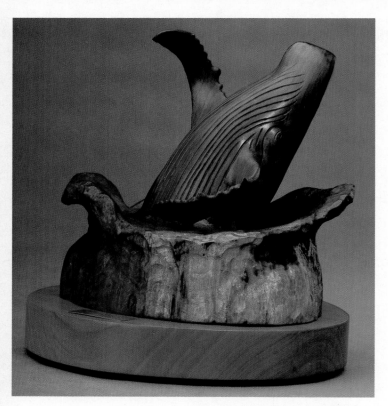

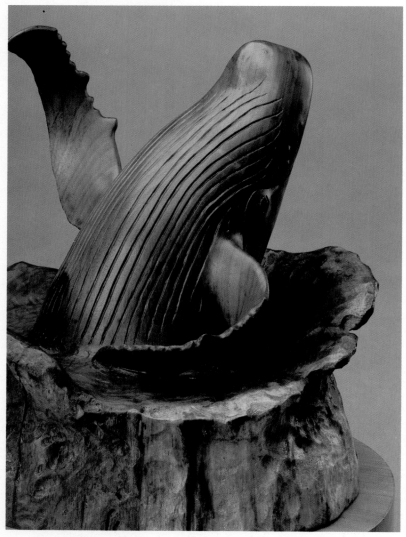

172

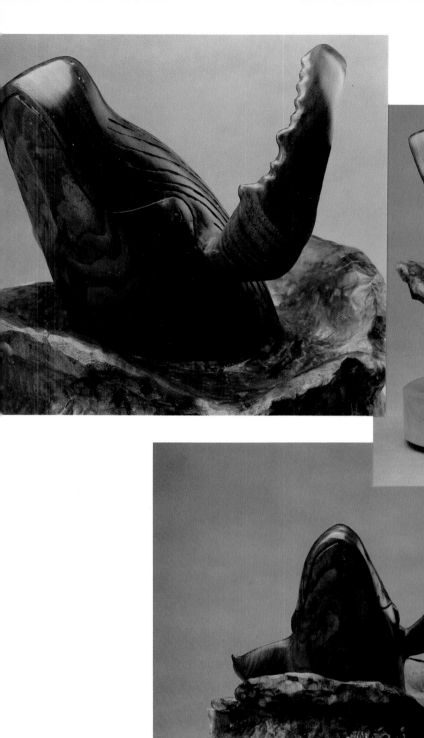

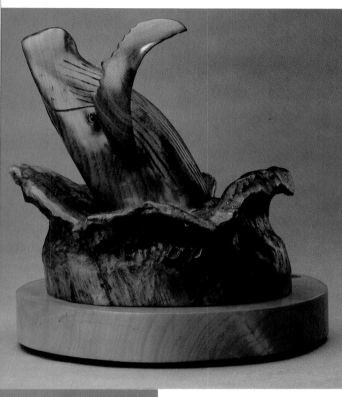

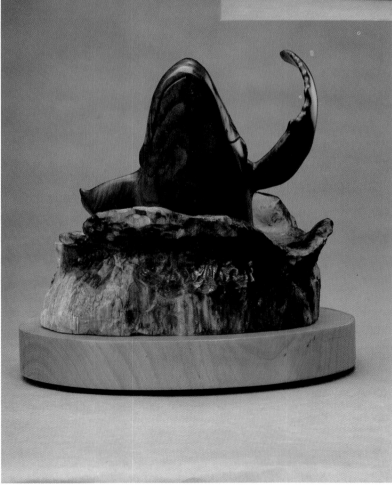

REFERENCES

Bony and Cartilaginous Fishes

Böhlke, J.E. and C.C.G. Chaplin, 1993. *Fishes of the Bahamas and Adjacent Tropical Waters*. 2nd Ed. University of Texas Press, Austin.
> Outstanding classic work, revised and updated. Fine descriptions of Elasmobranches and bony fishes.

Daniel, J. Frank, 1934. *The Elasmobranch Fishes*. University of California Press, Berkeley. 3rd Ed.
> Fine technical treatise on Elasmobranchs.

Fischer, W. (ed.), 1978. *FAO Species Identification Sheets for Fisheries Purposes*. Western Central Atlantic Fishing area 31. Food and Agricultural Org. of United Nations. Part 5 Sharks and Batoids.
> Excellent loose-leaf sheets on food fishes important to humans. Excellent clear line drawings with easy to use species differentiators.

Midgalski, E.C., and G.S. Fichter, 1983. *The Fresh and Salt Water Fishes of the World*. Greenwich House, New York.
> Fine layperson's book on rays, sharks, and other fishes.

Randall, J.E., 1968. *Caribbean Reef Fishes*. T.F.H. Publications. Neptune City, New Jersey.
> Excellent brief discussion of sharks, rays and other fishes.

Rays

Bigelow, H.B., and W.C. Schroeder, 1953. *Sawfishes, Guitarfishes, Skates and Rays*, (From Tee-van, J., C.M. Breder, S.F. Hilderbrand, A.E. Tarr, W.C. Schroeder, and L.P. Shultz, eds.) Fishes of the Western North Atlantic. Mem. Sears Found. Marine Res. No 1, Pt 2, pp. 1-514.
> Excellent technical reference with superb descriptions and excellent line drawings.

Sharks

Bigelow, H.B., and W.C. Schroeder, 1948. *The Sharks*. (From Tee-van, J., C.M. Breder, S.F. Hilderbrand, A.E. Tarr, & W.C. Schroeder, eds.) Fishes of the Western North Atlantic. Mem. Sears Found. Marine Res. No. 1, part 2, pp. 1-514.
> Detailed technical description on sharks.

Castro, José I., 1983. *The Sharks of North American Waters*. No. 5: The W.L. Moody Jr., Natural History Series. Texas A and M University Press, College Station.
> Well-written and illustrated (photos and line drawings) comprehensive book.

Ellis, Richard, 1976. *The Book of Sharks*. Grosset and Dunlap, New York.
> Comprehensive book on the subject

Johnson, R.H., and D.R. Nelson, 1973. "Agonistic Display in the Gray Reef Shark, Carcharinus menissorrah, and its relationship to attacks on Man." Copeia 1:76-83.

Schwartz, F.J., and G.H. Burgess, 1975. *Sharks of North Carolina and Adjacent Waters*. North Carolina Dept. of Natural and Economic Resources, Division of Marine Fisheries.
> Clear line drawings with succinct descriptions for field identification.

Skocik, R.D., 1975. *The Sharks Around Us*. Star Publishing Co. Boynton Beach, Florida.
> General layman's review of sharks inhabiting the Caribbean and Atlantic coasts.

Sea Turtles

Carr, Archie, 1952. *Handbook of Turtles: The Turtles of the United States, Canada, and Baja, California*. Comstock Publ. Assoc. Ithaca, New York.
> A well written and illustrated reference on turtles.

Fischer, W. (ed.), 1978. *FAO Species Identification Sheets for Fisheries Purposes*, Western Central Atlantic, Fishing Area 31, Food and Agricultural Org. of United Nations, part 6, Lobsters, Cephalopods, and Turtles.

Marquez M., Rene, 1990. *Sea Turtles of the World, An Annotated and Illustrated Catalogue of Sea Turtle Species Known to Date*. FAO Species Catalogue, Vol 11, Food and Agriculture Org. of the United Nations

Alligators

Reese. A.M., 1915. *The Alligator and its Allies.* G.P. Putman's and Son, New York.

Ashton, R.E., Jr., and P.S. Ashton, 1985. *Lizards, Turtles, and Crocodilians. Handbook of Reptiles and Amphibians of Florida.* Windward Publ. Inc., Miami, Florida.
> Excellent book with superb color photographs on natural history, description of species.

Cetaceans

Ellis, Richard, 1980. *The Book of Whales.* Alfred A. Knopf. New York
> Well-written and beautifully illustrated book.

Ellis, Richard, 1982. *Dolphins and Porpoises.* Alfred A. Knopf. New York.
> Well-written and beautifully illustrated book.

Kaufman, D.K., and P.H. Foresetell, 1986. *Hawaii's Humpback Whales.* Pacific Whale Foundation, Kihei, Maui, Hawaii.
> Excellent general book on Humpback whales.

Leatherwood, S., D.K. Caldwell, and H.E. Winn, 1976. *Whales, Dolphins, and Porpoises of Western North Atlantic.* NOAA Techn. Rept. NMFS Circ. 396.
> Excellent photos and description.

Minasian, S.M., K.C. Balcomb, and L. Foster, 1984. *World's Whales.* Smithsonian Books, Washington, D.C.
> Excellent book, succinctly written, well-organized and with excellent photographs.

Minasian, S.M., 1975. "The Killer Whale: Indiscriminate Killer or Misunderstood Predator." *Skin Diver.* December, pp. 34-37.
> Fine article on behavior of Orca

Ridgway, S.H. (ed.), 1972. *Mammals of the Sea.* Biol. and Med., C.C. Thomas, Springfield, Illinois.
> Chapt. 1: Masaharu Nishiwaki, "General Biology," pp. 3-204.
> Chapt. 4: R.F. Green, "Observations on the Anatomy of some Cetaceans and Pinnepids," pp. 247-297.

Tinker, S.W., 1988. *Whales of the World.* Bess Press, Inc. Honolulu, Hawaii.
> Oustanding book with fine discussions on the anatomy of the various organ systems, and description of the various species.

Walker, E.P., F. Warnick, S.E. Hamlet, K.I. Lange, M.A. Davis, H.E. Uible, P.F. Wright, 1975. *Mammals of the World. Cetacea.* Johns Hopkins Univ. Press, Baltimore, Vol. II, pp.1083-1145.
> Excellent descriptions and photos of actual whales and museum models.

Manatees

Husar, S.L., 1978. *Trichechus manatus.* Am. Soc. Mammal. Mam. Spec # 93, pp .1-5.
> Superb synopsis on the biology of the manatee with detailed references.

Kingdon, J., 1974. "Sea Cows, Sirenians," *East African Mammals, An Atlas of the Evolution in Africa.* Acad. Press. London, Vol 1, pp. 388-399.
> Well illustrated biology and anatomy of dugongs.

Phillpotts, Beatrice, 1980. *Mermaids.* Ballantine Books, New York.
> Mermaids in Art, a historical perspective with beautiful colored reproductions and additional references.

Zeiller, Warren, 1992. *Introducing the Manatee.* University of Florida Press, Gainesville, Florida.
> Well-illustrated book on the biology of manatees including stories about specific individuals.

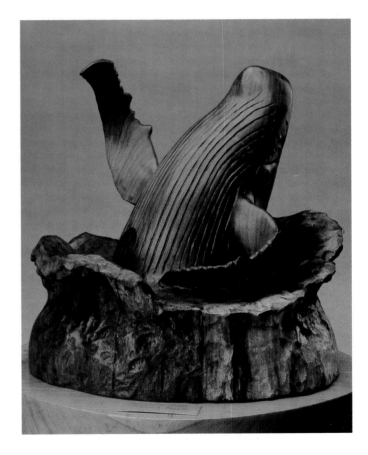

GLOSSARY

Agonistic combative, as in sharks getting ready to attack prey

Alveolar pertaining to tooth sockets in a jaw

Callosity a hardened bump on the skin, callus

Callus a localized thickening of the skin, a bump

Carapace back portion of the turtle shell

Caudad towards the tail end of the body

Caudal near the tail end of the body

Caudal peduncle a stalk-like structure near the tail end

Cephalic relating to the head

Clasper elongated process on male elasmobranch pelvic fins used in mating

Diastema(ta=pl.) wide space between teeth, as in the Orca

Dorsal pertaining to or on the back part of the body, as in dorsal fin

Dorso-ventral extending from the back to the abdominal surface of the body

Falcate sickle-shaped

Fluke refers to horizontally oriented tail of Cetaceans

Fusiform spindle-shaped

Heterocercal refers to tail fin having unequal lengths of lobes

Homocercal refers to tail fin having equal lengths of lobes

Lateral relating to the side of the body

Orbital referring to the eye socket

Philtrum groove in the midline of the upper lip

Plastron ventral or abdominal part of turtle shell

Peduncle stalk-like structure, as in caudal peduncle of cetaceans or sharks

Rostrum beak-like projection or structure on the head

Spiracle first gill slit, present in most Elasmobranchs. Small in sharks, large in rays

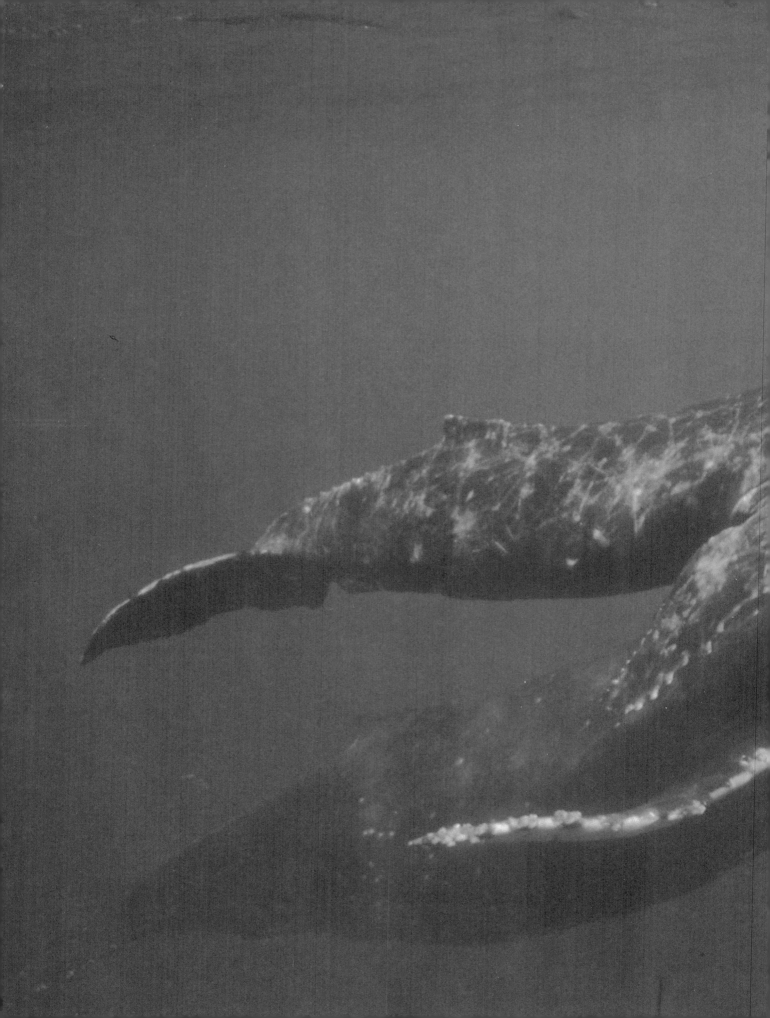